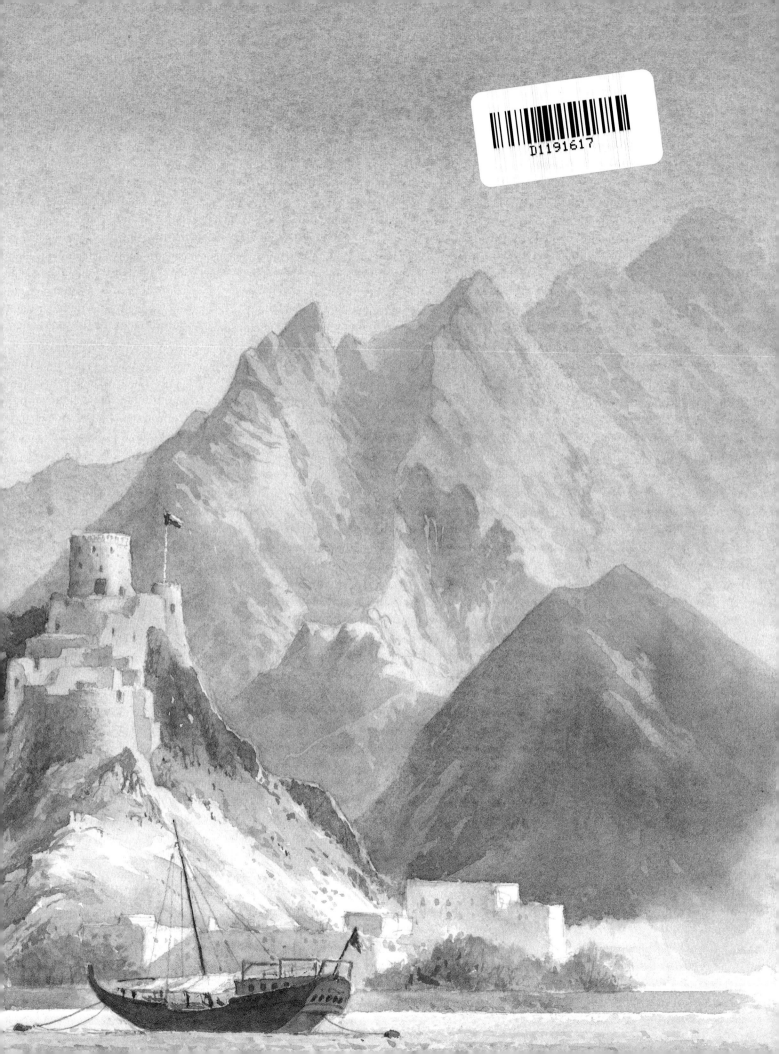

DAVID BELLAMY'S
ARABIAN
LIGHT

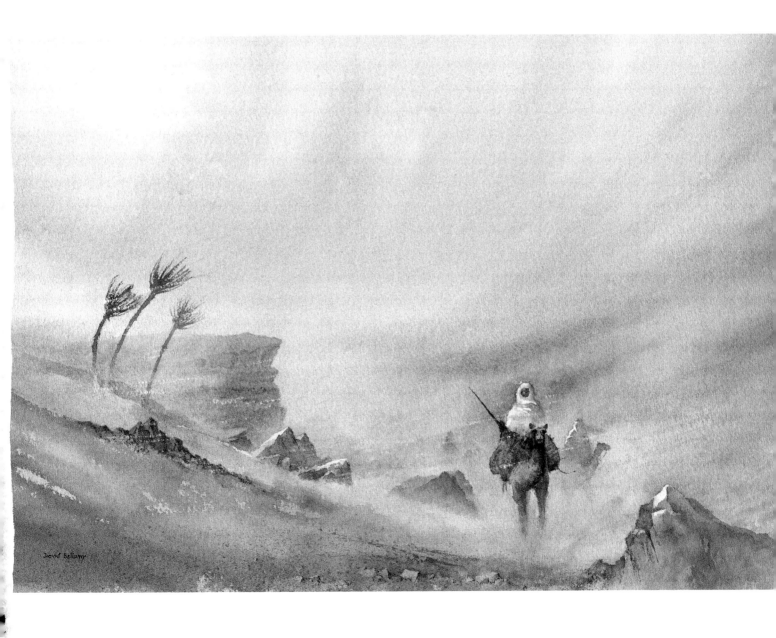

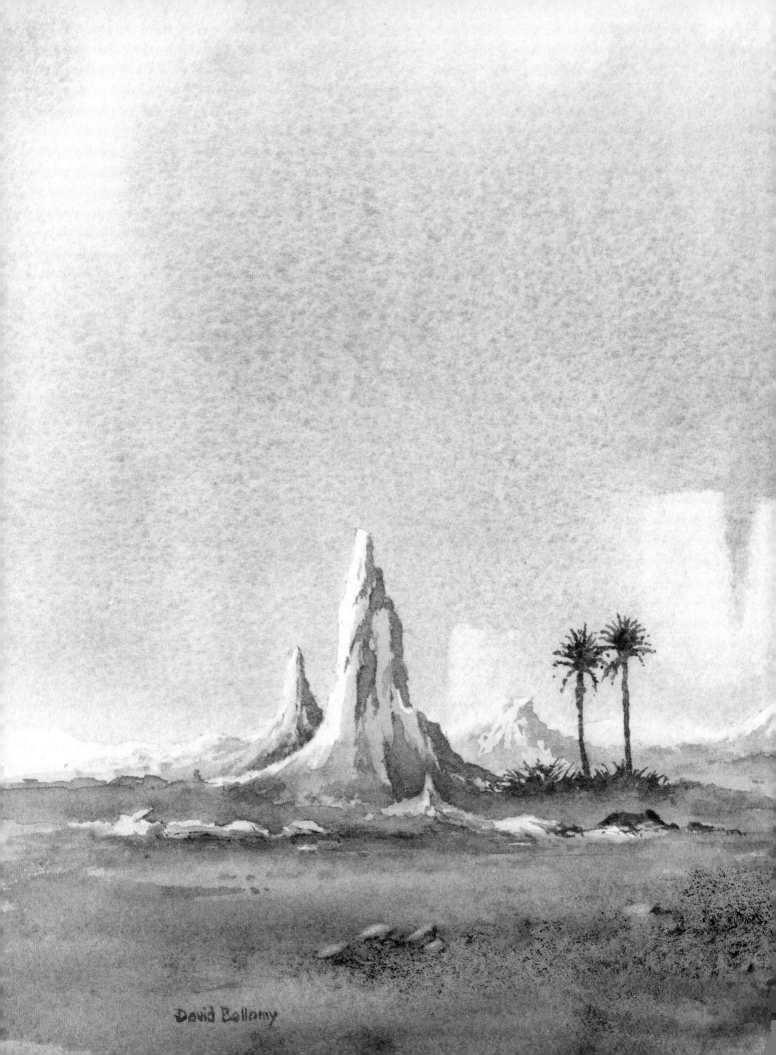

David Bellamy

DAVID BELLAMY'S
ARABIAN
LIGHT

An artist's journey through deserts, mountains and souks

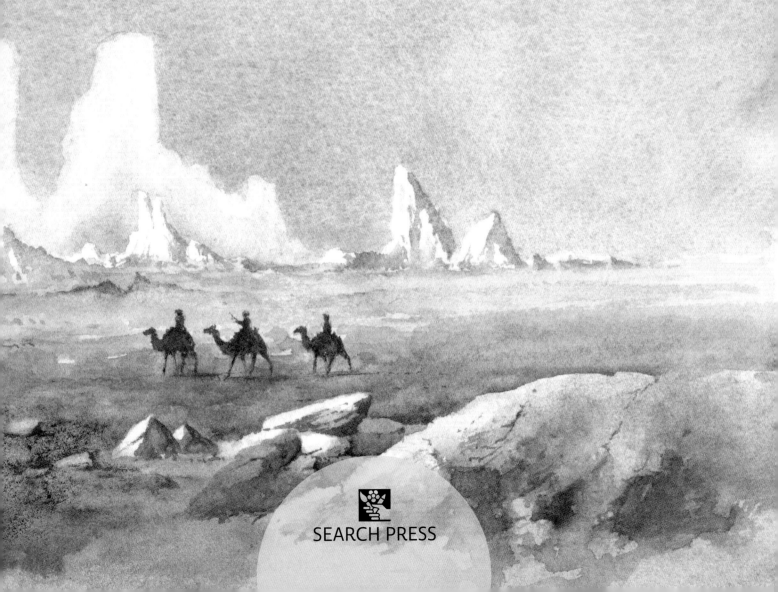

SEARCH PRESS

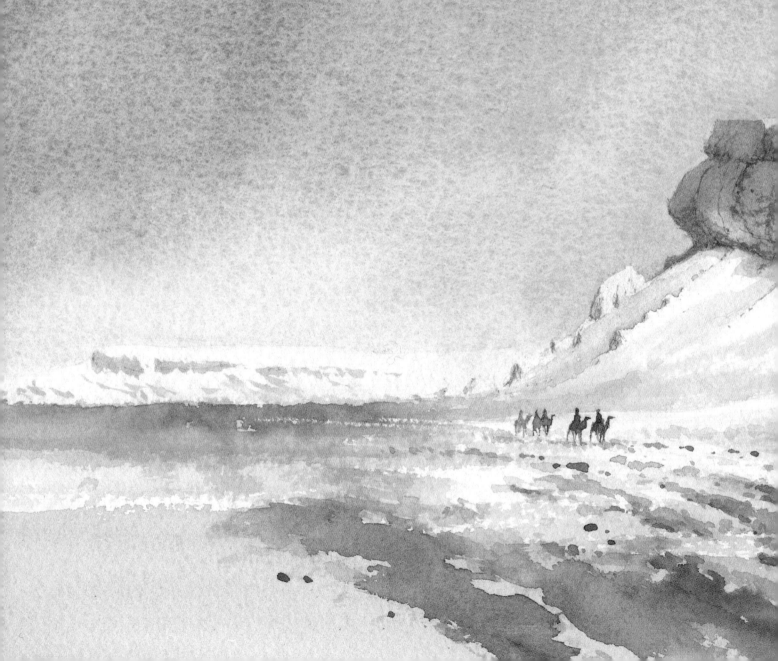

Dedication

To Gwinny, who at four years old is a joy to paint with, as she skips and gambols gleefully while spattering paint over the developing composition – preferably her own.

Page 1:
Sandstorm

Pages 2–3:
Inselbergs in Morning Haze

Below:
Darb al Rayyan

Contents

David Bellamy

INTRODUCTION

"I take you nice place," said the amiable taxi-driver.

"I want to see the waterwheels and sketch them," I replied as the taxi roared away. We struck up a cheerful, if slightly bewildering, conversation.

"Where you from? What country?"

"Wales."

"Meirs?"

"No, Wales!"

"Meirs. Meirs very good. I like very much."

"Yes, I'm sure."

"I show you the gardens."

"The waterwheels, please," I emphasized deliberately – I had a tight schedule to keep.

"There is mango here. My name is mango." Baffled by this turn of phrase, I put it down to this being a less touristy area. He was clearly trying to help me understand the place, but we were getting crossed signals. This guy's English was far better than my Arabic, and I couldn't think how else to make it clear that I wasn't after a general tour: no matter how generous the intention.

We passed another village. "There is tomato here. My name is tomato." At this point, the taxi phone rang.

The driver cursed in Arabic and did a rapid U-turn. "Police want us go to police station," he said.

As we screamed to a halt outside the police station I wondered what I was in for now. A tall plain-clothes chap got into the back of the car and we sped off again in the direction of Fayoum Oasis. It appeared I now had a bodyguard.

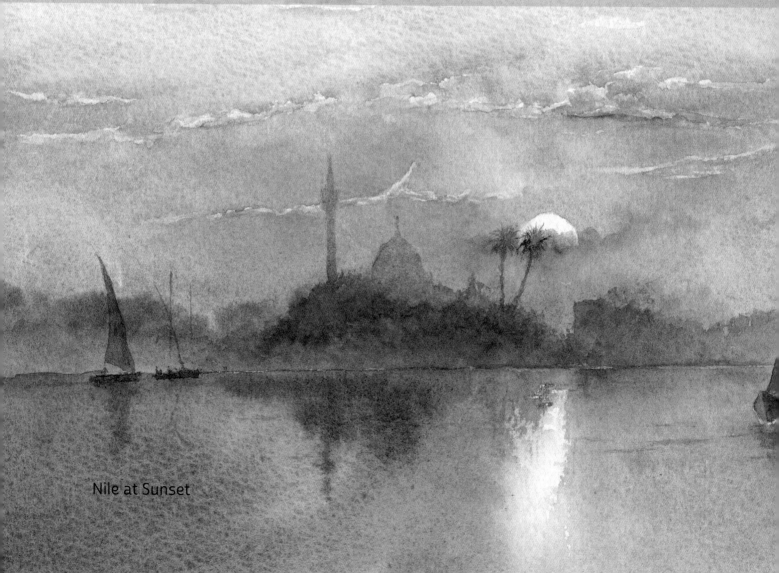

Nile at Sunset

Spies, imperialists, artists, escapists and ecclesiastic troublemakers

A slow-moving car got in our way so the taxi driver, after issuing forth several violent-sounding curses, reached under the dashboard and, to my astonishment, set off a loud police siren. The car in front quickly swerved to one side, narrowly missing a donkey and two angry fruit-sellers.

Soon we reached the Youssef Canal and the enormous waterwheels that wailed dismally as they turned with metal grating on metal. As I sketched, I gave the bodyguard a short lesson in linear perspective – with particular emphasis on elliptical attenuation regarding the wheel structures – for which he seemed most grateful, although he didn't appear to do much bodyguarding.

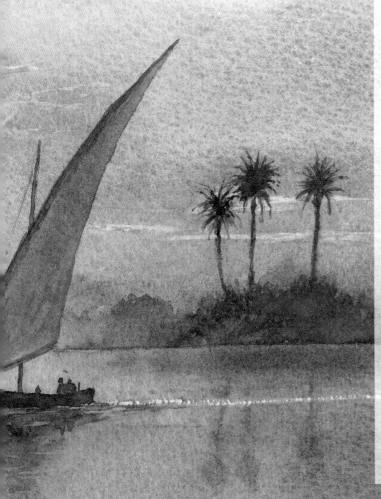

This Egyptian episode – bewildering and joyful in equal measure – is typical of my wanderings in the Middle East, which began as I drifted from my teenage years into semi-adulthood, keen to see the world.

A posting to Aden in 1963, during my military service, galvanized my interest in the region. The cultural differences were mind-boggling. I was hooked.

Mountains, deserts and wild places have always inspired me, both for adventure and my art, and so the call of the desert lands, with their history of exploration, adventure and wars became too strong to ignore. Well aware of the jaundiced light in which the region is portrayed in the Western media, I was keen to balance this insidious polemic, and at the same time to highlight some of the exciting places, outstanding scenery, spellbinding antiquities and cities teeming with the most fascinating people, whose humour, kindness and generous hospitality made me want to return again and again. They are certainly not all angels, but the book is intended as an affectionate personal response to my many fond memories of these enriching times.

The book strays a little beyond the Arabian peninsula suggested by the title, as I roam well into the Western Desert of Egypt. I begin with South Arabia, which was my introduction to the region, and with it the Swahili coast which is so closely linked. Egypt is a country I always wanted to visit, and the country and its people never failed to enthral me during my visits. Indeed, the country had a profound effect on me: I found the people friendly, kind and welcoming, with a wonderful sense of humour. The main draw in Jordan was the Rose Red city of Petra and Wadi Rum, both outstanding locations. Oman was not a country in which I expected to find a great deal of fascinating features, but as a mountain-lover it simply knocked me out with its stunning crags, gorges and summits; in places festooned with dramatic fortresses and castles. War-torn Lebanon appealed in a different way. The people here have been so oppressed, so at odds with their neighbours and themselves for so long, that this was a different side to the Middle East. Other countries were high on my list, such as Syria, but with ISIS rampaging, it proved impossible to visit the country.

EARLY HISTORY

To meaningfully discuss the region, however, we need to make some sense of the often fractious history. It is undeniable that the West has collectively been exploiting the region and its people, to a greater or lesser extent, since the Crusades. In 1096 Pope Urban II received a request for help from the Byzantine Emperor Alexius I Comnenus, whose lands in Asia Minor (modern Turkey) were being overrun by the Seljuk Turks. The Pope relished the idea of conquering the Holy Land, and saw an opportunity to get rid of some of the local riff-raff at the same time, by recruiting soldiers from the thieves, murderers, rapists and villains crammed in European jails and sending them to march into Arab lands; there to fight battles to stamp European imperialist aims on the Holy Land. A smattering of gallant knights to lead the way, along with a number of particularly bloodthirsty bishops to direct military operations (as was their prerogative in those days) gave this effort both direction and a stamp of authority.

The resulting First Crusade fell upon Jerusalem and massacred the population in the most barbaric ways, the clerics even expressing delight in their slaughter and torture of the Muslim innocents, unsurprisingly giving the Arabs little idea that we professed to be civilized. The Second Crusade fell apart in defeat for the Christians, who quarrelled amongst themselves. This led to much land being lost. Its leaders constantly broke truces with the Muslims.

During the Third Crusade, Saladin's Muslim army defeated the Crusaders at the Battle of Hattin on the shore of Lake Tiberias (in modern Israel) in 1187. Jerusalem was back in Muslim hands. Richard the Lionheart, King of England, arrived on the scene, keen to do battle with Saladin. To goad the Muslim leader into attacking, King Richard shamefully massacred over 3,000 prisoners, including the women and children, but failed to recover Jerusalem.

Al Karak Crusader Castle, Jordan

Built around 1142, this castle stands high above the surrounding countryside in an nigh-impregnable position. For much of the time it was held by the notorious Reynald de Chatillon, an abominable sadist who was as much a liability to the Crusaders as he was against the Muslims. One of his favourite pastimes was hurling prisoners from the castle walls, into the distant valley below, after torturing them. He was eventually killed personally by Saladin who was sickened by Reynald's never-ending atrocities. The castle fell to the Muslims after a year-long seige in 1188.

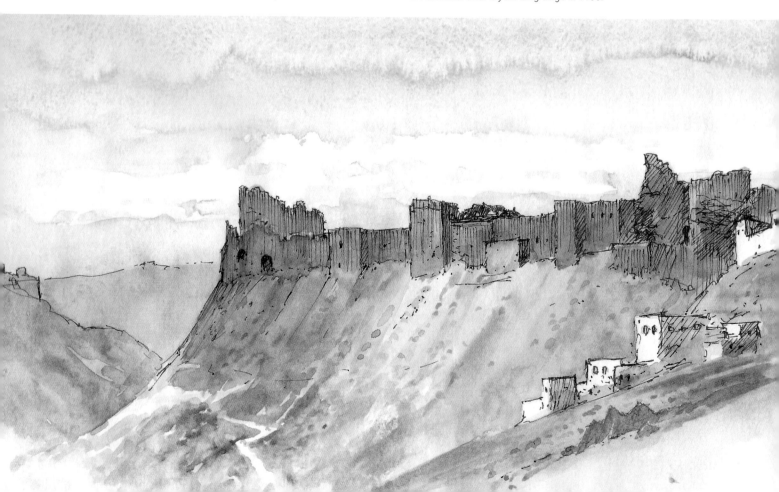

THE OTTOMAN EMPIRE

For centuries vast areas of the Middle East, North Africa and south-east Europe were ruled by the Ottoman Empire, which was founded in 1299 in Anatolia by a tribe of Oghuz Turks. In 1453 they captured Constantinople – now modern Istanbul – and demolished the Byzantine Empire. Following this, they captured Belgrade in 1521, Hungary in 1526 and then laid siege to Vienna in 1529.

This European adventure was achieved under Suleiman the Magnificent (1494–1566), a just and humane ruler who was a great patron of the arts and even wrote poetry. Brilliantly organized, their military campaigns featured weaponry and equipment so beautifully designed and decorated that one can instantly see what a formidable force they represented.

Their success in Europe further reinforced European Islamophobia, although there was little justification in regarding the Muslims as barbarians when the West was equally keen to dish out atrocities, often with a greater relish. Not until the end of the First World War did the Ottoman Empire collapse.

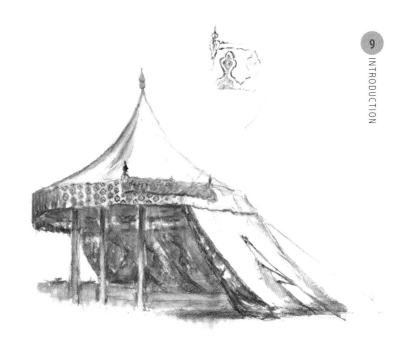

Ottoman campaign tent

These magnificent tents provided a palatial home from the sultan's palace where he and his senior officers could dine in splendour and plan campaigns. This enormous example had three main poles, with the awning and interior walls completely decorated with colourful appliques of satin, cotton and gilt leather in exquisite arabesques. Many were created with such opulent designs that they were almost as comfortable as palaces. Hundreds of camels were needed to transport all the tents for the sultan alone.

Ottoman tent-pole cap

Even the Ottoman tent-pole caps exhibit an intricate design, showing the extreme care that was taken on even the most minor of objects, and thus the formidable nature of the Ottoman Empire.

Ottoman dagger hilt

Floriated arabesque designs appear on many artefacts and buildings. Swords, daggers and other weapons are no exception.

Bedouin Tea, Kharazeh
Canyon, Jordan

THE ALLURE AND MYTH OF THE ORIENT

Down the centuries many visitors to Arab lands have reinforced and refined a sense of European superiority. In 1836 Edward Lane's *Manners and Customs of the Modern Egyptians* reinforced Western prejudices, implying that the Orientals were decadent, sex-crazy languishers, and religious fanatics, with 'perversions too awful to describe to the reader', thus leaving it completely to the reader's imagination as to what these perversions might be, and denying them of any comparison with perverted practices in London and Paris, or with the religious fervour widespread at the time. Much of his information Lane ascribed to the authority of respectable persons, whom he reveals as being fellow Englishmen. Such authority could not possibly be suspect because 'they are guarded against the possibility of dubious testimony by the strength of their nationality' as Rana Kabbani, a British-Syrian cultural historian, acidly relates in her excellent book, *Europe's Myths of Orient*.

Richard Burton

One of the most colourful explorers to write influential books on the Middle East was Richard Burton (1821–1890), an imperialist, bully and linguistic genius who was commissioned into the 18th Bombay Light Infantry in 1842, but was thrown out of the army for writing in-depth accounts of homosexual practices in male Indian brothels.

In 1853 he disguised himself as Sheikh Abdullah, an Afghan doctor, for his pilgrimage to Medina and Mecca. An accomplished artist, he hid a notebook inside his copy of the Koran, working on this when he was alone. Had he been discovered as an infidel in Mecca he would undoubtedly have been killed, but with his flawless Arabic and his help in curing people, his identity as Sheikh Abdullah was never doubted. While Burton's descriptions and observations brought vast new areas of knowledge about the Orient, his attitude to the Arabs is revealed in his statement that 'the cameleer, like the lowest orders of the Orientals, requires to be ill-treated'. Like many Western visitors and institutions he delighted in reinforcing a dominating attitude over these people.

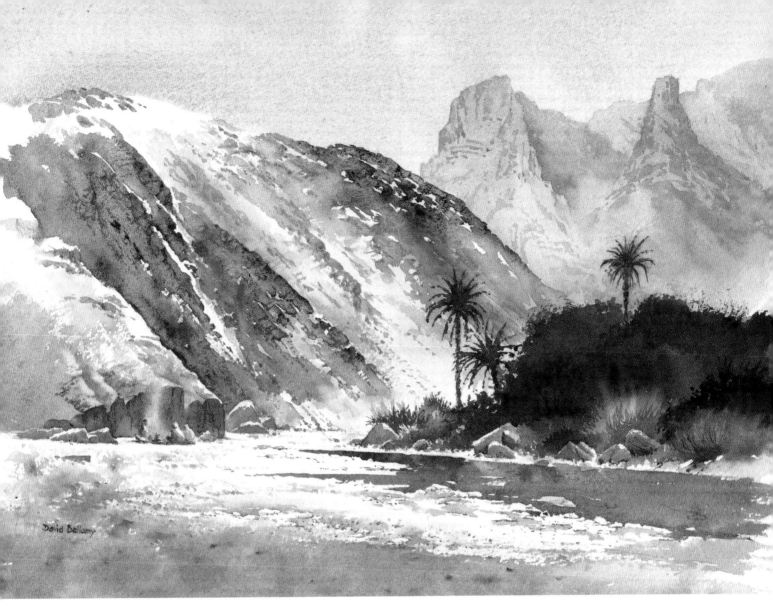

Wadi Bani Awf, Oman

Nothing much seems to have changed during the intervening period. This appalling attitude shown throughout the centuries by the European powers towards the people of the Middle East, fuelled by immense greed, power and religious fervour, created immense and ongoing problems, particularly for those who travelled in the region. Edward Lear, the artist and poet most famed for his nonsense verse, who travelled vast distances across the Arabian Peninsula, commented, 'When will it please God to knock Religion on the head and substitute charity, love and common sense?'

During my numerous visits to the region, I have found it desperately sad to see so many people who are dependent on the tourist trade finding it almost impossible to survive on the few travellers brave enough to visit. Petra was like a ghost town when I was there in 2002, and Lebanese Tripoli was almost devoid of Europeans in my most recent visit in 2019. I returned from these trips with hundreds of sketches and journals brimming with stories and anecdotes, yet with a disturbing feeling that, as far as much of the Middle East was concerned, we were returning to 18th-century values of disdain, exploitation and lack of understanding.

WESTERN ARTISTS AND ARABIA

Many artists have visited the Arabian Peninsula before me, from the well-known Orientalists to amateurs and gifted military artists. Before the age of the camera, sketching was vital for explorers to record their experiences – and also a crucial ingredient in overseas military campaigns. As a result, some were suspected of spying – and indeed, a number were involved in this dodgy trade.

Even today, sitting around or lurking in the shadows while sketching fortifications could get you into hot water. In Tunisia, while sketching and taking notes as normal when travelling with my wife, Jenny, we were followed by two men dressed in trilbies and raincoats with their collars turned up, and looking so out of place in the hot, baking sunshine on the edge of the Sahara, that they had 'Special Branch' stamped all over them. On approaching us they were (perhaps fortunately) baffled by the many ludicrous cartoons in my sketchbooks, rather than concerned with the rest of the contents.

Arab relaxing

The Orientalists

Orientalist painting reached its height in the 18th and 19th centuries. Its members varied considerably in both style and subject diversity, with most of the main European countries represented. The British and French, however, tended to dominate, with the French Orientalists particularly active in their North African colonies across the Maghreb.

Some, like Englishman John Frederick Lewis (1804–1876) spent many years based in cities like Cairo, while others engaged in arduous expeditions across the desert regions. David Roberts (1796–1864) and Edward Lear (1812–1888) were two who spent long periods in the wilds. Others never went anywhere near the Middle East and relied entirely on the sketches of others, together with the artefacts brought back by the travellers, from which they could elaborate on the composition of a typical Middle Eastern harem or home.

The most popular subjects of the Orientalist genre were the harem and the baths, both of which attracted the most criticism. Some critics view these painters as instruments of cultural imperialism, portraying Easterners as decadent languishers in opulent harems. Painting the harem became a controversial issue, especially as few Westerners had gained access to one. However, the Orientalists' paintings gradually softened the West's prior sense of fear and hatred of the Muslims, by depicting them as people instead of enemies of Christians. Many showed the simple life: elderly men smoking a *narghile*; children playing in the street; or women collecting water in their large water-pots, for example. Such ordinary life scenes (as well as the more spectacular) were the hallmark of the outstanding American painter Frederick Arthur Bridgman (1847–1928) who studied in Paris under Jean-Léon Gérôme (1824–1904), who was regarded as the leading light of the French Orientalists. Gérôme's meticulous draughtsmanship and exceptional ethnographic accuracy provided a standard that others strived hard to achieve.

Bridgman's compatriot, Edwin Lord Weeks (1849–1903), also a brilliant and highly successful American artist, travelled much in Algeria, Persia (modern day Iran) and India, although he didn't seem at ease in Cairo. His notes on a visit to the pyramids betrays a lack of humour, and the need to use a whip on any locals that got in his way or had the temerity to ask for *baksheesh*.

The work of the Orientalists has created an outstanding visual record of the Middle East before the age of the camera, resulting in a clamour to own Orientalist paintings by contemporary Middle Easterners.

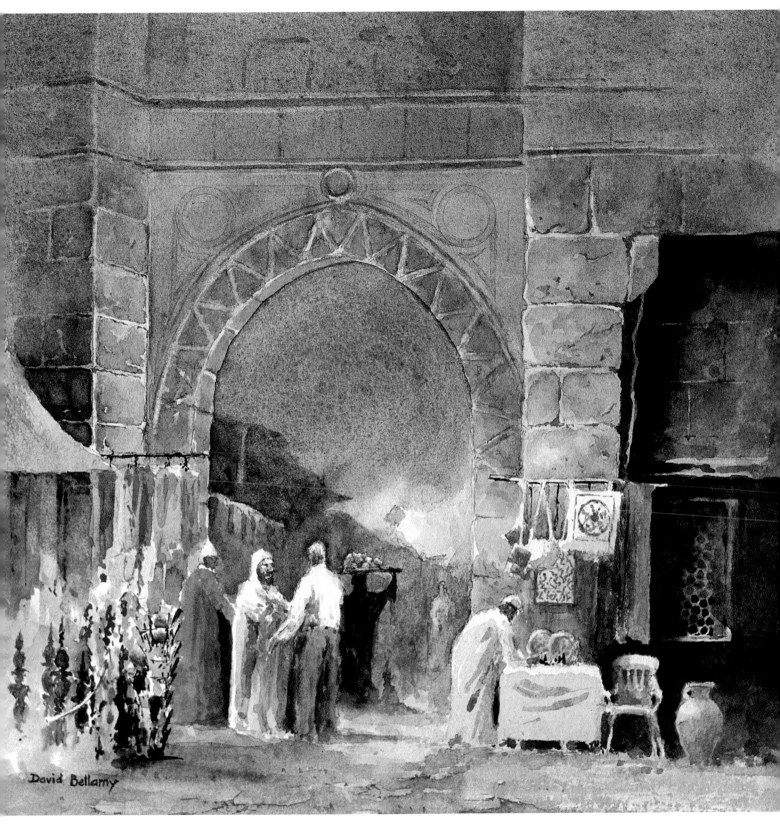

Gateway in Khan al Khalili, Cairo, Egypt

The souks come alive at night-time, and Khan al Khalili is one of the best. Happily I failed to encounter any of the mopeds; donkey-carts; sales-people; fire-eaters; whirling dervishes or Greek soldiers in short, frilly fustanellas, that have made sketching in Arab souks on previous occasions more of a challenge. The flash of coruscating lights reflecting off glimmering metalware added to the sparkle of this lively place.

ADVENTURES IN THE MIDDLE EAST

Apart from the artists, the Middle East has attracted an amazing variety of explorers, both male and female. They have included spies, imperialists, circus acrobats, general trouble-makers, bumblers, escapists or, in a few cases, a combination of almost all these types.

Sir Wilfred Thesiger (1910–2003), the last in a long line of Arabian explorers, and much revered by the Bedouin, states in the foreword of Richard Trench's excellent *Arabian Travellers* book, that he did not expect to compete with the Bedouin in physical endurance as they had been born to this life of extreme hardship, but with his family background and education at Eton and Oxford, he did expect to excel them in civilized behaviour. He found it humiliating to realize that he often failed to measure up to the Bedouin standards in this as well.

Female travellers have been accorded little recognition over the years in comparison with their male counterparts, yet theirs was often a more dangerous undertaking. These were generally upper-class, well-to-do ladies who could afford to indulge in expensive travel; 'persons of distinction', as they often called themselves, such as Lady Hester Stanhope, Gertrude Bell, Lady Jane Digby, Lady Anne Blunt and Freya Stark. They would set off into the desert to travel hundreds of miles, often with a large retinue, well aware that they would most probably be attacked by Bedouin tribes along the route – and all this in the face of intense heat, a lack of water and the obvious difficulties in navigating the desert. It was pretty much *de rigeur* for these individuals to be able to draw and sketch, something that most ladies of distinction pursued as a hobby in any case. They could then record their finds and experiences, and many were highly accomplished artists.

Of these, arguably the most interesting and likeable was Lady Jane Digby (1807–1881) who, after marrying, eloped with an Austrian prince; married a German baron; had a wild affair with the King of Bavaria; and, before departing for Eastern lands, indulged in a romantic fling with an Albanian general. In Syria she met Sheikh Medjuel el Mezrab (1827–after 1881) who was to escort her to Palmyra where they were married. He was some twenty years younger. From then on she contentedly lived the life of a Bedouin wife, and was so loved by the Bedouin that they were prepared to die for her. In the following pages we shall meet some of these extraordinary explorers.

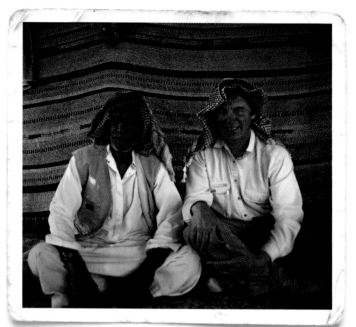

Author enjoying Bedouin hospitality with Sheikh Mohammed al Fluoy in Wadi Rum.

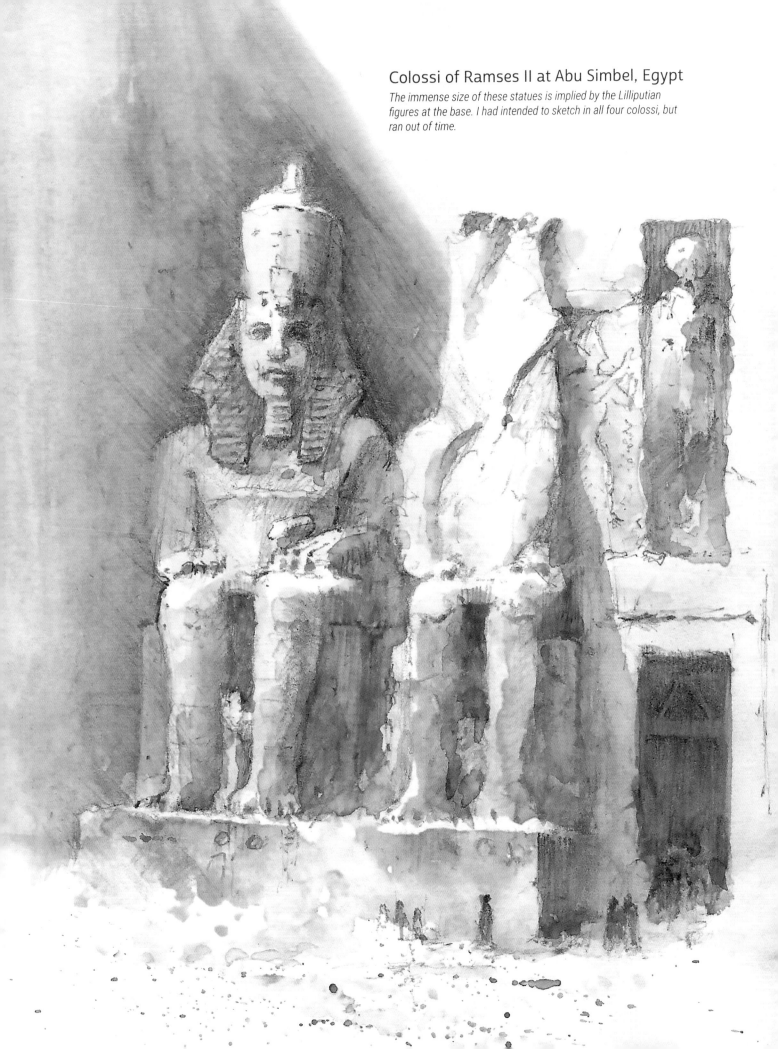

Colossi of Ramses II at Abu Simbel, Egypt

The immense size of these statues is implied by the Lilliputian figures at the base. I had intended to sketch in all four colossi, but ran out of time.

Minarets in Muskat, Oman

While Lady Jane's experiences with the Arabs were mainly positive, she did encounter a certain amount of hostility, and while this does occur I have found it extremely rare. Certainly, I have met plenty of anger against Western governments and Israel – in the latter case mainly from displaced Palestinians – yet even in the face of extreme provocation and even destruction of their homes and possessions, so few of these people seem to bear grudges. Indeed, they are far more accommodating than I would be!

There is an Arabic glossary and select bibliography at the rear of the book, and in the final chapter, which begins on page 158, I discuss some of my working methods and how I tackled certain subjects, also covering painting challenges peculiar to the Middle East, such as the intense heat and brilliant light. It gives an idea of my working methods in hot places – sometimes 'hot' in more senses than one.

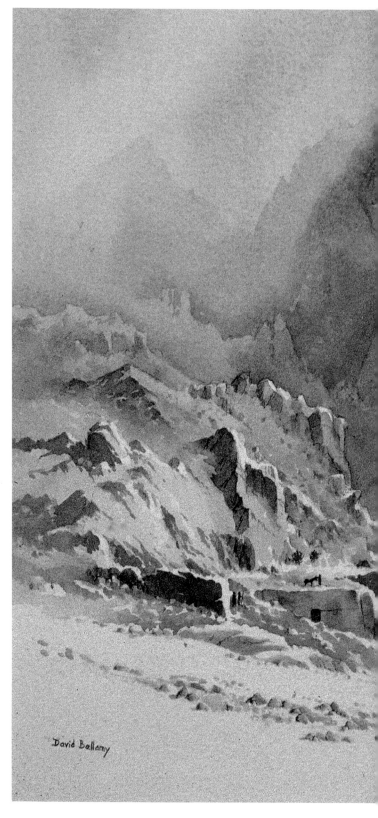

David Bellamy

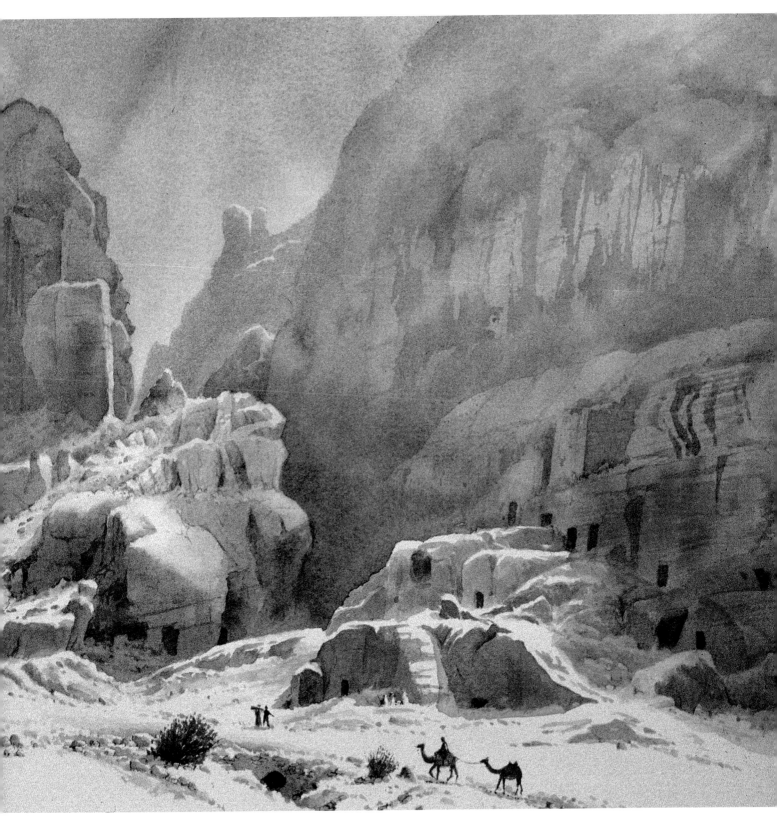

Outer Siq, Petra, Jordan

SOUTH ARABIA & THE SWAHILI COAST

Dying days of Empire

In June 1963 I arrived in the Land of Sheba, whence camel caravans once carried frankincense, myrrh and spices to far-off lands, and from where the Queen of Sheba sojourned on her famous journey to visit King Solomon in Jerusalem. Solomon's belief that the queen had the hairy legs of a goat was shattered when he found out they were shapely, and they ended up in his bedchamber with said queen.

The air base where I would work over the next two years was the largest in the Royal Air Force (RAF), and introduced me to the Arab world, which was to become a big part of my life. A blast of scorching heat hit me like a wall as I emerged from the Britannia aircraft, and staggered down the steps onto the Aden tarmac. Ill-prepared in suit and tie, the humidity quickly soaked me. This airfield was to be my home for the next two years.

Khormaksar brimmed with no fewer than nine squadrons of aircraft, from helicopters to Hunter strike aircraft and from transport types to the Avro Shackleton maritime patrol aircraft derived from the famous Lancaster bomber of the Second World War fame.

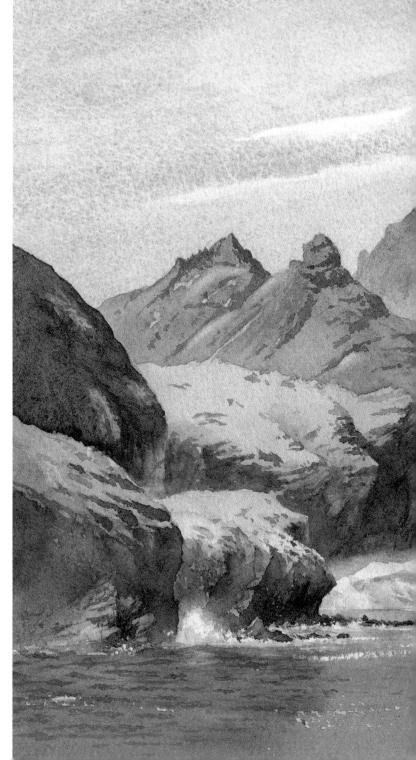

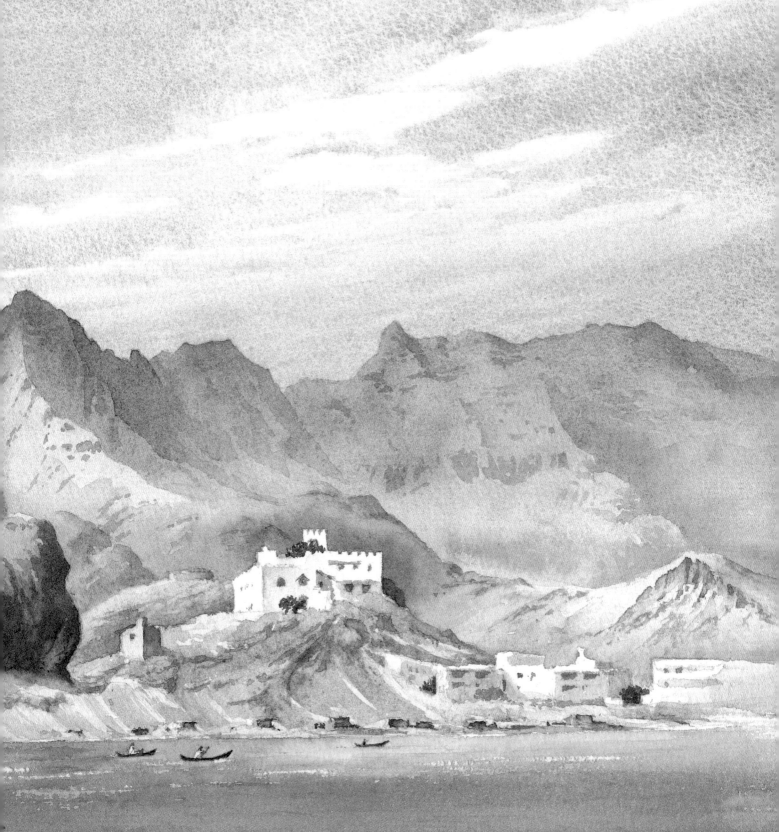

Fishermens' Cove, Aden

Rising in the background is the great rim of peaks that define the bowl of Crater, an old town. Since my original sketch in the 1960s the area has become much more built-up.

David Bellamy

YEMEN AND ADEN

In 1839, Aden became the first territory acquired by the British Empire in the reign of Queen Victoria, and the opening of the Suez Canal in 1869 brought much prosperity to the colony through visiting ships. Friendship treaties were established with the local rulers, but Yemen remained under Ottoman rule until the end of the First World War.

When I was stationed here, the population of this South Arabian colony was a mixture of mainly Arabs, Indian traders and Europeans. Generally friendly, the Adenis often displayed a great sense of humour. The women wore their traditional black *abaya* covering, while the men dressed in their cotton *futah*s, thin cotton wraps wound several times round the lower body.

A huge number of Adenis and Yemenis were addicted to *qat* (also called *khat*), chewing the leaves of the shrub to induce a feeling of pleasure that tended to detach them from the real world – though some claim it helped them concentrate for work or while studying. Qat is also chewed at weddings and funerals – and speaking of which, Adeni funerals could be rather rumbustuous affairs, the corpse being carried with the most indecent haste, to the accompaniment of a lot of noise.

During my early days in Aden, parts of the colony could be explored fairly easily. Up-country, however, which was inhabited by tribes that were constantly at war with each other, travel proved more difficult. This 'back-country' was little explored.

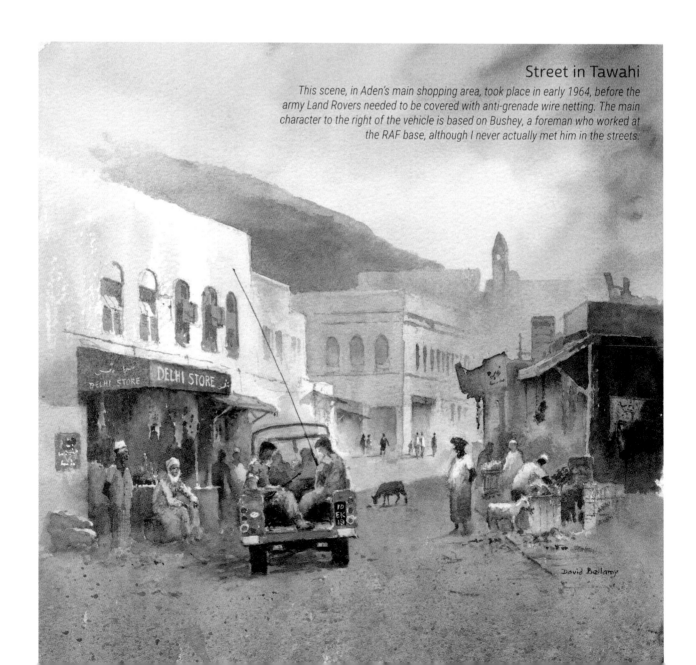

Street in Tawahi

This scene, in Aden's main shopping area, took place in early 1964, before the army Land Rovers needed to be covered with anti-grenade wire netting. The main character to the right of the vehicle is based on Bushey, a foreman who worked at the RAF base, although I never actually met him in the streets.

In Aden I rarely sketched apart from the occasional drawing, and my painting was limited to gouache and a small number of oil paintings. Sometimes I would work on an enormous canvas. My subjects were not terribly inspiring, sometimes being theatre scenery for the Dolphin Players, an amateur dramatics society for civilians and service people. Although I had no studio and limited room, I would happily work outside on the first-floor verandah in perfect light, anchoring the canvas to a column to stop it blowing away. This system, however, invited rather a lot of the sand blowing in from the desert to cling to the wet oil paint, adding an element of dubious textural quality to the work.

My work involved electronic aircraft components, from Hunter gunsights to maritime sonobuoys, which were dropped into the sea to detect Soviet submarines. When I arrived things were fairly peaceful, but once the Radfan Campaign began, with round-the-clock Hawker Hunter and Avro Shackleton aerial sorties, things began to heat up.

Painting in Aden

The author completing a sign, one of a varied selection of subjects carried out during his stay in Aden. These ranged from cartoons, line drawings, signs, flying safety posters, oil paintings, a few sketches and several appalling watercolours, one of which is thankfully pretty much hidden in the top right-hand corner.

Freya Stark

British travel writer and explorer Freya Stark (1893–1993) came to Aden in January 1935. She had been an annoyance to the French administration in Druze country in Syria in the late 1920s, owing to her wanderings in prohibited wild country. In Aden, she wanted to explore the Hadhramaut region in the north of the colony, and in particular be the first European to find Shabwa, a buried city of untold wealth and the former capital of the kingdom of Hadhramaut. After much exploration she fell ill and had to be evacuated by air back to Aden.

To her annoyance, the German photographer Hans Helfritz (1902–1995) beat her to Shabwa, although he was chased off by angry Bedouin. Undeterred, Freya returned two years later with two companions: Gertrude Caton-Thompson

(1889–1985) and Elinor Gardner (1892–1980), both archaeologists keen to work in the Hadhramaut. Gertrude insisted on being addressed as 'Miss Caton-Thompson', and reportedly spent most of the time with her nose stuck in the air, making it clear that she considered the Arabs disgusting. The two ladies found Freya an annoying companion: her organisation of the expedition left much to be desired, and she fell out with her two friends. The trip ended in sickness and had to be prematurely abandoned.

Freya's talents, however, were put to good use during the Second World War when, against the odds, she slipped into Yemen, taking with her three British propaganda films to show to the locals, at the same time noting the movements of the Italians.

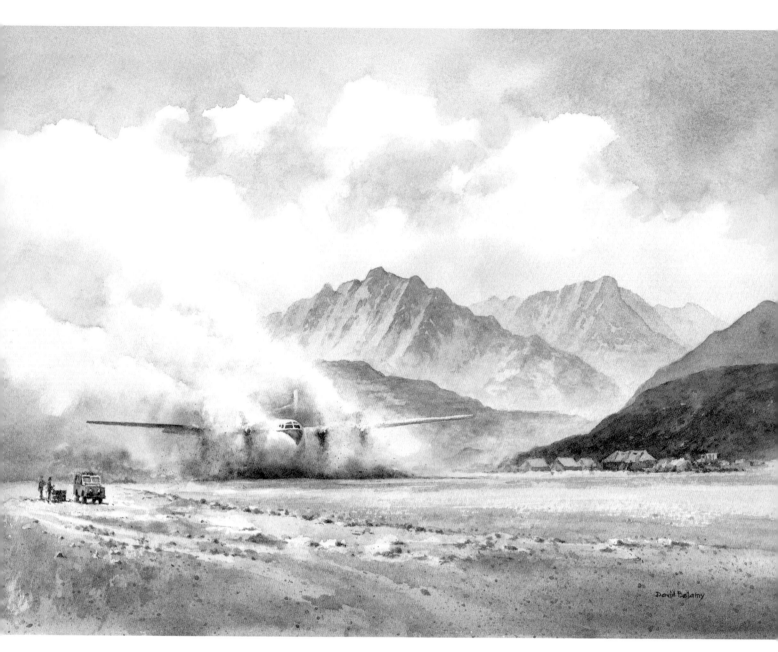

Radfan is a mountainous region some forty or so miles north of Aden, where the tribes engaged in the dubious pastime of ambushing vehicles driving along the road leading from Aden to Dhala, just inside the South Arabian border.

During early 1964, encouraged and supplied with more modern weapons by the Yemenis and Egyptians, the tribes increased their attacks and disruption to life in the Protectorate. The runway at Thumier airstrip was extended to take our large Blackburn B-101 Beverley transports, which could land on short runways. The Beverley was a rather ungainly affair, closely resembling a flying cowshed. It carried troops and all manner of equipment, vehicles and artillery pieces, even 3-ton Bedford trucks, creating vast clouds of dust on take-off and landing up-country.

Desert Landing

A Blackburn B-101 Beverley transport aircraft of 84 Squadron lands at Thumier airstrip in the Radfan mountains, generating its own sandstorm. These ungainly transports brought in supplies for the army units engaged in the battle.

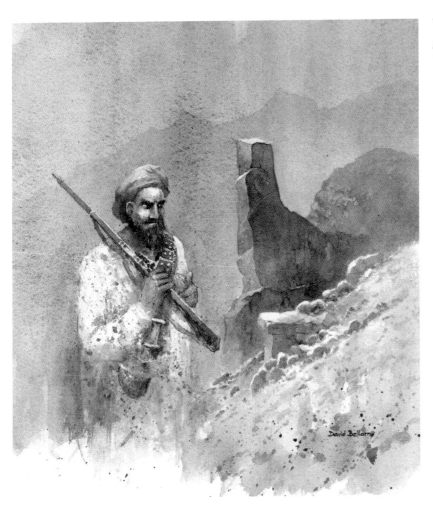

Yemeni Tribesman

Painted from the rough pencil sketch I did in 1964, which you can see below.

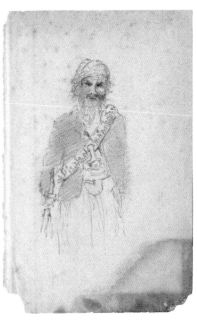

Yemeni Tribesman sketch

As I had no camera or sketching gear I did this drawing from memory, shortly after the encounter. Unfortunately I made him look far too benign. His left cheek is bulging with qat, the scourge of Yemen.

The mountains were ideal territory for guerrilla warfare, at which the Radfanis were adept, having learned to fire rifles from an early age. One early encounter with a Radfani tribesman left me frustrated as I had no sketchbook or camera on me and had to memorize the details of his appearance, especially the bandolier round his shoulder, the ancient rifle, and the ubiquitous *jambiyya*, a curved dagger stuck in his 'belt'. To the Yemeni, this is a symbol of honour and masculinity.

The locally-recruited Federal Regular Army battalions fighting the battle in Radfan were supported by British battalions. Helicopters dropped supplies, including 105mm guns, onto the peaks and ridges where the troops operated. Meanwhile, Hunter FGA9 jets and Shackleton propeller-driven aircraft provided ground support, the Hunters diving low and, at times, having to make 7-G turns to avoid the peaks.

As the battle intensified, two SAS soldiers were killed under the cover of darkness, then beheaded. Their heads were displayed on poles in Taiz, the then-twin capital of Yemen. Appalling photographs of decapitations were common to us at that time.

By mid-1964 terrorism began to take a hold in Aden itself, mainly in the form of grenade attacks. President Nasser of Egypt (1918–1970) was keen to be seen leading the Arab world in expelling the Western nations from the Middle East. His portrait hung in almost every Aden shop.

The local terrorists were pretty inept; at one point rolling a grenade into a crowded restaurant in Steamer Point, only for it to hit an inside wall and roll back out again – blowing up the chap who had thrown it. Places where one relaxed, such as open-air cinemas, became popular targets for the grenade-throwers. One day at the beach I finished my swim and heading for the changing rooms, only to realize I was about to step on a grenade lying on the ground. I leapt over it and yelled out a warning as I ran for cover, but happily it failed to explode.

Everyone had to take their turn on guard duty, and on one occasion I found myself in charge of an RAF bus that had to go into Crater, hotbed of Arab nationalism, in the dead of night in case there were any personnel who needed transport to the base. Waiting in a lit-up bus in the middle of Crater that night seemed an eternity. I expected a sniper or an armed mob at any moment. Armed with a rifle but only five rounds of ammunition, I wondered what my Arab driver would do in case of an attack. We stayed about fifteen minutes, and then set off passenger-less back to the airfield, to my relief. Riding shotgun on a bus that could be easily ambushed was not my idea of fun. Guarding aircraft was less stressful as you could melt into the dark or lurk in the open bomb bay of a Shackleton. Being British, we had to play it like a game of cricket and shout 'halt!' three times in both English and Arabic before we were allowed to open fire.

During the second year of my posting, I did some work for flight safety with designs and posters, bringing in some artistic flair and crazy humour, which was much appreciated. Sadly I didn't keep any copies of these. As threats increased, we became more confined to the base and other secure areas. Gone were the days of lounging on sandy beaches, or watching the Arabs spearing squid, with the inevitable inky cloud followed by a flash as the squid took off into deep water.

I introduced a series of shows for the lads. Aden was awash with tape recorders, transistor radios, and so forth, so we had ample equipment for creating productions that normally ended in absolute mayhem, but it certainly boosted morale. On one occasion we needed a wig, so I sent a corporal along to the camp barber to get some hair which we could attach to a typical Adeni skull-cap. He returned with a box full of vari-coloured hairs, and told us how he had caused quite a stir when scraping up all the hair off the floor. The Arab barber thought he was quite mad – the effect heightened by the corporal being completely bald.

These were the final days of the British Empire, and the last major 'showing the flag' parade was a stirring spectacle. The High Commissioner stood on the dais to take the salute, complete with resplendent plumed hat redolent of colonial times. The navy marched past, splendid in blue, followed by the Royal Marines to the tune of 'Life on the Ocean Wave,' and then came the King's Own Scottish Borderers. Finally it was our turn, and as the band struck up the RAF's anthem, the 'Air Force March Past', there was a terrific roar as the full complement of Hunters from 8 and 43 squadrons roared overhead with spot-on split-second timing. The sense of pride was electric. We stole the show but the imperial glory had passed.

Camel Trooper

A trooper of Aden's Federal Regular Army.

Post-imperial Aden

The situation deteriorated alarmingly as attacks in Aden grew. No longer restricted to battles in the mountains, the Egyptian-backed insurgency spread into Sheikh Othman, Crater, Ma'alla and Steamer Point. In 1966 the British government announced a withdrawal from Aden in 1968. Instead of getting round the table to negotiate a decent agreement which would give the Adenis a reasonable start, the attacks increased further. Many British and Arab lives were lost senselessly.

Britain's ignominious exit from Aden in November 1967 was described by Brian Barron (1940–2009), the last BBC correspondent in Aden, as 'one of the country's shabbiest retreats from colonialism.' During British rule Aden had become a thriving port, with cruise ships constantly calling in, but the economy collapsed shortly after this. Many Adenis were glad to throw off foreign rule, but a great many lost well-paid jobs in a safe environment, and looked back on British rule with affection. Eventually Aden was absorbed into Yemen.

Civil war and the rise of the Houthi Movement (Ansar Allah) in Yemen created further violence, and in 2015 the Saudis and their coalition partners began bombing the Houthis, whom the Americans claimed to be funded by Iran. Yemeni experts on the conflict, however, state that the Houthi acquisition of arms has little to do with Iran.

The Campaign Against Arms Trade (CAAT) reported on 26th September 2020 that over 100,000 people had been killed in Yemen as a direct result of military action. According to the Yemen Data Project, the Saudi-led Coalition had carried out over 21,400 air raids in Yemen, with around a third against clearly-identified civilian targets such as weddings where most of those killed and maimed are women and children. Not only are most of these weapons and aircraft supplied by the UK and US, but Britain also trains the Saudis, apparently to avoid civilian casualties – but as CAAT reports, there is no evidence that this has reduced the death toll.

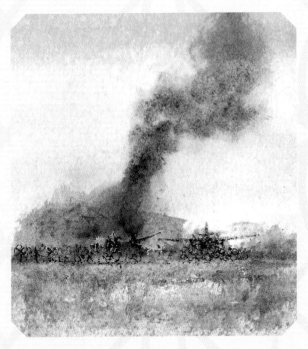

RAF Dakota blown up

One afternoon in May 1965 a bomb blew up our dear old Dakota aircraft – strangely enough, the only aircraft blown up during my stay. This shows the pall of smoke that rose high above the civilian part of the airfield, where the Dakota had been parked.

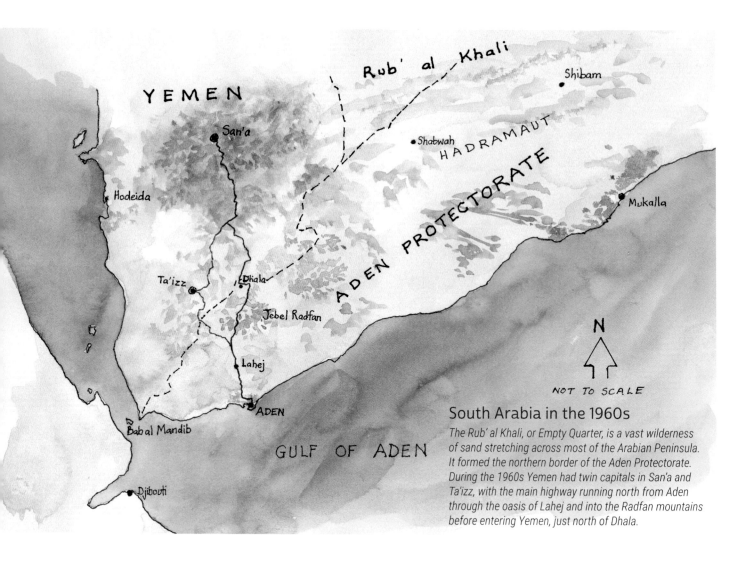

South Arabia in the 1960s

The Rub' al Khali, or Empty Quarter, is a vast wilderness of sand stretching across most of the Arabian Peninsula. It formed the northern border of the Aden Protectorate. During the 1960s Yemen had twin capitals in San'a and Ta'izz, with the main highway running north from Aden through the oasis of Lahej and into the Radfan mountains before entering Yemen, just north of Dhala.

Getting washed

This young lad was reluctantly being washed by mum in the waters of Lahej Oasis. I have enhanced the original period sketch to strengthen the image for reproduction, as my work in those days tended to be rather tentative.

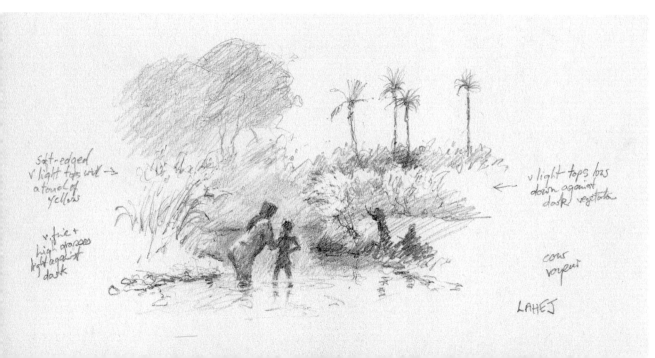

RUB' AL KHALI: THE EMPTY QUARTER

The Aden protectorate lies immediately to the south of the Rub' al Khali, or Empty Quarter, the vast interior of Arabia. Most of this area remained untouched by Westerners, and the first to cross this inhospitable desert region were the diplomat and explorer Bertram Thomas (1892–1950) and Harry St John Philby (1885–1960), to be followed later by Wilfred Thesiger (1910–2003), who made two crossings in the late 1940s. Thesiger was at his happiest travelling on camels with his faithful Bedouin guides. He hated cars and nothing cheered him up more than seeing one get stuck in the desert sand. The thought of living a life where your only excitement was cinemas or the wireless appalled him. Thesiger's descriptions of Bedouin life were often graphic: his account of a circumcision ceremony of a young boy described how everyone in the tribe would come to watch, and the old man performing the act used a rather blunt knife, hacking away for ages. Following this a mixture of salt, ashes and powdered camel dung was rubbed onto the wound. The camel seems to be an extremely useful beast to the Bedouin. Beyond its capacity as a beast of burden, they claim that drinking camel's urine is excellent for stomach pains.

Charles Montagu Doughty – or 'how not to do it'

While Thesiger knew well how to look after himself and blend in with the Bedouin, the same could not be said about an earlier explorer, Charles Montagu Doughty (1843–1926), who went out of his way to be most obnoxious and arrogant to the Bedouin. Descended from a line of bishops, he possessed red hair and a stammer, and proved a social disaster not only to the Arabs but to his English friends as well.

His writing is incredibly distorted and archaic, yet his descriptions were comprehensive and form a valuable body of information about Arabia. In 1876 he left Damascus to join the *hajj* caravan of some 6,000 pilgrims bound for Mecca, although he only intended to do half the journey – at the time, entering Mecca as a *nasrani*, or Christian, would have seen him killed. He dressed as a 'Syrian of simple fortune', calling himself Khalil, but despite having perfected his Arabic in Damascus he was obviously a *nasrani* to the Arabs. Stopping at Mada'in Salih, he spent three months exploring the monuments and locality, making excessive demands of Bedouin hospitality, and seemingly going out of his way to be provocative, especially in his religiously hectoring, superior manner.

He then travelled eastwards towards Hail with various Bedouin companions, expecting them to feed and help him while he continually insulted them with his lack of courtesy and tact. He was warned to turn back: Hail was a dangerous place for foreigners, and the only Europeans to visit the place before him were William Palgrave, an Englishman spying for the French, and Carlo Guarmani, an Italian also in the pay of the French, but more interested in Arab horses. Ibn Rashid, the Emir, would be unlikely to tolerate a fellow like Doughty.

He was, however, allowed to stay for a while and treated many locals with his medicine box. He became notorious for demanding immediate payment even though he was receiving considerable benefits from these people. Eventually he outstayed his welcome, and was forced to leave Hail. Continuing his erratic progress, he was forced to beg off the locals and sometimes reduced to tears. Countless times he was almost run through by a Bedouin lance, saved only by some sympathetic tribesman. At one point he fled into a harem where the women saved him from the wrath of angry locals. Had they been aware of his derogatory writing about women, they might well have acted otherwise.

Eventually his bumbling wandering, with little regard for his own safety – to the point of almost suicidal abandon – took him to Jeddah, where he boarded a ship for Aden and then on to India.

THE ARAB DHOW

While I lived in Aden one of the most fascinating features was the large numbers of Arab dhows in the dhow harbour at Ma'alla. The lateen sails of the dhows, arguably the most elegant form of rig ever developed, make these vessels graceful painting subjects.

These beautiful craft were mainly *sambuqs* with their scimitar-shaped prows, that plied along the coast of South Arabia, up to the Gulf and Red Sea ports, then south to the East African towns of Lamu, Mombasa and Zanzibar.

While some *sambuqs* were built at Sur in Oman, most operated in Western Arabia and the Red Sea. The whole scene, backed by the towering bulk of Jebel Shamsan, seemed so much part of another world. The *sambuqs* would be propped upright on rustic wooden poles on Ma'alla beach. Leaning at crazy angles, they were repaired and caulked, a process achieved by rubbing a mixture of lime and camel fat into crevices with bare hands. This was done by many *futah*-clad seamen at once, often chanting in unison. It was a scene I found so entertaining – whether the locals were working on old-fashioned boats or hauling state-of-the-art aero-engines, their approach was the same. At

times you would see the workers up to their waists on the hulls, until the tide rose too high.

On the large dhows, hoisting the main yard with the huge *lateen* sail took considerable effort, with all the crew joining in, often with sailors from neighbouring vessels to lend a hand. This frequently took nearly an hour and was accompanied by much singing and dancing, and sometimes by drumming, making the process quite a spectacle, if a rather inefficient one.

The toilet arrangement was usually a simple boxed seat slung over the side of the vessel, perhaps not the safest nor most dignified way to conduct such matters.

It was a hard life being a crewman on these boats. The dhow trade from Africa included tea, coffee, mangrove poles and slaves, though the latter had disappeared long before I arrived. These dhows brought in dates from Basra and left with salt from the Khormaksar salt pans. Under sail they had to beat eastwards along the South Arabian coast as far as Mukalla before turning south-west to take advantage of the north-easterly monsoon for the East African coast.

Jahazi dhow sailing off Lamu

This shows the same jahazi *from slightly different angles, and how the various angles affect the view of the* lateen *sail and mast.*

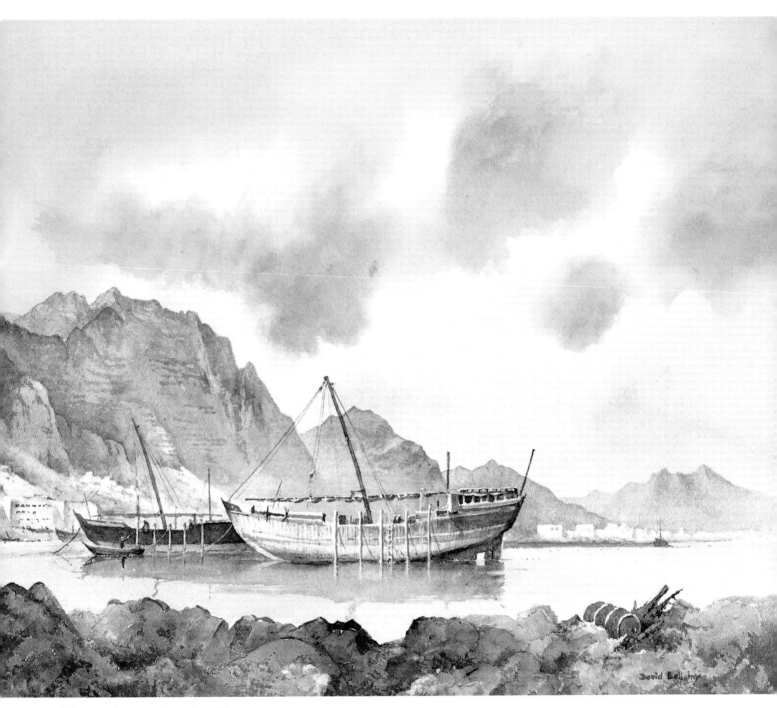

Dhows beneath Jebel Shamsan

These sambuqs, *with their scimiter-shaped prows, lay in Ma'alla Harbour just as they had for centuries. The place teemed with dhows in the sixties.*

ACROSS THE ARABIAN SEA: THE SWAHILI COAST

In 1999, my wife Jenny and I spent many happy hours sketching the vessels and the African and Arab workers, sailors and fishermen in Zanzibar.

On the fishermen's beach at Stone Town, bestriding pools swamped with the remains of dead fish, ripe-smelling of salt, slime and seafish, we found new subjects in the form of dhows, fishermen and the most exotic fish, some so large they had to be dragged up the beach. On one memorable (if unfortunate for the subject) occasion, while I was sketching half-naked stevedores in tatterdemalion trousers heaving bags of cement off a dhow, one of the bags split open and cement spilled out over the sweating shoulders of a worker, rapidly creating an amazing concoction of varied colours and textures swirling down his back.

The slave trade

Omani settlers invaded the East African coast around 1828 and within a decade were exporting some 40,000 slaves annually to the Arab lands. African villages were raided for their able-bodied men and women, and many died, both on the long marches to the coast and on board the dhows.

The voyages of the dhows were governed by the monsoon winds along the Swahili coast, bringing the ocean-going dhows from Arabia on the north-easterlies from October to March, and for the return journey by way of the south-easterlies from April to September. The main centre for the slave trade was Zanzibar on the coast of Tanzania.

Slave Beach, Manda Island

Thousands of African slaves embarked from this beach to head across the Indian Ocean to the slave markets of Arabia, crammed into the holds of dhows, with many not surviving the voyage.

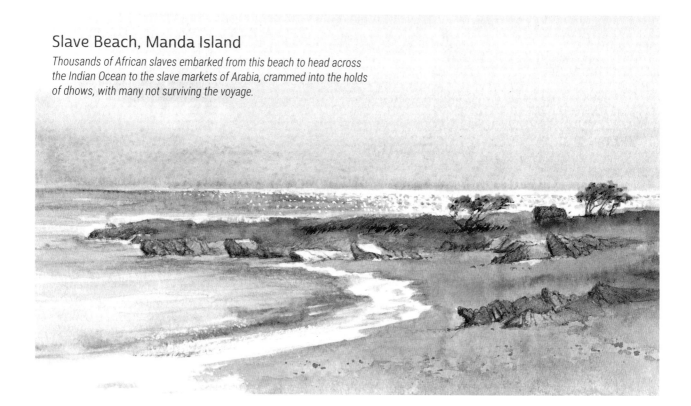

Swahili dress

Local dress on the Swahili coast is influenced by both South Arabian and Western cultures, and is quite distinct from that of inland Kenya.

Men's dress here is similar to that of South Arabia, with a headdress of cotton fabric embroidered with geometric or floral motifs. This is called a kofia, and the design gives a clue as to which part of the coast the wearer hails from – Zanzibar, Lamu, Somalia etc. A kikoi, or loincloth, is worn around the waist, with a loose shirt or t-shirt on top. Younger men often wear trainers and jeans. Shorts are regarded as shameful.

The Omani dishdasha – a full-length robe in white or a pastel shade, is mostly worn on Fridays and at religious festivals.

For the majority of Swahili women, women's dress incorporates a dress and veil that cover the body and head, the veil being mandatory once they reach puberty.

The buibui, normally black, covers them from head to toe to protect them from the view of strangers. The illustration on the left shows a green top which indicates clearly the type of mask worn by some women. This example is held on by a basic band, but some bands are more colourful and ornamental.

Many younger women wear head coverings that reveal their face and often wear Western clothing underneath the buibui, including trousers or short skirts – although for the sake of clarity I didn't do any firsthand research on this aspect!

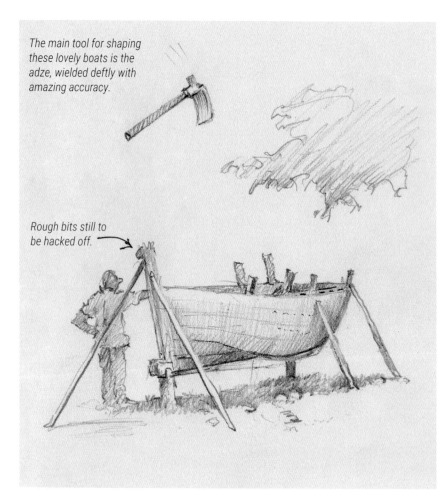

The main tool for shaping these lovely boats is the adze, wielded deftly with amazing accuracy.

Rough bits still to be hacked off.

Building a small dhow

This small dhow was being constructed beneath a giant fig tree in Zanzibar. Also shown is a drawing of an adze, the main tool employed by these craftsmen. It takes six to seven weeks to build a dhow of around 9m (30ft) in length.

During much of my travelling in Africa, I have always enjoyed sketching amongst the locals without any real problems. Here in Zanzibar, however, the locals were seemingly startled at the unfamiliar presence of *mzungus* armed to the teeth with books and pencils. Jenny became – perhaps understandably – agitated at being stared at by the men wielding *pangas* the size of Turkoman scimitars. Less accustomed to the atmosphere than I had become, she wanted to leave almost as soon as we arrived, finding the ambience threatening; but I was in my element, working on the very scenes that had induced me to come to Zanzibar.

Before the situation could become bothersome, I resolved to try to change the atmosphere. Nearby, two chaps were watching me intently, their saturnine glances heavy with suspicion. I took the bull by the horns, strode over and engaged them in conversation. It's amazing what a broad grin and a smattering of Swahili will do. Had they done any drawing? I began sketching in the wet sand with the wrong end of a paintbrush to entertain them. Soon we were laughing, and more folk joined in. Once she saw the merriment Jenny realized things were not as threatening as she had imagined, and she relaxed a little. I resumed my sketching, still trying to engage the locals as I did so, juggling sketches with outrageous theatricals.

The heat became blistering and Jenny was suffering badly – and no amount of bluster will deal with the midday sun. We had to pack up and get out of the heat, which was a shame, as there were still so many fascinating subjects to paint.

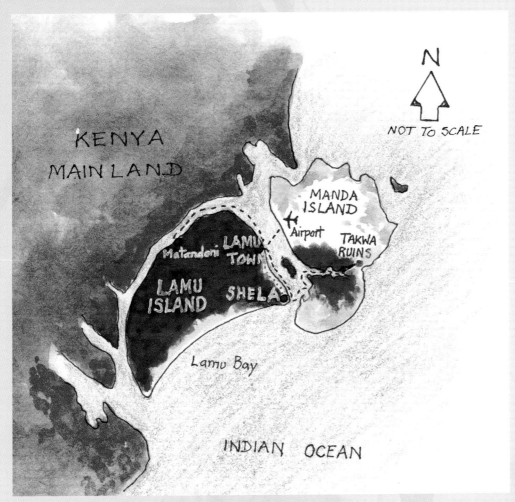

Lamu Island, Kenya

The dhow journeys are shown in red dotted lines.
Somalia, a hotbed of pirates and the Al-Shabaab terrorist
group, lies not far to the north of Lamu.

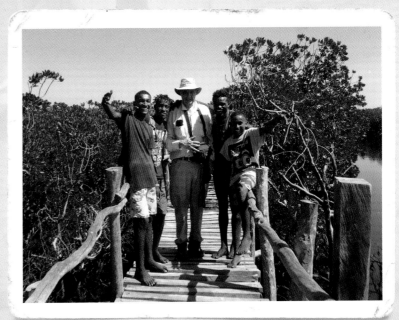

Author with the crew of *Queen* on
Manda Island, Kenya.

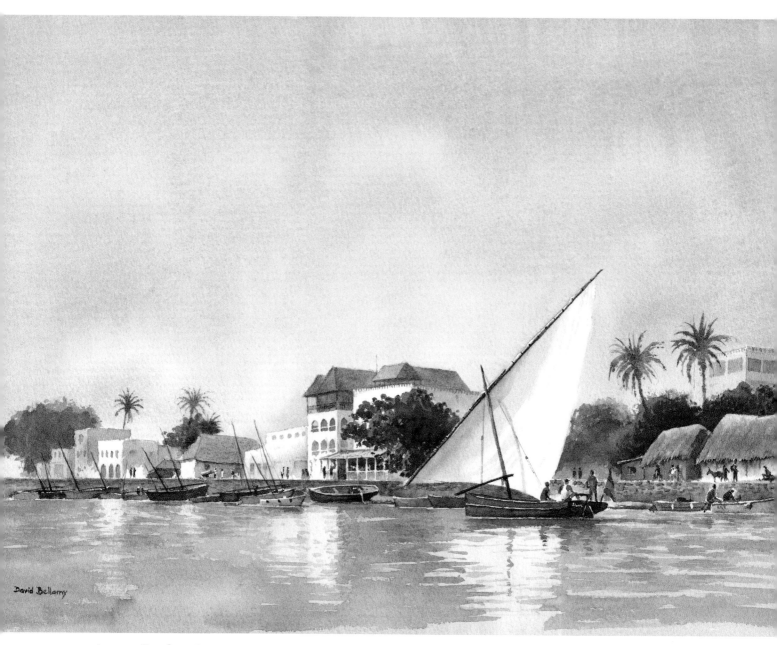

Lamu Seafront

*Even today, the shoreline at Lamu is crammed with local
dhows, mainly the smaller jahazi types.*

HOOKED ON LAMU

Further up the coast, at Lamu in northern Kenya, lies another location where slaves were brought. Lamu dates back at least to the 12th century and is the oldest surviving Swahili town in East Africa. Half African, half Arab, it lies close to the Somali border. Somali pirates and incursions by the al-Qaeda-backed al-Shabaab have spoilt much of the local tourism, so being just about the only tourist in town attracted countless approaches. I lost count of the number of fishermen who asked for money to buy a fishing hook, and these hooks must have been gold-plated given the incredible amounts they were asking. The seafront bustled with boats and varied characters, but even when sketching from the verandah of a more upmarket hotel-restaurant I still found the erstwhile fishermen pestering for their damned hooks. One place I loved, though, was the Tamarind Tree Café run by a charming lady. You climbed a narrow staircase that wound round the tamarind tree which grew out of the middle of the building, and sat high up overlooking the seafront, well away from the fishermen. There were no walls on one part of the café first floor, making it easy to sketch from while I enjoyed afternoon tea – you can see my painting of the place on pages 38–39.

Alley in Lamu, Kenya

For years I had wanted to visit Lamu, and rather than stay in the posh hotels at nearby Shela I chose to stay at Subira House, a large building built by Said bin Hamid the local *liwali* (governor) of the Sultan of Zanzibar in the early 19th century. With its elegant arches, inner courtyards and fascinating balconies, it stood in the centre of Lamu town. Michael the cook, a happy, spherical sort of fellow, produced excellent meals – indeed, the only stomach upset I suffered in the region was when I dined at an upmarket restaurant at Shela.

The main problem I found at Subira House was that the call to prayer five times a day came from a small minaret overlooking the place. Whilst this is something I normally love to hear, these particular calls were extremely loud; with the evening edition abandoning its normal poetic exhortations in favour of lecturing on for about an hour or so, drowning out all thoughts of restful relaxation.

Nearby Manda Island, with its ancient Takwa ruined settlement, attracted my attention. After much bargaining I hired a dhow for the day with a crew of three eager lads. The *Queen* was a *kasa*, a Mozambique-style dhow with the usual large lateen sail featuring the obligatory gaping holes here and there, and pointed at stem and stern. Kamal the young skipper, was accompanied by Abdellai the cook, Mohammed a crewman and a boy called Naghib who joined us for the ride. They were a jolly bunch and delightful companions. These old traditional working dhows are certainly not tourist vessels. Smaller than the *jahazi* types, they exhibit the usual delightful tattiness that makes them attractive to the artist. They are used up and down the Swahili coast carrying local cargoes.

In Lamu the cargoes are predominantly *boriti* – mangrove poles from the vast mangrove swamps in the region. When the British arrived In the 19th century, they set about building quays and the infrastructure for maintaining the sea trade, and soon they were charging the seamen taxes. This did not go down well with the Arabs: they had no need for landing quays and while happy to pay the locals for their mangrove poles, did not see why they should in addition pay the British. Making their dhows particularly foul-smelling with stinking fish helped deter the inspectors, but they would surreptitiously double their load of poles after the inspectors had departed.

The lads hauled up the *foromani*, or boom, to unfurl the sail, and we slid along the palm-fringed seafront of Lamu, on past Shela town, the white-villa homes of the more affluent, then cut across the strait to Manda Island. I sketched as we sailed along, and when the subjects grew fewer, I worked on drawing the boat, noting down the name of each part as the crew pointed out each one. Though at times hilarious, this became rather long-winded when they insisted in including every type of nail in the translation, which naturally involved a drawing of each feature. With the faintest of breezes filling the sail, we drifted along the coast of the island, basking in the tropical sunshine.

Here the coastline comprised endless mangrove trees and after a while we turned up a creek into the mangrove swamp. An egret, standing stark white against the dark lower branches of the mangroves, gazed warily and disapprovingly at us near the creek entrance. I wondered what lurked beneath the dark waters of this shadowy swampland. Happily growing in the salt water, these mangrove trees are harvested for making dhows, furniture and homes, so it is a busy area. The dense dragon-green mangrove jungle closed in as the *kasa* floated lazily along, the peace and solitude dreamlike in a quiet ecstasy. It seemed sacrilegious to break this hauntingly beautiful silence. The crew fell into a soundless spell, perhaps aware of my languorous mood. My reverie bumped back into reality when the *kasa* hit the bottom, coming to a sudden grinding halt as we stuck fast on the rocky bed of the creek, in the middle of the swamp, unable to go forward or back. We were marooned.

Creek in the Mangrove Swamp

This was where we became marooned when the craft grounded.

Takwa Ruins, Manda Island

Built around 1500, the Takwa buildings were constructed with coral rag set in a mortar of earth, sand and lime. They were excavated by archaeologist James Kirkman (1906–1989) in 1951. The baobab tree pictured here is thought to be over three centuries old.

Moments like this call for decisive action – so we sat down to eat a delicious fruit lunch of mango, papaya, passion fruit, banana and orange prepared by Abdellai, who had a fascinating store of knowledge. As we waited for the tide to raise the boat sufficiently to get us afloat again, my imagination conjured up hordes of Somali pirates armed to the teeth, suddenly swarming up the creek under the al-Shabaab flag. Europeans had been kidnapped here in the recent past, so the threat could not be taken too lightly. Suddenly, to my astonishment Kamal, the skipper, jumped over the side. He checked the depth of the water, and then began to pull the boat along a short distance to where the creek widened. A rickety landing stage came into view, standing high out of the water. We tied up against this unstable-looking edifice and walked along an unsteady planked walkway onto Manda Island. The heat intensified, sapping all energy. Gone were the cooling sea breezes. After a few

hundred yards the ruins of Takwa came into view, with magnificent baobab trees scattered around, spreading out their welcoming shade. While the crew rested in the shade I sketched and explored the old ruined settlement. In the centre of the coral-and-mortar town stood a mosque which incorporated a tall pillar in the north wall. Takwa was abandoned during the 17th century, some two hundred years after its founding, because of increased salinity in the well water. The fact that the Takwa folk did not get on with their neighbours on Pate island might also have contributed to its demise.

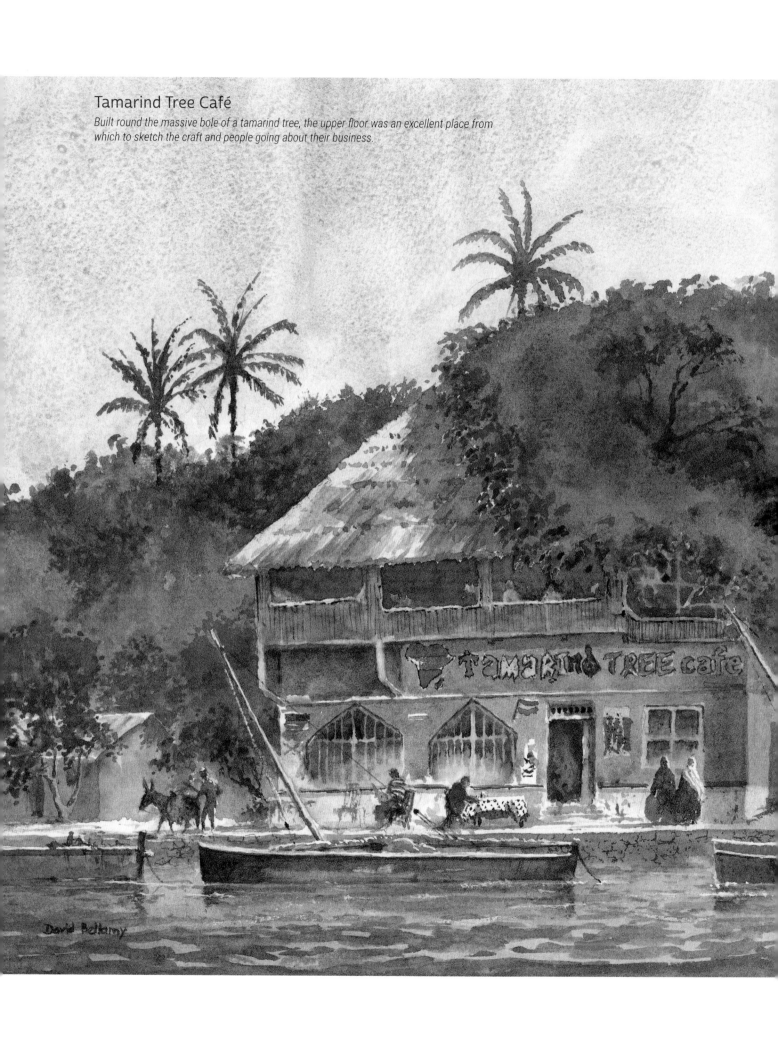

Tamarind Tree Café

Built round the massive bole of a tamarind tree, the upper floor was an excellent place from which to sketch the craft and people going about their business.

David Bellamy

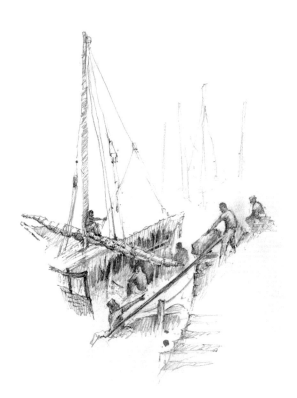

A sandy track led to the sea-shore on the far side, where they once loaded the slaves onto dhows bound for Arabia and the Gulf. The beautiful beach belied what dreadful events must have taken place here. I sketched while watched by an enormous spider hanging from rich vegetation beside me. The searing tropical heat made me feel listless, but I forced myself to scribble away – 'sketch' would be too grand a term for such incoherent scrawls – while trying to imagine those poor unfortunates being dragged in chains into the stinking holds of those dhows.

Eventually it was time to return to the boat and we all set off back to the rickety jetty, to find the tide had risen considerably. Negotiating the mangrove creek this time proved to be no problem. Once out in the main passage beyond the mangrove swamp, the wind filled the sail and the vessel sang across the calm waters in a beautiful dreamlike journey back to Lamu. The heat of the sun was cooled by gentle sea breezes, and we hove to several yards short of the seafront wall, and as I was about to slide down into the water to wade ashore, the lads insisted that they all carry me across, so I arrived on their backs like some rather tatty-looking nabob, to be ceremoniously deposited on the wall amidst the donkeys, street-sellers, *abaya*-clad mums and kids, and those infernal fish-hook cadgers. Nearby stood the Tamarind Tree Café – an irresistible port of call after the trip. Bidding the crew farewell, I climbed to the first floor for tea and to sketch the endless comings and goings of the seafront from my favourite retreat. The perfect end to a great day.

Loading dhows, Zanzibar

Here they were sliding sacks down a chute. With so many vessels crammed together, trying to ensure that each feature belonged to the appropriate craft was almost impossible from where I stood.

EGYPT

Up the Nile in a cattle barge

The enduring fascination with the civilization of ancient Egypt, which flourished from about 3,000BC to 30BC, has long drawn tourists to the Nile Valley.

Modern Egyptology more or less began during the latter part of the 18th century, when Egypt lay under the Ottoman yoke, with a Mamluk ruling caste. In 1798 a French army under Napoleon invaded the country. Ferocious and brave as they were, the Mamluks were no match for a modern European army and the country fell to French rule. The French carried out a vast programme of cataloguing everything they saw, using an army of scholars, architects, surveyors, artists and engineers, producing nearly 5,000 original drawings and engravings. These were eventually published as *Description de L'Egypte* in 1803. A work that celebrates the campaign by Léon Cogniet (1794–1880) from the expedition was painted on a ceiling within the Louvre in Paris, showing artists, archaeologists, soldiers and others hard at work under a hot Egyptian sun. Most extraordinarily, a woman is depicted carrying a water jar on her head as she wanders nonchalantly towards the lads, dressed incongruously in a diaphanous covering that reveals her womanly assets to all and sundry – a detail which raised the ire of the detractors of the Orientalists. The French army succumbed to disease and, with a little help from the British, the locals evicted them. Napoleon scurried back to France.

I first encountered Egypt in 1966 during an overland trip from England to Kenya, and was instantly captivated by the place. In those days cheap air travel did not exist, and unless you were fairly wealthy, the done thing was to travel overland from the UK to India or Africa. Most were young adults relishing the experience of adventure travel with a group, typically travelling in a 3-ton Bedford truck and camping along the way, taking in the sights and smells. Personally I preferred to go it alone as I appreciated being able to stay longer in a place I liked, change the route, and engage with local people more. In a group you tend to stick together and have less contact with locals.

Leaving Athens on a Greek tramp steamer, I travelled deck-class across the Med to Alexandria, sharing a rather basic galley with a Dutch Reuters correspondent, a German motor-cyclist on his way to visit the Second World War battlefield of El Alamein, and a few other young folks, all interesting company. Jan, the Dutch lad, was going to Cairo, so we went together by train from Alexandria and stayed in an outrageously posh hotel for a pittance – a welcome luxury after youth hostels and sleeping the night on a stone bench on a Greek railway station (not to mention the tossing deck of the tramp steamer). Visiting the pyramids had a dreamlike quality, with hardly any tourists around. We penetrated deep into the dusty, claustrophobic heart of the great pyramid of Cheops without encountering anyone else.

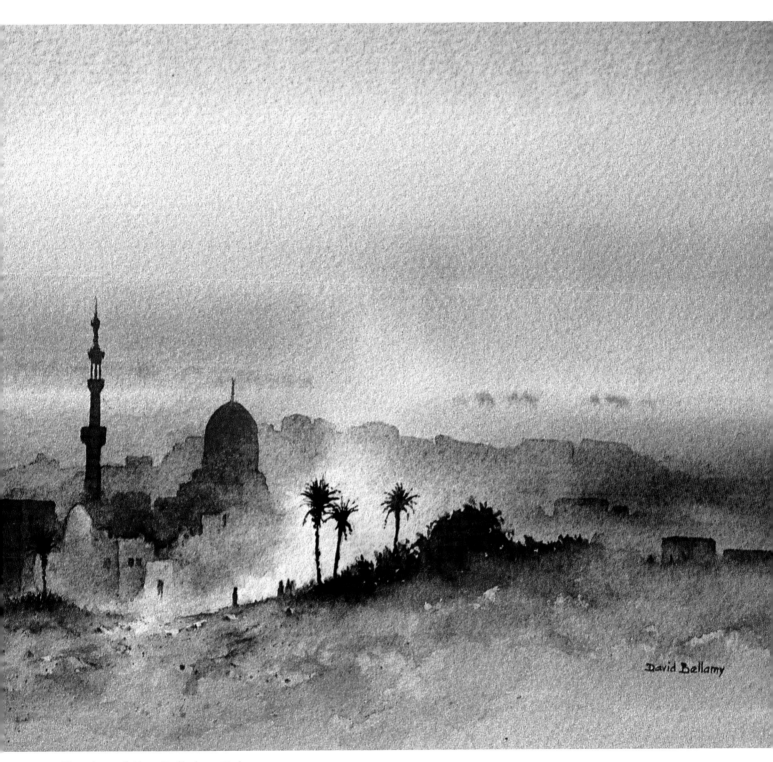

Tombs of the Caliphs, Cairo

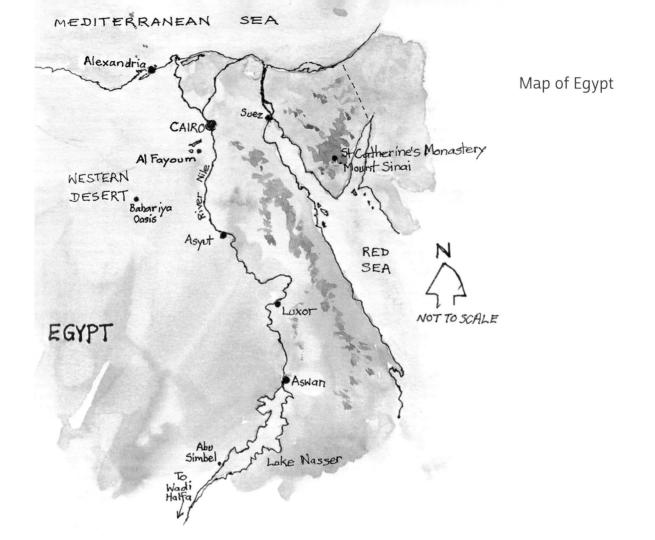

Map of Egypt

MEDITERRANEAN SEA

Alexandria

Suez

CAIRO

Al Fayoum

WESTERN DESERT

Bahariya Oasis

St Catherine's Monastery
Mount Sinai

River Nile

Asyut

RED SEA

N

NOT TO SCALE

EGYPT

Luxor

Aswan

Abu Simbel

Lake Nasser

To Wadi Halfa

HEADING SOUTH: THE SUDAN

After a few days in Cairo we aimed to head south into the Sudan, so went along to the Sudanese embassy to get visas. Alas, they didn't like Jan because he was a journalist, and as we were together they didn't like me either. Jan decided to fly onwards, and I made up my mind to return to the Sudanese embassy on my own the next day. This time they gave me a visa, though I had to explain that the 'artist' on my passport referred to painting and I definitely wasn't a dancer. For some obscure reason dancers seemed to be considered a health hazard in Khartoum.

With my visa tucked away, I took a train along the Nile to Aswan where I jumped into a taxi and asked to be taken to the jetty where boats left to cross Lake Nasser, with the intention of proceeding up the Nile to Wadi Halfa on the Sudanese border. The taxi didn't move. After a few minutes I indicated I wanted to leave and was rewarded with a grunt in Arabic. Next thing the door opened and an extremely large lady, completely covered in an *abaya* the size of a barrage balloon entered. She

shuffled her steatopygous frame across the seat with the rippling gait of a bull walrus, and rammed herself hard against me, causing me to gasp as mountains of her vast buttocks spread across my thighs. Perhaps she was too short-sighted to notice me – being a thin blade of a fellow, easily mistaken for a taxi arm-rest, I gave her the benefit of the doubt. I'd always had the impression that Arab ladies kept well away from infidels, so this was confusing, not to mention suffocating. Despite her enormous bulk there was still ample room on the other side of her, but as I was about to protest, someone else clambered into the space she'd left. It then dawned on me as I gasped for breath that the taxi would only depart once we had a full load.

At the jetty a crowd of Egyptians, Sudanese, customs officials, boatmen and the odd *bashi-bazouk*, clad in *dishdashas*, turbans and *abayas*, and festooned with a bizarre variety of possessions, jostled noisily around in a state of mild chaos. Nobody official-looking seemed to understand that my sole reason for being there was

to buy a ticket for the boat. I spotted a young man in European clothes who answered to the name of Fatthi, and happily he spoke English. He was a Sudanese student on his way to study in Germany, but had been turned back by the Egyptian customs because his visa was incorrect. He was glad of someone to chat to – he now had to return to his home in Atbara. He helped me secure a place on the next boat, which turned out to be an old converted cattle-barge that would take several days to reach Wadi Halfa. There was no restaurant and refreshments were limited to a large *Ali Baba*-style ceramic pot of water, but I had stocked up with enough food to get me to the Sudan, and hoped to supplement it by catching some Nile perch. Alas, every time I hooked a perch on the end of my line it inconsiderately fell off, so I remained fishless. My shenanigans, however, did have the benefit of giving the other passengers on the boat considerable entertainment.

In the hot afternoon sun we sailed out onto Lake Nasser. With the water rising as they built the new Aswan Dam, many palm trees stuck oddly out of the water, displaying only their upper trunk and fronds. Several villages were being displaced by the rising waters, which also threatened the Temples of Abu Simbel and other monuments. These were being taken down and transferred to another site nearby, and after some time the workings came into view. The work proved to be a great triumph and achieved against the clock.

Come evening, we were in the upper Nile beyond the lake and hove to by the bank to rest for the night. I found some wood lying in the sand and managed to shape it into a bat; then created a 'ball' from a block of half-rotten wood. I then began teaching some of the Arabs to play cricket, and we had a riotous time until the 'ball' totally disintegrated. Having become extremely hot, I then jumped into the Nile and swam about, hoping there weren't many crocodiles around. Thankfully, the huge Nile crocodiles in the area didn't make an appearance.

At night I climbed onto the flat roof of the boat, and used my bag as a pillow, sleeping inside my sheet sleeping bag. The cold desert night eventually woke me up. It wasn't the most comfortable night's sleep, and I was also concerned about rolling over the edge and plunging down into the river, but the night passed without any traumatic incidents. Next day brought a monotonous journey with just sandy desert on either side. The most interesting moment occurred when the Arabs in the hold invited me down for afternoon tea. They all sat around on huge sacks and the large jolly fellow producing the tea asked if I would care for a dollop of whisky in mine. No doubt he hoped Allah wasn't watching at the time. Some spoke good English, and they were curious about my journey, never before having seen a European doing this trip. We covered many topics before I retired to my sleeping quarters.

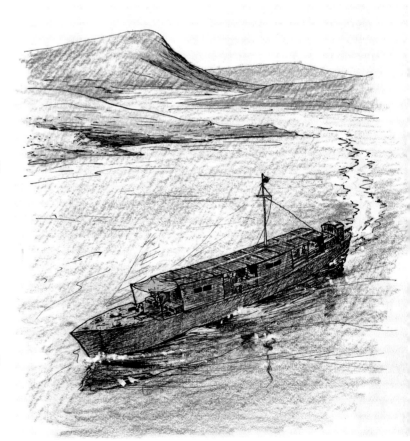

Ferry boat on Lake Nasser

I did this rough ink drawing on my journey overland to East Africa in 1966, filling in the colour with pencils recently. It took three days to sail from Aswan to Wadi Halfa at a time when the waters were rising as they built the Aswan Dam. I slept on the roof each night.

BREAKDOWN IN THE DESERT

On the third day, we arrived at Wadi Halfa. The station comprised a few makeshift huts. A train stood waiting for us, clouds of black smoke pouring out of the locomotive. The carriages had small windows to keep the inside cool and reduce the blinding glare of the Nubian Desert, which we were about to cross on our journey south to Khartoum. Fatthi insisted that I stay in Atbara where he lived, and meet his family. Conveniently this was about halfway to Khartoum. I sat in a compartment with Fatthi and several other blokes as we trundled across the desert with endless vistas of sand on either side. A group of Sudanese men in white *dishdashas* discussed politics with me, seething with anger at the British government and almost at my throat. At one point I thought we were going to come to blows. The train stopped at one of the desert stations deep in the Nubian Desert, with just a line of five *goobas* – small circular dwellings with roofs like giant pointed hats – along the far side of the platform. The Sudanese fellows got out. A few minutes later they returned and to my astonishment handed me a present – a sort of Sudanese flag-cum-fly-swish. After that we laughed and joked until the train stopped at the next station.

It stayed for some time, as a politician gave a speech to the locals at the station. Apparently it was likely that he would do this at every station, so it was in the lap of the gods as to what time we would reach Atbara. The next halt was in the middle of nowhere, just sand dunes – no station, not even a bush or rock. After some time word spread that the engine had broken down, and rumour had it that it was deliberate so as to delay the politician, who was in the opposition to the government. We would have to await a new engine coming from Khartoum, in the heat of the day with no air-conditioning. Apparently breakdowns on this line were frequent. The line was built in the late 19th century during the Anglo-Egyptian conquest of Sudan against the forces of the Mahdi. The only refreshment was a huge gourd filled with luke-warm water. Luckily I had my own mug, and a few bananas left. The rescue engine eventually arrived after several tedious hours, so it was late when we reached Atbara and wandered through the darkened town to Fatthi's home. His family made me welcome. I spent the night there before continuing my journey southwards, and on to further adventures in Sub-Saharan Africa.

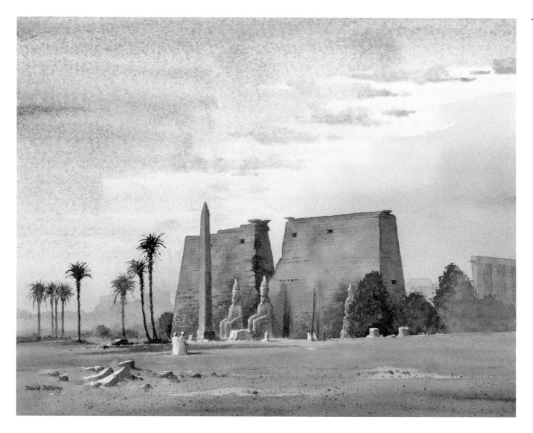

Temple of Luxor

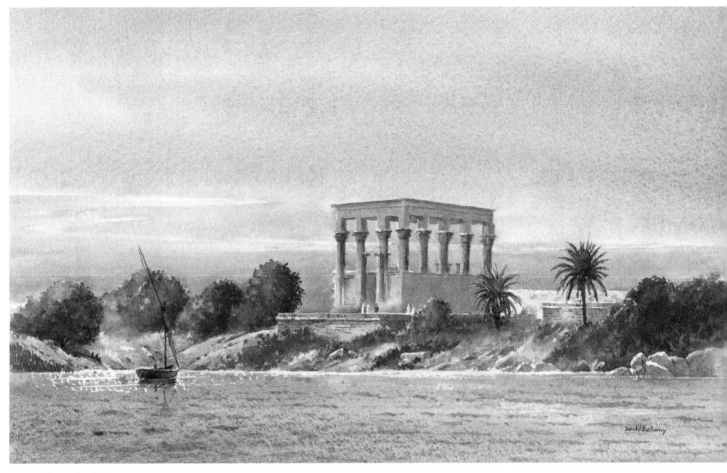

Temple of Philae, Aswan

A watercolour of part of the Philae complex, created from the sketch below with other sketches and photographs.

Sketch of the Temple of Philae

This wash and line sketch was carried out from a boat jammed up against rocks. I began by drawing with a fine pen and then laid on washes of watercolour, as I did with the Temple of Horus on page 49.

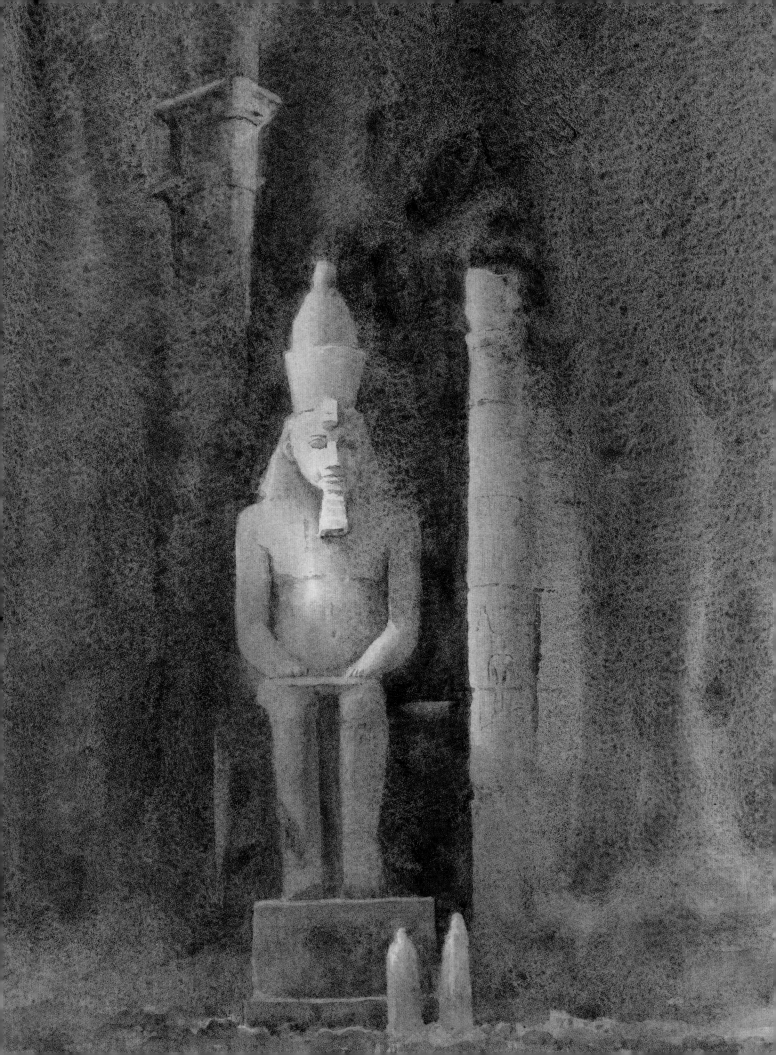

A RETURN TO EGYPT

Thirty-seven years later I returned to Egypt, bringing a painting group to explore the main tourist sites and record them in our sketchbooks. We spent much time in Luxor and the Valley of the Kings and, as usual, found many fascinating characters. That night we all visited Luxor Temple, lit up in the fabulous atmosphere of Son et Lumière.

 After the official guiding, Jenny and I did a little exploring by ourselves and came across a couple of guards. I began sketching one of them. He became curious and wandered over to see what I was up to. I showed him my part-finished drawing and asked him to go back to his stance and try to look fierce. He didn't seem to fully understand this, so Jenny went over to where he had stood, smiled at him and beckoned with her finger. At first he looked startled, then a broad smile drew across his face and he joined her, holding his rifle like some agricultural accessory. His friend Mohammed joined him and Jenny backed off so that I had a clear view. It wasn't quite right. I strode over to them and moved his gun into a more normal position, slung over his shoulder. Bemused, he took it in good humour and I returned to my sketching position. I had hardly resumed drawing when many more guards suddenly started to appear, wondering what all the commotion was about. I groaned inwardly, concerned that I'd have to pay a whole battalion of guards to pose if I wasn't careful, so I tried to indicate that I only wanted two in my picture and attempted to politely shoo the rest away, much to their consternation. Fortunately things calmed down and I got my rather crummy little pencil drawing done without further ado. Achmed and Mohammed were perfectly happy with their reward, not to mention the entertainment value.

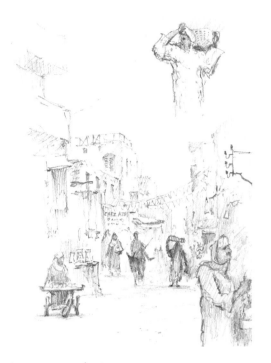

Luxor market

Wonderful characters were coming at me in droves here: on donkeys, pushing carts, carrying the most ludicrous things on their heads. The chap on the right is swinging a sinth – a metal pot on chains with a fire inside. This is swung about in shops to create a pleasant atmosphere and discourage flies.

Colossus at Luxor

At night, figures cloaked in white dishdashas appear ghost-like as they flit amongst the ruins, adding to the mysterious drama of this enigmatic place.

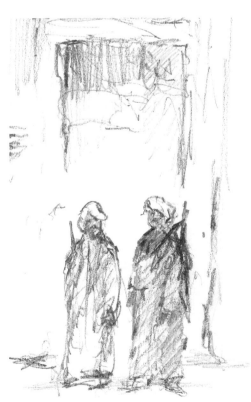

Luxor temple guards

Mohammed and Achmed, the happy guards at Luxor Temple.

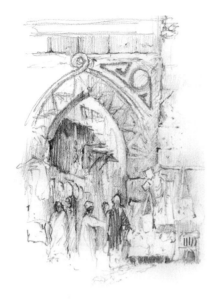

Sikket al-Badestan, Cairo

With its continual hubbub, colourful stalls, the clamouring of the vendors, Arabic music and sparkling brassware, this place oozes with the flavour and mysticism of the East.

Lake Nasser stretched away to merge into a hazy horizon as we took the short flight to Abu Simbel, bringing back memories of my boat journey to Wadi Halfa. The great monument was first discovered by Europeans in 1813 when Johann Ludwig Burckhardt (1784–1817), a Swiss explorer, came in search of the nearby temple of Nefertari and stumbled upon the monumental heads of Ramses II. Buried in sand, the rest of the temple was inaccessible until 1817, when Italian explorer and circus performer Giovanni Battista Belzoni (1778–1823) freed the entrance.

It would be impossible to do Abu Simbel justice in the time we were to spend there, so I needed to work fast, trying to explore the site and fit in as many sketches as possible. These, however, are not the sort of subjects one can dash off in minutes. To stand in front of such immense colossi is humbling: the monumental scale is overwhelming. I explored the interior first, then began sketching the colossi in the entrance hall. To render everything in stark detail would take all day: I needed to be selective and play down the less striking objects, yet attempting to make sense of the whole. Outside I worked on the colossi where the tourists appeared no higher than Ramses' mid-shin garter (had he been wearing one, of course). Happily there were a

Tomb of Meremptah

This view shows the descent into the tomb from the entrance. I had to work rapidly, but although it is a rough sketch it has enough detail to produce a painting from if necessary. Meremptah was the thirteenth son of Ramses II, and the tomb was excavated by Howard Carter.

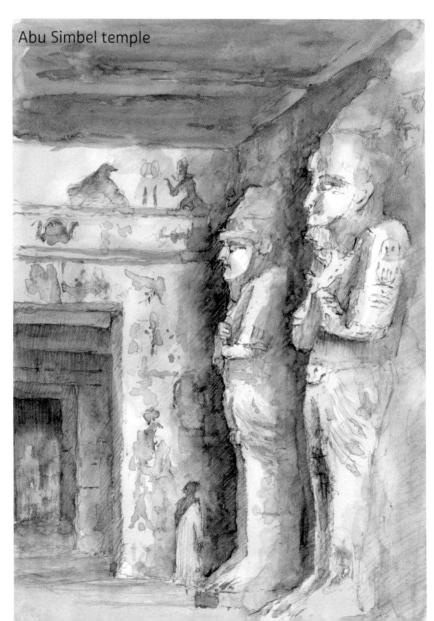

Abu Simbel temple

Snake man with cobras at Kom Ombo

Also in the sketch is a local djellabiyya-*seller.*

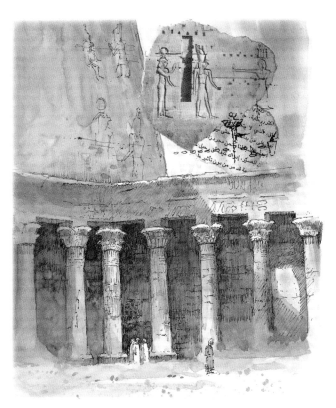

Temple of Horus, Edfu

Horus, the hawk-headed god, lost an eye in one of of his many battles with Seth while avenging the killing of his father Osiris. This view of his temple presented an awkward composition, so I added some collage on the top right.

number of locals amongst the tourists, so I tended to draw these rather than the mini-skirted variety which seemed to be in great profusion. Hardly had I started than Abu, our guide, appeared exhorting us to finish off our sketching and head back to the airstrip. I barely managed two of the four enormous figures, and one of them had the best part of his head chopped off, so it was not a complete picture of the great façade.

That night we stayed at the Old Cataract Hotel overlooking the Nile, an old colonial-style building that had hosted famous visitors including Winston Churchill, Agatha Christie and Lord Kitchener. The staff wore red tunics adorned with a line of gold buttons down the front, black pantaloons and black fezzes. The rooms had high ceilings and were beautifully airy. At the Terrace Bar we ordered refreshments, sketching the Nile as we waited.

As more of the group joined us we spread out over the place, with easels and art paraphernalia scattered everywhere, for it was a perfect viewing gallery. I wondered whether Churchill painted from this spot, as it must have appealed immensely to him. I had brought my sketchbook to dinner and while awaiting the order, managed to create a pencil sketch of the impressive room, while someone played the *oud*, a guitar-like instrument, in the background.

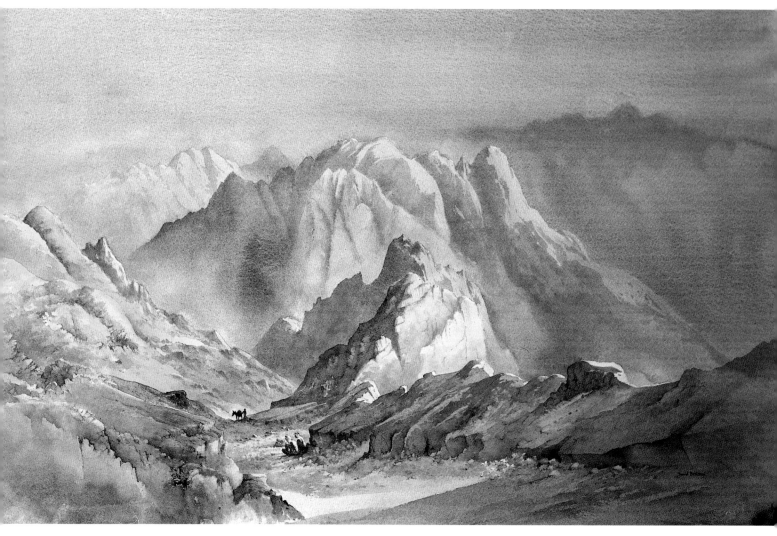

MOUNT SINAI

One of the must-do activities on the Sinai Peninsula is to climb Mount Sinai in the dark to witness the sunrise. Most of the group were game for this, even 90-year-old Margaret, a Scot who never gave up. She, like some of the others, went up on a camel. The track was fairly easy going. We set off from St Catherine's Monastery at 2.45 am in absolute darkness, with only our torches for light. Abu led the way up and I stayed at the rear to make sure nobody fell by the wayside. The night sky was clear, but without a moon. Stars shone with an intensity that I hadn't seen at home in Britain for years.

On Mount Sinai

The early morning view across to Gebel Moreiga from the summit of Mount Sinai. I did the original sketch after witnessing the sunrise from the summit.

With the painting group in Sinai

Not really clothed for mountain climbing, we found it rather cold, so I was relieved to stop in one of the refreshment huts and drink hot coffee. Four Arabs began to play *tawula*, a board game with draughts-like pieces, so I sketched them with their intense concentration. Higher up, the sky began to lighten. Some of the group began to struggle, so I carried their rucksacks to get them to the summit in time. Approaching the top, we found hordes of people lying around in the dark, huddled up in blankets like gaggles of crows on a telephone line.

As the fiery colours of dawn gathered in the eastern sky, I found a flat rock on which to perch. The sun ignited in a burst of light, then hunkered behind a dark cloud as though reluctant to show its face. Just after 6 am it suddenly flooded us with lovely warm sunlight. The colours in the eastern sky glowed with violent crimson and gold, the effect dazzling and ever-changing.

Capturing the colours before they change can be a challenge for the alfresco artist working in a hurry, as the wet paints may well run into one another. Ending up with a vivid green sky instead of a glorious sunrise can easily happen if you allow your blues to run *en masse* into a still-wet yellow passage, so I try to maintain a slight margin between the two. This can always be softened out later when the colours have dried.

We lingered on the summit, despite the cold, to carry on sketching the dramatic views of peaks all around, as most people ambled off still wrapped in their blankets.

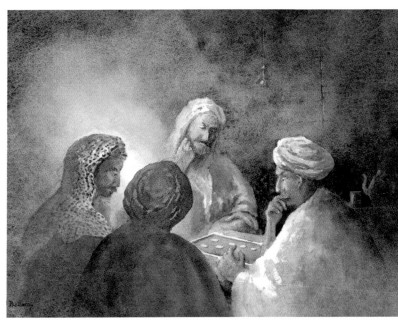

Tawula Players, Mt Sinai
Tawula, a sort of Turkish backgammon, being played in a hut halfway up Mount Sinai in the early hours.

Mines, mountains and sand
With land mines in the vicinity, it was vital not to stray off the beaten track.

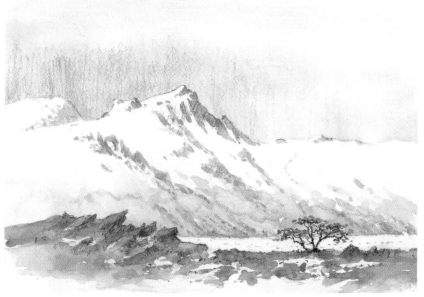

Sinai Mountains

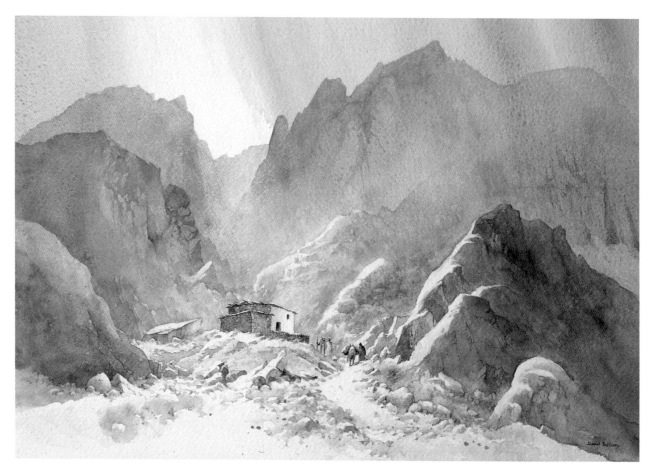

To return to St Catherine's Monastery, we took the Monk's Path, down 3,700 or so steps. Several in the group needed to take it slowly, which gave the others time to grab a few more sketches on the way down as the light improved. Magical golden light effects slanted sunbeams through soaring peaks above us, turning even the wildest, ugliest subject into a masterpiece in the manner of Claude Lorrain. Having sketched the sunrise after reaching the summit in the dark, everyone was in a good mood. At the bottom we sketched and explored the monastery lying at the foot of wild cliff and crag scenery. Some of the rocks resembled monkeys' faces.

The mountains of Sinai make stunning subjects to paint, the lovely warm colours adding to the appeal. Travelling along some of the routes needed care to ensure we kept to well-worn tracks, as much of the area was still an active minefield. Curiously enough, one of our group was a bomb disposal expert, but thankfully we didn't need to call on his services. The Egyptian guides loved to describe how in the war with Israel they wiped out vast numbers of Israeli tanks and swept to a magnificent Egyptian victory, then magnanimously gave ground to the enemy. This, of course was nonsense, but nevertheless entertaining. We bumped across miles of rough sandy terrain, always with a background of savage rock-girt mountains.

Monk's Track up Mount Sinai

This is the route we descended from the summit, all 3,700 steps.

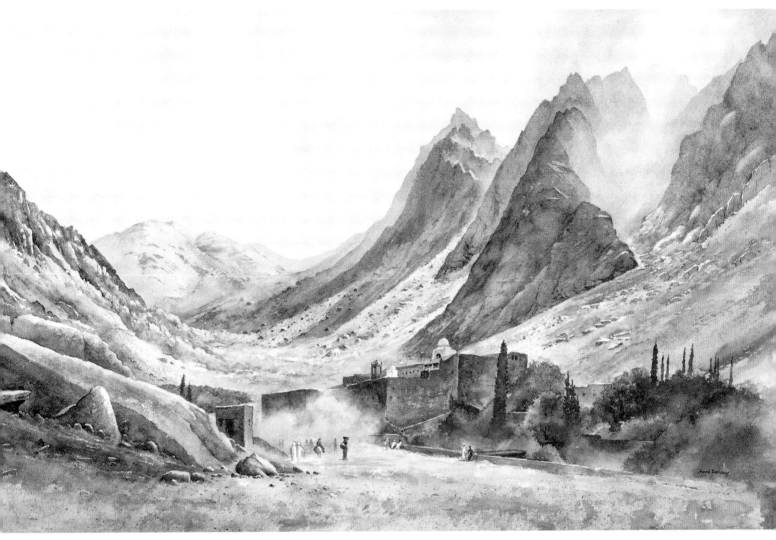

St Catherine's Monastery

The monastery stands at the foot of Mount Sinai. We had descended the hazy gully on the right-hand side.

After many hours we came to an attractive Bedouin village where we were to have lunch – around 4 pm, by which time we were all gasping with hunger. I wandered off to sketch a group of palm trees nearby, and a young Bedouin girl called Hlem joined me. She wanted to sell me a turban. We then haggled in the traditional manner as I knelt down painting. She was a tough bargainer. I pretended to play a tough game as well at first, though I was happy for her to win the battle. She began winding the turban round my head, taking her time. Her mother watched impassively from a distance and in the end I bought her turban. She deserved to make a profit as she'd been so entertaining. Many sketches later, we were summoned for lunch as the light faded, sitting around on carpets on the sand.

THE WESTERN DESERT

A fascinating part of the mighty Sahara, the Western Desert of Egypt contains a wide variety of natural features. It held great interest for me, so I arranged a sketching expedition accompanied by Mohammed Marzouk, one of the best guides in the country. A diminutive man with kindly eyes and greying hair beneath his white turban, he reminded me so much of King Hussein of Jordan. We set off from Cairo on a cold and windy December morning, with leaden clouds gathering ahead. At first the desert lay flat, drab and uninteresting, and after a while it began to rain, adding to the melancholy atmosphere. Sand swept in vicious gusts across the road. My pencils remained firmly in their case.

After some time we drew into a piece of rough ground to stop beside a forlorn, drab old building of dubious construction. We scurried inside to escape the sandblasting as the wind howled round the door. If anything the interior was even more depressing: a run-down café with one side resembling a bomb-site. Miniature whirlwinds of dust swirled round the floor and a small sand-dune connected two of the tables. The place had obviously not seen a broom for years, though an artist had tried to brighten up the place by painting livid-coloured landscapes on the walls. We ordered coffees. Before leaving I visited the toilet, but immediately staggered back out, as it had surely to be the foulest place between here and Baghdad.

Around mid-day we arrived at Bawiti, the capital of Baharyia Oasis which is spread over many square miles in a huge depression. We lunched at the Popular Restaurant. Bayumi, the owner, sat with us and exchanged gossip while I sketched him. Hamada, one of the local lads then joined us. He was taller and younger than Marzouk, and a pleasant fellow. He would accompany us on our trip. I set off to explore the old Qasr at Bawiti, a warren of narrow alleyways linking a maze of mud-brick buildings, some of which were ruinous. They had uneven windows and doors, some sloping at crazy angles – the doors in particular were well-worn and delightfully artistic.

The local children turned up to see what I was sketching; the girls were extremely well-behaved, but the boys tended to leap about rather a lot and jerk my sketchbook. Beside Zawyia Square stood the ancient Sanussi Mosque, its conical minaret festooned with a rickety platform protected by the most dubious-looking wooden railings.

Old Sanussi Mosque, Bahariya Oasis

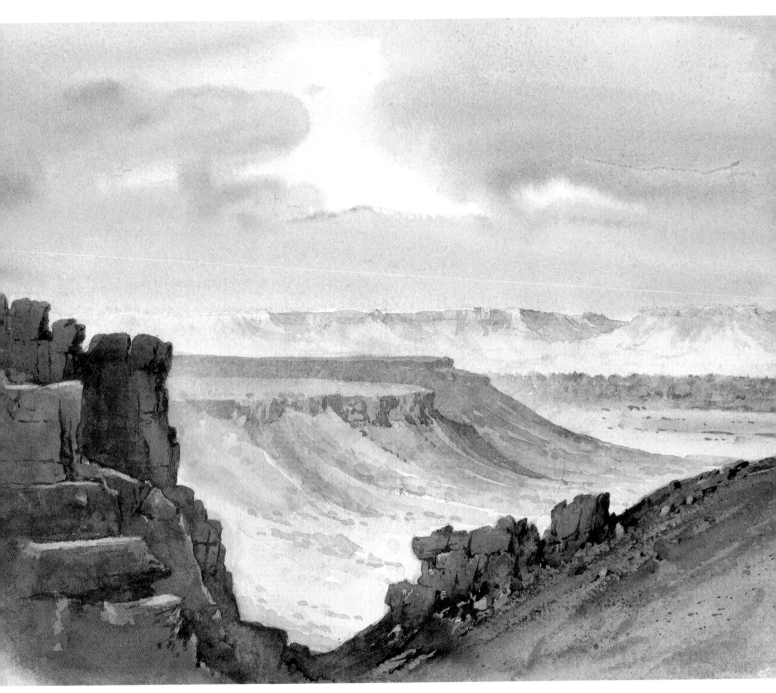

English Mountain, Bahariya

This was a British look-out point manned by Captain Claud H. Williams to observe Sanussi troop movements during the First World War.

In this square caravans would arrive and set off for a number of destinations. We drove out to the salt lake, and then Marzouk accompanied me to climb to the summit of Gebel al-Maysarah, or English Mountain. Here, during the First World War, the British manned a look-out post to watch out for any movements of the Sanussi tribe, who fought on the side of the Turks and would raid the oases of Baharyia and Farafara, loot and carry off the women. During the Second World War the Sanussi, who mainly inhabited Libya, gave the British Eighth Army considerable help in the fight against the Axis forces.

My hotel was a small Arab one, clean and pleasant. A delicious dinner was served, better than in the four-star tourist hotels in Cairo, for Arabs are better at cooking Arab food than Western food. Nearing the end of my slap-up meal, Marzouk and Hamada came in to say that we'd all been invited to dinner at Hamada's parents' home. Not wanting to offend anyone, I wondered how on earth I could fit in a second dinner. I abandoned the rest of the hotel dinner and we drove into town.

The house we entered had a pleasant airy lounge furnished with an armchair and two settees, the floor covered in carpets. On one wall hung a photograph of the great mosque at Medina. Hamada's father joined us for dinner, a kindly gentleman in glasses in a grey *dishdasha*. A young lad brought in a low table, followed by a huge silver tray on which stood many dishes. This was placed on the table and the four of us squatted around it. Fresh naan-style bread looked inviting, but I had to take this easy, already well-bloated. The spread included humous, cheese, a salad of tomato and cucumber, turkey and a thick kind of lentil soup; but the delicious-looking pile of rice was beyond me in my current state. Somehow I remembered to use my right hand when picking up the food with a piece of bread – it would be unthinkable to do it with my left, which in the Arab world is reserved for less savoury tasks. Sadly, although I heard several female voices from the direction of the kitchen, we saw nothing of the women who had prepared such a lovely meal. With doubtful success I tried to subdue the groans from over-eating two dinners. We talked awhile, then Marzouk indicated we must be on our way, as he still had some Bedouin culture on the evening's programme.

Down a dark lane we came to a large building. Intrigued as to what was about to unfold, we entered the building, removed our desert boots and entered a large circular room with a high ceiling. In the centre a welcoming log fire stood next to an open space. The rest of the floor was covered with cushions on top of carpets. We squatted down and awaited the maestro. A group of six Germans joined us, and then the maestro himself appeared in a smart *dishdasha* and red *kaffiyeh*. He came round, exchanged greetings in Arabic, shook hands with us all, then squatted down in front of the fire, practising on his instrument. This was called a *simsimiyya*, an Egyptian stringed instrument, which to my unaccustomed eyes resembled a couple of old chair-legs tied together, sticking out of a box with a cross-piece retaining the strings, which he twanged enthusiastically. This was Abd Disardeq, a Bedouin folk singer, accompanied by his son on a drum.

Abd began with some Bedouin love songs, passionate and noisy, often mournful, sometimes excruciating, with the exact meaning unfortunately lost to me. His face, heavily wrinkled by the desert wind, flickered with painful expressions as he sang with passion. I sketched as he sang, relishing drawing a portrait of such a characterful face. More people entered, followed a while later by a group in suits and ties, looking thoroughly out of place. Abd immediately changed his songs, beginning with a rather repetitive 'Marhab Bahariya' song with precious few other words, a welcoming song for visitors

Marhab Bahariya
The Bedouin folk singer Abd Disardeq threw everything into his emotion-charged love-songs, his heavily-furrowed brow convulsing in sympathy with the contortions of his huge eyebrows as he launched into a haunting wail.

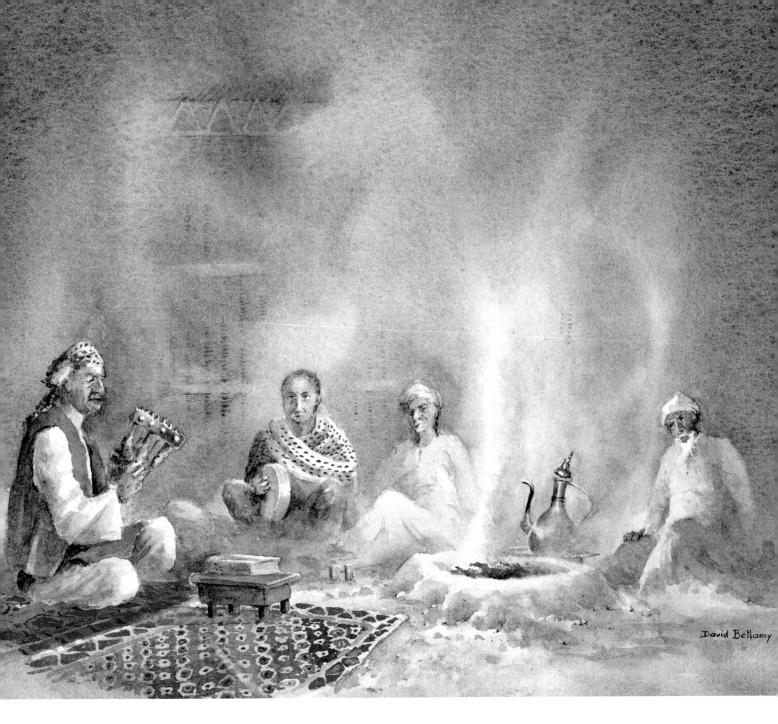

to the oasis. This was followed by a song about the spectacular wonders of the Egyptian government, rising to a crescendo as he warbled with reverence about 'how perfect its ways!' Marzouk whispered to me that the new arrivals were government officials. Abd was clearly an accomplished diplomat.

After about fifteen minutes listening to these eulogies, the government fellows rose and left, leaving a more intimate group. Thankfully Abd returned to wailing out love songs with much use of '*habibi*' ('my love'), the audience joining in with much clapping, particularly from the German chaps, one of whom had a remarkable resemblance to the comedian Barry Humphries' character Dame Edna Everage. Eventually we bade Abd farewell and returned to the Panorama Hotel for a welcome rest after a rather full day.

THE WHITE DESERT

Moving on in the morning, we soon reached the
White Desert, a vast area littered with thousands of
white rocks, crags, inselbergs and pinnacles, some
in the surreal forms of giant mushrooms, dragons,
immense meringues and an unworldly maze of vanilla
ice-cream cones, each the size of a bus shelter.
Many resembled grotesque and fantastic creatures,
appearing to come alive in mist or half-light. Here
and there, large fields of white smooth and ridged
pavement broke up the sand cover. A few acacia trees,
twisted tamarisk bushes and date palms occasionally
soften the harshness of this desert wonderland and
help sustain wildlife such as birds, insects, desert
foxes and horned vipers.

In the White Desert with Marzouk (centre)
and Hamada (left)

The fantastic shapes of the White Desert are caused
by wind and sand blown across from the Great Sand Sea,
and I sketched one after another of these astounding
formations. As evening approached, the white monsters
turned a magical pink, golden and red, with exquisite
violet and purple shadows morphing
into mysterious forms as the light
faded. By moonlight the effect was
unreal, as these brooding monoliths
seem to spring to life, surrounding the
tent. Sunrise left me spell-bound as the
first rays of sunlight struck the stark
whiteness of the crags.

Our planned route back to Cairo
involved crossing the desert north-east
to Fayoum Oasis, a distance of around
150 miles (240km), initially over almost
featureless flat, hard-packed desert.
It is easy to go astray and become
completely lost in its vastness.
Mohammed Marzouk had been
instrumental in setting up many of the
desert safari routes. For navigation he
used landmarks, many of which, such
as distinctive crags, inselbergs and
mountains, were obvious, but sometimes there was little
to work on. In these cases, he looked for discolouration
in the sand, soft sand areas, or the number of dune
summits, though these would change over a period.
At night he used the stars.

Giant mushroom, White Desert
One of many bizarre-shaped rocks in this fascinating region.

After some time we encountered the Darb al Rayyan, an ancient caravan route running some 150 miles (240km) from Baharyia to Fayoum. Camels took five or six days to travel this distance, and lines of camel tracks still scored the sand, some fifty years after the last caravans were abandoned with the introduction of the truck. In soft sand, the tracks disappeared, and were sometimes obliterated by tyre tracks. The wide *wadi* we drove along became completely blocked at times by a transverse dune up to several hundred feet high. This would necessitate roaring up the steep side slope, driving along the ridge and then descending on the far side back into the wadi to continue the route. Sometimes it took two or three attempts to get up these side slopes. Each time on reaching the top of a dune we would come to a sharp halt. Ahmed, a guide I was chatting to in Baharyia, told me how on one occasion as a young guide he had failed to stop and shot over the top. His wagon had flown several metres through the air before crashing down the other side, injuring the five clients inside. It was Marzouk who had got them to hospital.

Darb al Rayyan
The old caravan route to Fayoum Oasis and Cairo, with the camel-prints still showing in the sand.

Ploughing at Fayoum
This scene with the primitive ox-drawn plough could hardly have changed since pharaonic times.

The scenery became more interesting. We reached a spring fringed with palm trees with a beautiful ridge of dunes snaking away up to the craggy escarpment in the distance. Dug into the escarpment cliffs was the Coptic monastery of Saint Macarius. This had been hacked out of the rock by hand during the 4th century, and much extended over the years. A monk named Waffy showed me around. He was a small fellow who, for some reason, enthused about how little he was, and his status as the most unimportant and insignificant of monks. His round face sprouted a profusion of side whiskers, hanging like goats' beards, a sort of Oriental Dickensian character. He showed me their Bible, written in both the Coptic language and Arabic. The cosy rooms ran surprisingly far back into the mountainside. Some thirty-one monks lived there, and his boss, who had a truly impish face, was called Michael. Waffy insisted on giving me an orange before we departed.

THE DELIGHTS OF ISLAMIC CAIRO

Back in Cairo I took a taxi to the Islamic quarter. Sharif the taxi driver had two deformed hands. Extremely polite and helpful, he pointed out all manner of interesting places and was happy to stop for me to sketch, even in awkward places. We passed through the great gateway of Bab al-Nasr and into the narrow thoroughfares of Old Cairo, where so many of the Orientalist painters had sketched their iconic scenes of streets and markets teeming with the most fascinating humanity.

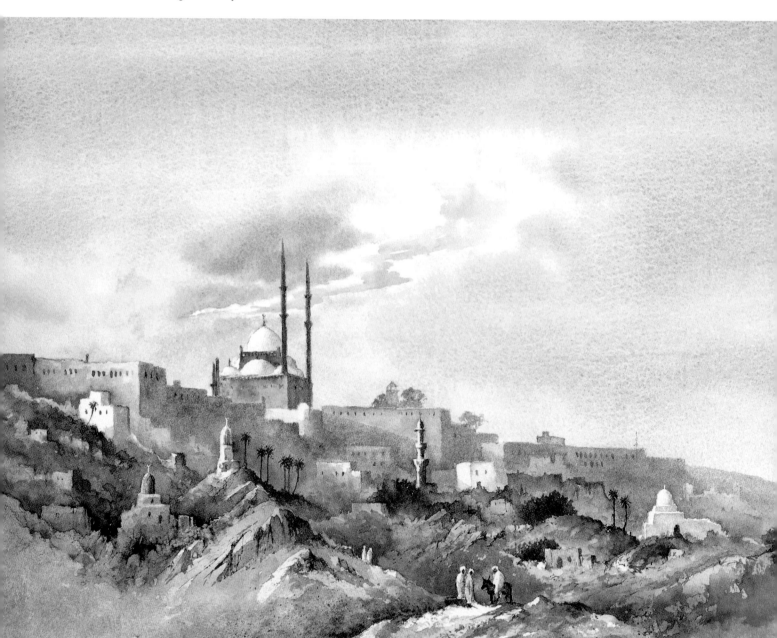

The Citadel, Cairo

The Citadel is dominated by the magnificent Mohammed Ali Mosque, built in the mid-19th century.

The Orientalists in Egypt

Charles Robertson (1844–1891), a British oil painter who turned to watercolours around 1880, painted views of Cairo streets with sumptuous detail combined with towering architecture that imparted a monumental sense on an otherwise ordinary market scene – if indeed any 19th-century Cairo street could be deemed ordinary.

Another artist who painted street scenes with extraordinary attention to detail was the Austrian Rudolf Ernst (1854–1932). His deliciously weathered walls and patterned doors featured a lost-and-found method of working, different to many Orientalists who included every minute fragment of detail. Many of his works were based on memory and imagination, and included artefacts that demonstrate designs from a variety of countries within a single painting. Working in these streets, teeming with people, animals, carts and more is far from easy for an artist. The English painter William Logsdail (1859–1944) hired a room near the Bab el Zuweila specifically to paint the scene in peace.

While most Orientalists visited Egypt for a brief period, a number, such as John Frederick Lewis (1804–1876) lived there for many years. He covered all manner of subjects, including the desert; often painting himself into the scene as a notable merchant, a sheikh, pasha or other important member of the community, beswaddled in grand Eastern robes. His brilliant narratives of harems attracted much acclaim, and his skill and dexterity with the brush allowed him to create outstanding compositions with beautiful renderings of the complicated Egyptian decoration and arabesque motifs. He is assumed to have used his own house – suitably furnished with Egyptian artefacts – as the harems, usually including excessive detail.

Because of the reluctance of Muslim ladies to pose, most Orientalists resorted to European models. As the sultans, pashas and upper classes tended to prefer pale-skinned Circassian women within their harems, the use of European models did not greatly matter. However, even if it retains a fairly plausible ethnographic veracity, it does little to enhance the mystique of the East.

By contrast, the paintings in the Maghreb by Parisian artist Alphonse-Étienne Dinet (1861–1929), sparkle with the joy and emotion of the true native Berber people without resorting to a Paris model. He made a permanent home in Bou Saada, spoke Arabic fluently, changed his name to Nasreddine and converted to Islam, which undoubtedly gave him vital access to the locals.

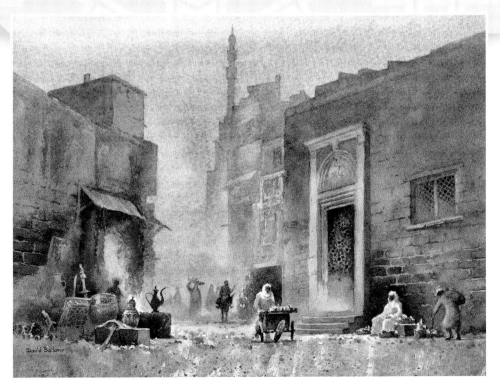

Cairo Street at Dusk

With so much architectural excitement and so many extraordinarily sketch-worthy characters appearing almost like some circus pageant, it became hard to concentrate on any one aspect of Cairo. Brassware, pots, donkeys, carts with wonderfully wonky wheels, women with great loads on their heads, and so much more provided an endless wealth of subjects, together with a background of exotic shapes.

Street lights began to come on, adding to the magical atmosphere. Exciting images hung on every corner. Carts, bikes, mopeds and people carrying all sorts of paraphernalia clogged up the streets, while cars hooted constantly: a delightful chaos. Sharif dropped me off at the Bayt el Suheini and refused a tip. He'd done me so proud, yet would not accept any extra money.

Here, in this place of Islamic architectural wonders, inhabited by the most picturesque characters, my pencil blazed across the sketchbook with so many fascinating subjects in a series of ever-changing tableaux. At times I sketched an interesting background, leaving the foreground blank in anticipation of a host of figures tumbling straight out of *One Thousand and One Nights*. These figures never failed to arrive, and sometimes had to be crammed into odd positions on the page because of a lack of room, leaving many sketches needing considerable interpretation.

In the metal-working quarter I sketched a jolly blacksmith at work by his forge. As darkness fell I came upon a large house with lovely arched and worn stonework around the doorways, and large *mashrabiya* screens on the upper windows. By then it was so dark that I could not make out the top of the building, but worked easily on the lower parts by the street and shop lighting. After some time a chap approached me, saying he had the keys to an adjacent house which featured in my sketch, and he would show me around for a fee. I declined as I wanted to get on with the sketch, and when he persisted, I said I might come back tomorrow in daylight. That would cost extra, he said. His name was Mr Saladin and I had difficulty keeping a straight face. Later I bought a few knick-nacks in the bazaar and the owner of one took my money, inserted it into a sandwich and pretended to eat it. There's never a dull moment in Egypt.

Women Orientalist artists

Little has been written about the female Orientalist painters. Henriette Browne (1829–1901), whose real name was Sophie De Saux, visited a harem in Constantinople in 1860. Her resulting painting of several ladies visiting a harem has a strong air of authenticity, but is cold in its sparsely-furnished setting, and quite unlike the sumptuous harems portrayed by the male Orientalists.

Polish-born Elisabeth Jerichau-Baumann (1819–1881) married a Danish sculptor, and despite male prejudices made a successful painting career, including audiences with Queen Victoria. Some of her work featured Oriental paintings, and she even painted in several Turkish harems. Unlike the fragile marble-white females of the seraglio painted by most Orientalists, her women embodied strong personalities and confidence. By comparison the women portrayed by her male colleagues were mainly obsequious, pale flowers, often as erotic as an artists' wooden lay figure. Had I come across the woman depicted in her impressive painting *An Egyptian Pottery Seller near Gizeh* as a real-life person it would not be pots I would assume she was selling! Many of her works were considered so controversial that they were kept hidden away in Danish museum store-rooms until more recent times.

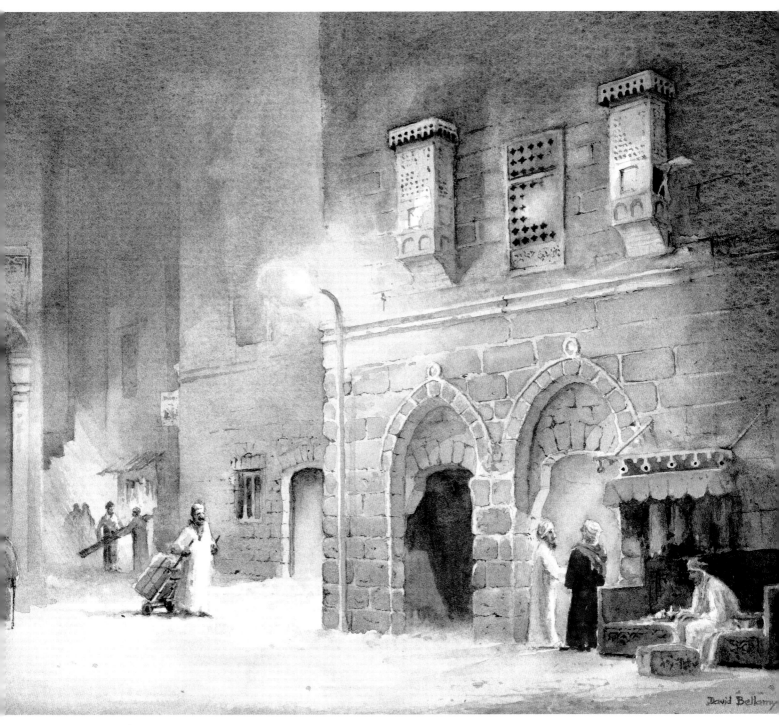

Qasr Beshtaq

Islamic Cairo after dark is a magical place to paint. Qasr Beshtaq is the building on the right with the upper windows covered with mashrabiya *panels through which the ladies of the harem could look out without being seen. The Turkish house on the left shows the 'joggled voussoir' technique in the arch – squiggly panels of different coloured blocks of stone. Emir Beshtaq, a notorious rake famed for his magnificent balls, married the sultan's daughter, but met a rather nasty end when he was killed by a jealous rival.*

JORDAN

At Home with the Bedouin

In the summer of 1812, Sheikh Ibrahim emerged from the
great slit in the mountain of Jebel al Khubtha known
as the Siq, and came upon the most incredible sight.
Before him rose the royal tomb of Al Khazneh with its tall
Hellenistic façade, the so-called Treasury. He had stumbled
on the rose-red city of Petra having crossed deserts to find
a suitable mountain-top to sacrifice his goat – or so he said.

PETRA

Disguised as an Arab, the good sheikh was in fact the
Swiss explorer Johann Ludwig Burckhardt. He was intent
on secretly visiting this remote spot in the Ottoman
Empire after hearing of this extraordinary place amidst
wild mountain scenery. Burckhardt was acutely aware
that he might not survive this trip if his true identity
were discovered, even by his guide. He was the first
European for many centuries to visit Petra, and although
he could not take notes or sketch as he observed the
ancient monuments, he did record much afterwards
from memory.

Although Burckhardt's news spread fast, it took sixteen
years before the first archaeological expedition was
undertaken by two Frenchmen, Léon de Laborde (1807–
1869) and Louis-Maurice Linant de Bellefonds (1799–
1883). They spent six days making notes and drawings
and taking measurements. Petra was the ancient capital
of the Nabateans, a powerful kingdom, but taken over
by Rome in AD 106. The mysterious Nabateans were
lost to history until Laborde rediscovered them in the
19th century.

Without doubt Petra is the highlight of Jordan, and has
been popular with artists from the time of David Roberts
and Edward Lear. With recent wars in the Middle East,
Jenny and I found we had the place almost to ourselves
on our visit. There were no great crowds blocking the line
of artistic sight, and the Bedouin could not have been
more pleasant. Our first day here began by wandering

down the Siq in absolute amazement at the violets,
ochres, oranges and blood-red colours of the rocks
that hemmed us in as they soared skywards at ninety
degrees, the light bouncing off one vertiginous wall to
light up the opposite shadow side in dazzling brightness.
Here and there a chink of sky would appear, while in
places the walls curved over to roof us in.

At the far end we disgorged into Wadi Musa. Straight
in front stands Al-Khazneh, The Treasury. An impressive
façade, like most of the buildings at Petra, is hewn out of
the huge cliff that confronts the viewer at this point.

These cliffs are composed of hard and soft sandstones
of varying colours. The softer rock was easily carved
out to form tombs, temples and cave-like dwellings, with
the harder rock forming the support. High up on many
peaks are distinctive domes formed of white sandstone.
While Al-Khazneh appears like the entrance to some
huge temple, it does not extend far inside. A camel by
the name of Alyan sat in the foreground. Along with its
owner, Ibrahim, clad in white *dishdasha* and obligatory
red and white *kaffiyeh*, I was provided with a faultless
composition. As I began sketching a policeman came up
to me and said,

"It looks as though you are going to be here some
time, so sit on this chair!" To my astonishment, he kindly
produced a chair and I sketched in supreme comfort with
an audience of guides and occasional tourists. This is
not the usual luck of the itinerant artist.

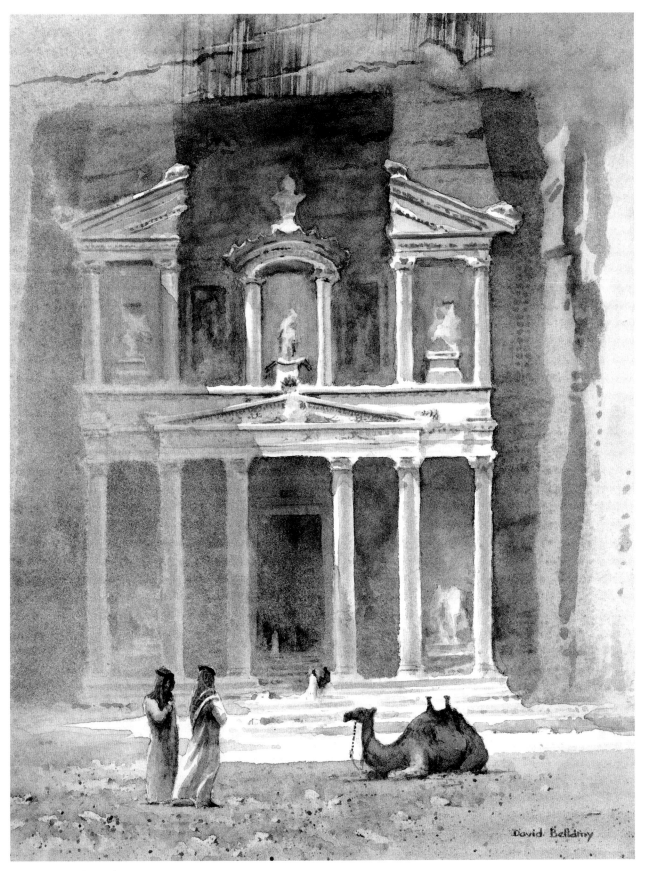

Al Khazneh, (The Treasury), Petra

This is the stunning view that engulfs your senses as you emerge from the narrow Siq. In earlier times
Bedouins would shoot at the urn at the top, thinking it was full of money.

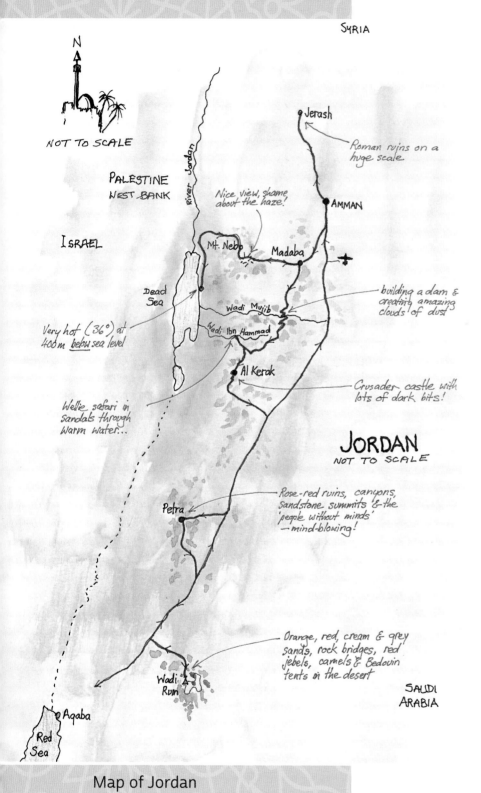

NOT TO SCALE

SYRIA

PALESTINE
WEST BANK

ISRAEL

River Jordan

Jerash
Roman ruins on a huge scale.

Nice view, shame about the haze!

AMMAN

Mt. Nebo
Madaba

Dead Sea

building a dam & creating amazing clouds of dust

Wadi Mujib
Wadi Ibn Hammad

Very hot (36°) at 400m below sea level

Al Kerak

Crusader castle with lots of dark bits!

Wellie safari in sandals through warm water...

JORDAN
NOT TO SCALE

Petra

Rose-red ruins, canyons, sandstone summits '& the 'people without minds' — mind-blowing!

Orange, red, cream & grey sands, rock bridges, red jebels, camels & Bedouin tents in the desert

Wadi Rum

SAUDI ARABIA

Aqaba

Red Sea

Map of Jordan

During the days of Burckhardt, Roberts and Lear, Wadi Musa often lay lush with vegetation, as the river flowed through during rainy periods, but this was diverted by a dam at the head of the Siq when tourists were swept to their deaths in the Siq following a violent storm. Further down the wadi opened out, with high, barren walls rising sheer on either side to great heights.

Because of the threat of war, few tourists turned up, so we were honoured with more than usual attention as every guide tried to join in. "Would you like a camel?", "Would you like a donkey?" the guides kept calling out in good humour.

Each new footfall revealed yet another subject to sketch with the most impressive Nabatean architecture sculpted in intricate detail, much of it weathered and crumbling badly in places, the wind-driven sand rasping the straight lines of elegant pilasters into deckle-edged stalks resembling sticks of battered celery. To the artist this adds significantly to the appeal of the façades, strung one after another along the eastern cliff, in an astonishing assemblage of monumental wonders. Too many straight lines detract from the aesthetic value. Here I am reminded of the contentious remarks of the artist and cleric Reverend William Gilpin (1724–1804) when confronted by Tintern Abbey in the Wye Valley; where he considered that bashing the abbey about with a well-aimed mallet might enhance its artistic appeal. At Petra nature has already done this for us.

I gazed in awestruck wonderment at the sheer skill and fortitude of the Nabatean architects and builders, creating extravagant façades high up on the cliffs in perilous situations. I attach strong value to recording information characteristic of a location, and here, for example, crow-stepped demi-merlons decorated many of

Bedouin Camp, Jordan Valley

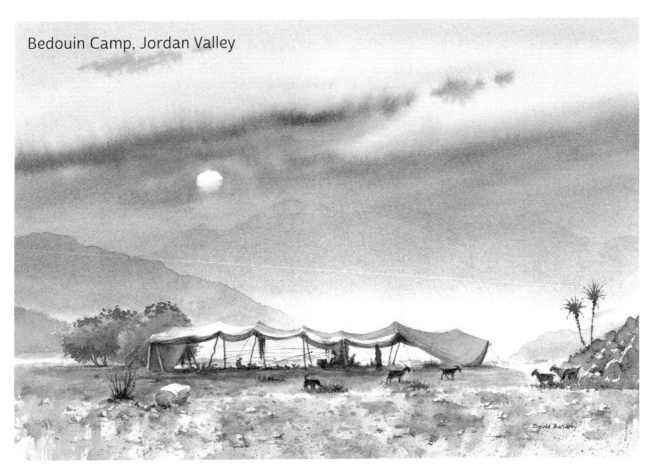

the façades (you can see an example on pages 74–75), making it essential to include these in my drawings, even if in the final painting they are barely discernible. The urn, another common Nabatean motif, adorned the apex or wings of many of the triangular pediments forming the decorative tops of the monuments. It would take weeks to do this place justice and I'd only allocated three days. We sketched feverishly before stopping for a lunch break. The sheer amount of enticing subjects with overwhelming decoration created considerable pressure: was I painting the best examples? Should I be looking elsewhere? Which ones to ignore? Should I come back at another time of day to obtain the best lighting on a subject? The mental anguish is considerable when you have so little time.

Orientalist artist David Roberts admitted feeling like throwing his pencil away when confronted with the sights – but I at least had the invaluable advantage of my camera as a back-up. Poor old Edward Lear would have had colossal problems coping with all this intricate detail using his field glass while at the same time conjuring up his eloquent descriptions. Both Roberts and Lear had to abandon their visits to Petra prematurely because of hostile Bedouin, yet Roberts managed to produce a fairly large body of work incorporating astonishing detail, which is a valuable resource in ascertaining how much erosion has taken place in the intervening years.

Wadi Ibn Hammad

This great breach in the landscape provided plenty of exercise, splashing through pools, clambering over rocks and revelling in wild nature.

In the heat of the day I climbed high above the theatre, traversing hot sandstone slabs to find a suitable sketching position of the impressive outer Siq. This was a complicated scene that took ages to record in watercolour – for colour is vital in this unparalleled place of fiery reds and oranges. While I worked, Jenny painted an impressive double-page sketch of the Corinthian and Palace Tombs in the opposite direction.

At Qasr al Bint it was possible to take in the whole of the distant Royal Tombs as they spread across a wide panorama of cliffs; but being forced to work rapidly in the shadeless direct sunlight of the baking Petra basin did not produce the best work. Painting with your artwork in direct sunshine is not only bad for the eyes, but can give a totally false impression of the tones in a painting. Even though I worked in the shade, washes dried almost instantly – you can read more on how to adapt to this on page 158.

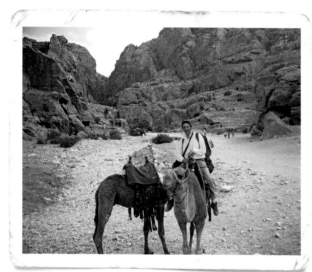

The author in Wadi Musa, Petra

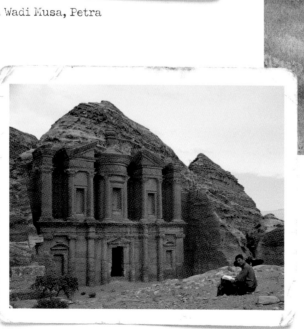

Sketching El Deir above the Petra basin

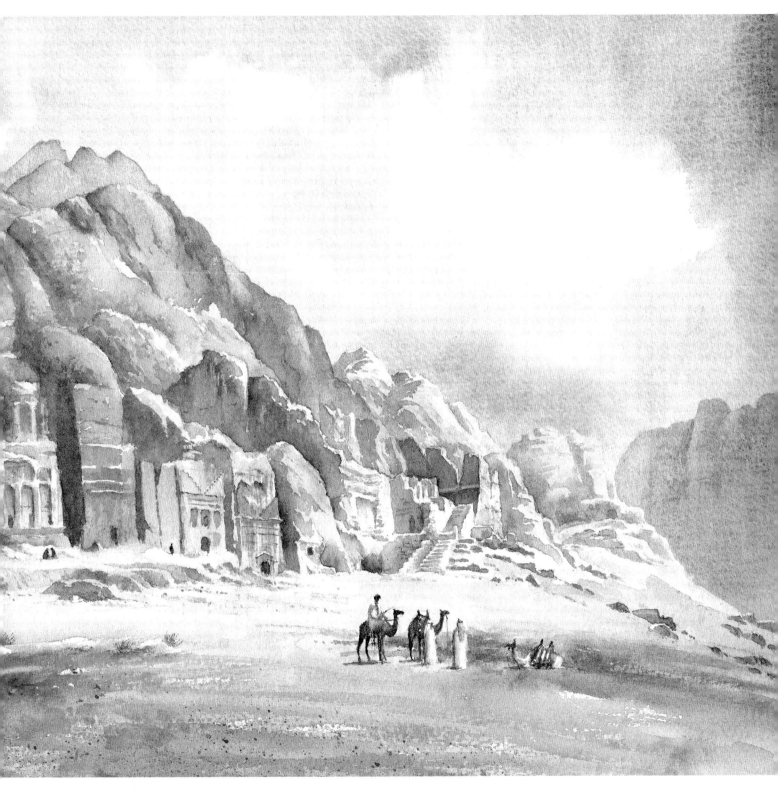

Royal Tombs, Petra

The great façades hacked out of the cliffs of Jebal al Khubtha at Petra. The soft rock that allowed the builders to carve out these intricate monuments with relative ease unfortunately also renders them vulnerable to erosion of the detail, which is becoming severe in places.

High Place of Sacrifice

Being here as twilight approached lent an eerie poignancy to this lofty spot where not only animals, but humans were sacrificed at one time.

Following afternoon tea Bedouin-style, the High Place of Sacrifice beckoned. Jenny, drained of energy by the excessive heat, would move not an inch further without the aid of a donkey. At first my donkey, Azouz, seemed slightly unstable, but I soon became used to the ride. The route up Jebel al Madhbah appeared impossibly steep amidst the savage rock scenery, making me question the wisdom of whether I should be on a donkey. We began to climb steps, which the donkeys took with ease, even with my weight. Vertical cliffs closed in on all sides, with no obvious way on – until we encountered steep steps cut into the cliff. To our left the drop fell sheer for hundreds of feet, and on the animal I felt exposed, praying it wouldn't develop a coughing fit and hurl me into oblivion. Where the steepness became too much for the burdened donkeys, we dismounted. Here Khaled, their owner, pointed out that both donkeys were male – apparently female ones were notoriously dangerous, and would probably have taken great delight in hurling me over the precipice.

Colonnaded Street

This was built by the Romans sometime after they invaded in 106 AD.

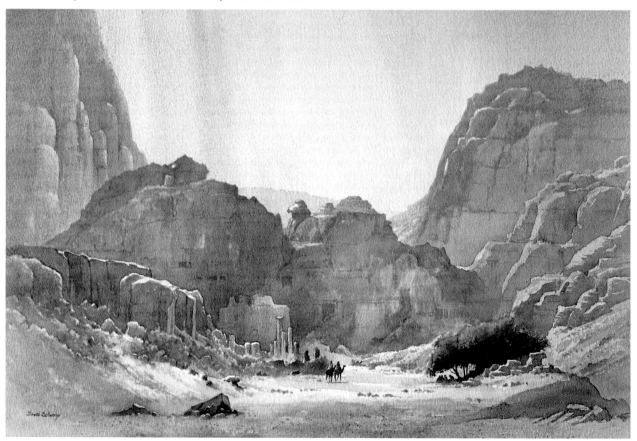

At the top of the steps we remounted and zig-zagged our way upwards, each step full of wobbly interest with views opening out to distant mountains. The rocks, in varied colours, featured carvings in places. Low evening light cast a warm glow over everything. Not far below the summit we paid off the guides and climbed the last section on foot.

More Bedouin greeted us at the top, eager as always for a chat. One of the questions they regularly asked was how many children we had. When I replied that I had one daughter they implored me to get a son – "Drink camel-milk and get a second wife!" Jenny was not amused.

The hush of calm evening atmosphere, as the dying blood-red sun began setting over Jebel Harun, conjured up childhood memories of the simple sensations of night-time exploits in the great outdoors. Sensational vistas of the tombs down in Wadi Musa brought a dizzying feeling. Both human and animal sacrifice took place here during the Nabatean era, and the altar had basins and drains for ritual washing and blood-letting. I sat down beside the Sacrificial Place and sketched the dying sunset, pondering on the thoughts of someone about to be sacrificed.

Nabatean aquaduct

My first sketch of this was carried out in line with the gorge, but that included some of the al bohl formations (see overleaf), making the sketch appear cartoon-like. This view gives an idea as to how the water channels wound their way round the crags and over the fissures.

Utter peace reigned, with no sound apart from the sigh of the gentle wind. I finished my sketch to find everyone had gone. Distant peaks began melting into the ultramarine violet atmosphere. Aware that we had to find a way down the mountain with darkness approaching, we packed away our sketching gear. Partway down riveting views of the Uneisha Tomb emerged out of the gloaming, begging to be captured on paper, though my hasty sketch was pleasantly bungled. We felt exhausted but thankful when we arrived back down in the wadi.

Refreshed and eager to set forth next morning, we approached the Petra tombs from a different direction, turning into Wadi Mudhlim where we immediately encountered a short tunnel. Beyond this the wadi narrowed. High cliffs hemmed us in: in heavy rain this would become a death-trap as floods rush through. Further down, as the slit squeezed into little more than a metre in width, evidence of this lay high above us where brushwood and mangled oleanders jammed against the sides, including a tree some seven metres (23ft) above us, giving a daunting impression of the force and depth of the surging water. The erosive action of fast-flowing water was evident in the smooth rock walls. We scrambled on down rocks and under jammed boulders as though in caving mode.

Tomb of the Roman Soldier

Watercolour sketch done on the spot.

Al Bohl

I have to admit to bringing together, in an aesthetic pile, rather a lot of the best examples of these strange rock structures scattered about the place.

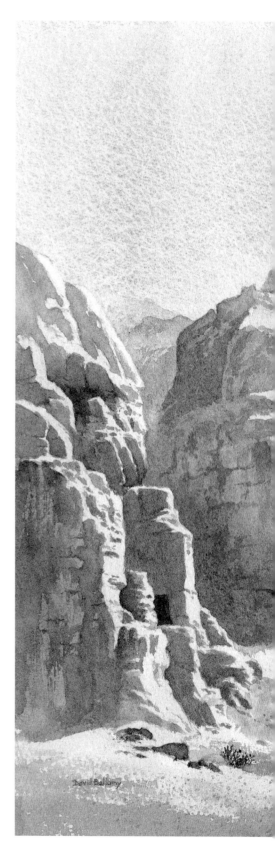

Where the valley opened out, we began to feel the heat of the day as we explored a rocky amphitheatre. A jumble of pale-coloured domed rocks, with many appearing like giant skulls, attracted my pencil. Demented faces stared back at me like some Bedlam orgy, and my sketch began to look like a fantasy drawing. The Bedouin call these features *al bohl*, 'people without minds', as though they had been turned into stone by Medusa, the Gorgon of Greek myth.

Moving on, the aquaduct carrying the Nabatean water course came into view, spanning a narrow ravine. The watercourse contoured round the cliffs, bringing water many kilometres to Petra. A shady spot beneath a crag enabled us to work in comfort, the main problem being to render a beautiful ancient stone structure overlooked by a gaggle of demented skulls that turned a serious work into cartoonish insanity. This bizarre composition would have appealed to Edward Lear. Petra made an immense impression on him: he wrote of the monumental architectural labour amidst the wildest extravagances of nature, and how 'these combine to form a magical condensation of beauty and wonder which the ablest pen or pencil has no chance of conveying to the eye or mind.' His exhilarated response to the Nabatean city stood in sharp contrast to that of Charles Montagu Doughty (see page 27), who wrote, ill-temperedly, 'Strange and horrible as a pit in an inhuman deadness of nature, is this site of the Nabateans' metropolis; the eye recoils from that mountainous close of iron cliffs, in which the ghastly monument of a sumptuous barbaric art are from the first glance an eyesore.' Alas, poor Lear hardly had enough time to explore the place properly, being hounded by fierce Bedouins for money. Undeterred, he managed to slip away for a while to sketch Al Khazneh, El Deir and the theatre. He must have worked with the fury of a rampant lion, as the first two places are some distance apart, with quite a climb to El Deir.

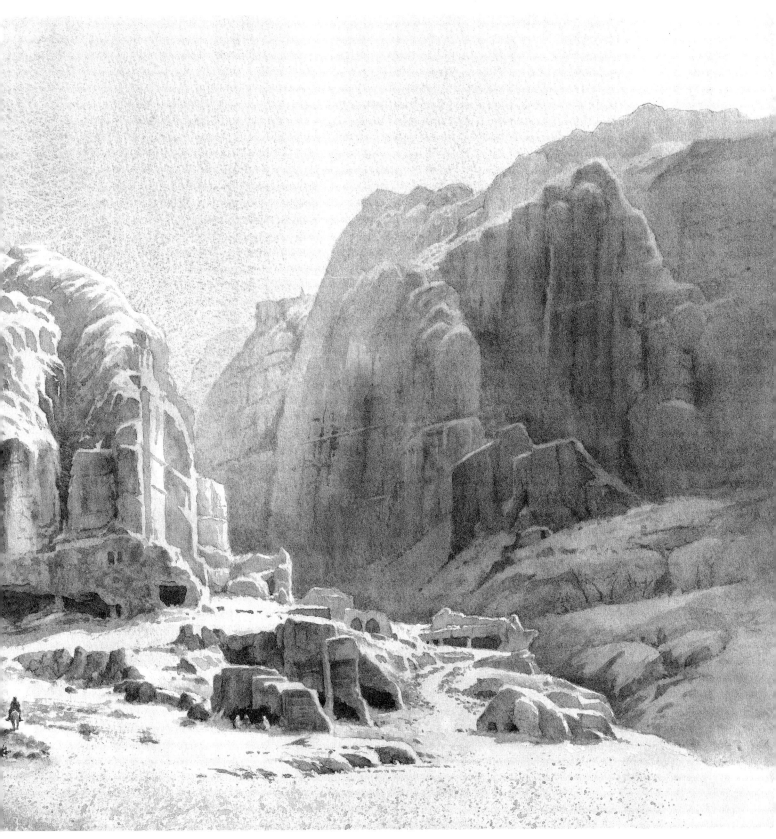

Heat of the Day, Wadi Musa

As with many of my watercolours of Petra, I have introduced a heat haze to subdue much of the overwhelming detail. Until a few years before my visit, the Bedouin lived in these carved-out tombs and temples, but the inhabitants have now been rehoused in a nearby Bedouin village.

Moving on into Wadi Mataha, we found small dwellings cut into the rock. These were some height above the valley floor, as a precaution against flooding. The view opened up to show the tombs and temples of Moghar al Nassara, overlooked by a summit of square ochre-coloured rock. Not a single tourist could be seen in this remote part of Petra, though Hammad, a local came and sat by me for a while. Even a Bedouin gets bored watching paint dry, so he left after a while, doubtless confused by my choice of subject. Further along, two Bedouin ladies tried to entice me to join them for tea but I needed to move on – I had temporarily lost Jenny somewhere. Reunited In Wadi Musa, we stopped at the café for refreshments and met Khaled and Gasim, who had taken us up on the donkeys the day before. One of the camels, called Zouzou, joined us and drank a bottle of Fanta. She apparently had a liking for whisky, which made her break into a lively dance. Our sketching continued until we called it a day and mounted camels for the journey back up the Siq to our base.

On the third day in Petra we came across a Bedouin jewellery-seller who spoke in a most authentic Brummie accent, which sounded so surreal. He'd picked it up from British Black Country visitors who had stayed with him.

Our main objective today was El Deir, the monastery set amidst high peaks and one of the outstanding features of Petra. Jenny chose to ride up on a donkey, but with my weight I felt guilty about riding these beasts up mountains. In any case, I could easily keep up with her donkey. The route lay up steep steps all the way, some distinctly rainbow-coloured. A ravine fell away vertically on the right-hand side: a dramatic location festooned with crags resembling wild and scaly monsters. Here and there evil-looking slits in the rocks plunged hundreds of feet into the abyss. Only the occasional small tree relieved the mountain savagery.

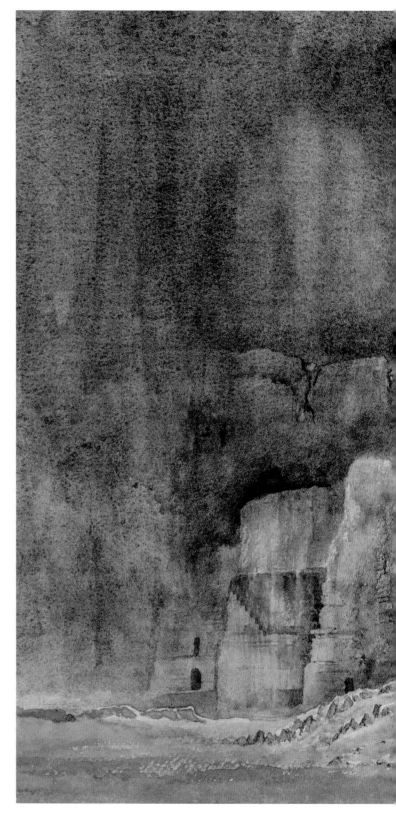

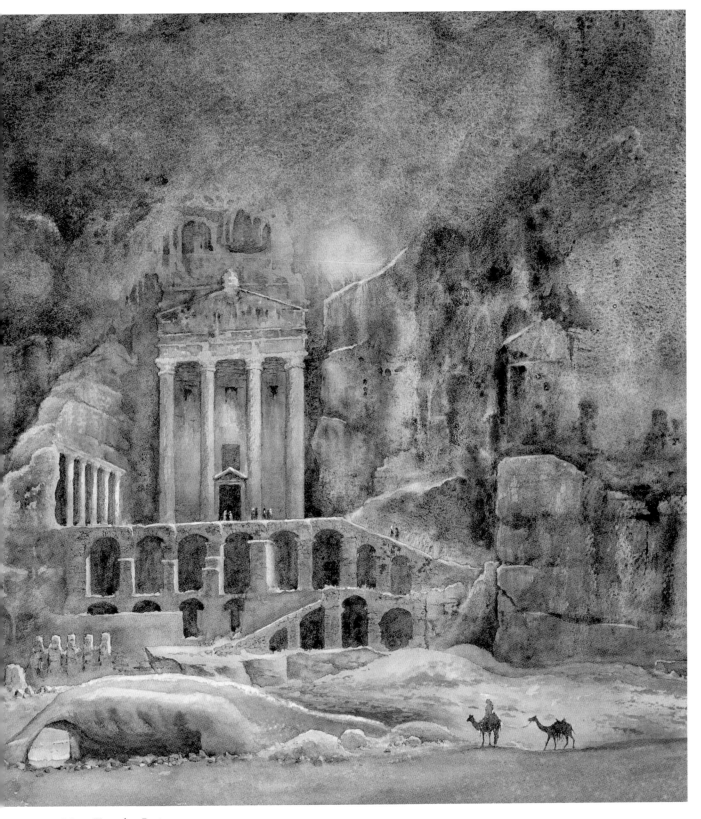

Urn Tomb, Petra

Painted as a night scene, I have arranged the lighting to create highlights in the more interesting areas, to enhance the potent sense of mystery of this dramatic monument. Built on two tiers of vaults, the structure rises high on columns to the urn at the top, which gives the building its name – although many other tombs at Petra are

also decorated with urns. The urn itself is heavily eroded, as is the triangular pediment on which it stands. Another common feature of the Nabatean architecture is the stepped demi-merlons, seen on the last-but-one building at the bottom left.

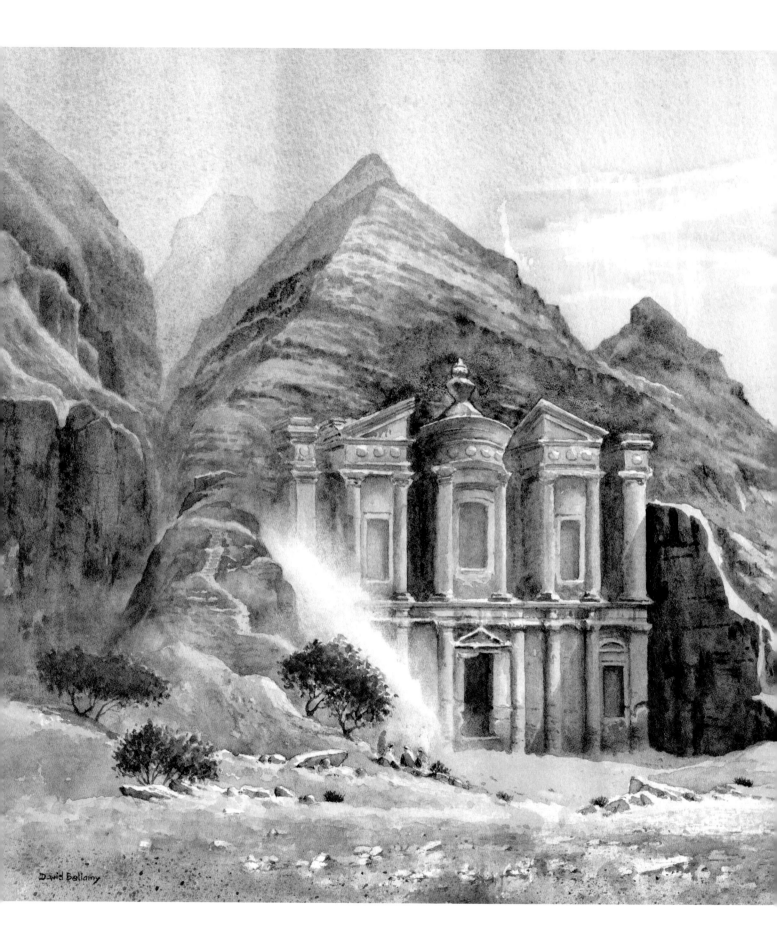

David Bellamy

At the top we came upon the great monastery, carved out of a huge crag amidst wild scenery. Haunting flute music floated across from some unseen musician as we sketched. A stray donkey wandered over to examine my work, though understandably it seemed unimpressed, for it turned out a ghastly mess. Probably it had hoped for a morsel or two, so I guarded my expensive sables, as goats had tried to make a meal of them in the past. Only the occasional Bedouin appeared. The sound of distant thunder rippled across the mountains, the sky became bleaker with striking sensations of colour and light across the distant peaks, and the mood became sombre.

Returning down the steps we found Khaled and Gasim at the bottom, to Jenny's relief, as the two and a half-mile (4km) hike back to the site entrance did not appeal. The evening light cast an eerie effect as we trotted across the vast Petra basin, creating a special moment. Free from all but the occasional Bedouin, the silent beauty and sweet desert air left a deep impression with a strong sense of historic associations.

All the locals here had been such hospitable and kind people. We passed the café where the kind owner waved farewell – he had been instrumental in making sure no-one ripped us off, had given us half-price tea and exhorted the donkey lads to ensure we were taken right on to the entrance gate.

Our route darkened as we entered the narrow Siq with its vertiginous walls closing in and by the time we reached the far end the moon beamed brightly. At the gate we dismounted and bid farewell to the Bedouin lad who leapt onto one of the donkeys and dissolved into the darkness.

El Deir

Known as the monastery, this impressive edifice stands high above the Petra basin amidst wild rock scenery. Partway through the original sketch, thunderclaps rolled across the peaks, but happily the rain stayed in the distance. Dark shadows of lowering clouds heightened the sensational mood of this mystical mountain retreat.

WADI RUM

Our driver, Ehab, who always turned up at the right time on the right day, drove us to Wadi Rum. We travelled through the desert of an-Naqab, every now and then pausing to carry out quick pencil drawings as we progressed. The desert lay flat, punctuated by huge sandstone buttes eroded by wind-driven sand. Here and there black Bedouin tents came into view, often with the obligatory camel tethered nearby. After some time we turned off the main road and, for a while, followed the oldest railway line in the Middle East, now used to carry phosphates. During the First World War, when controlled by the Turks, it came under constant attack from Lawrence of Arabia and his Arab irregulars. We were now entering a region where they had carried out many of their legendary exploits.

Lawrence of Arabia

T. E. Lawrence (1888–1935) is, of course, a British hero, regarded as courageous, a brilliant strategist with a touch of genius in leading the Arab Revolt against the Turks, and truly altruistic in his desire to see the Arabs rewarded with self-rule,.

His massive ego and self-aggrandizement may be forgiven, but as British war secrets have been declassified his links with British Intelligence become clearer, together with much controversy in many areas. Lawrence knew full well that he had betrayed the Arabs and this sense of guilt stayed with him for the rest of his life.

In Jordan he is viewed as an imperialist who convinced the Arab armies that they would be well rewarded, when in fact he knew full well that it was a giant pretence. His faults, however, should be viewed in the light of the pivotal role of his great victories during the First World War.

We drove past the Seven Pillars of Wisdom from which Lawrence named his book, and arrived at the Wadi Rum Rest-House. Here we were met by a Sudanese called Osama and discussed our guiding needs with him over tea, while Ehab departed for Amman. Osama showed us our tent, a spacious Western-style type able to sleep four comfortably. The floor was partly covered with sand and the zips did not quite meet up, so I prayed we would not be blessed with a sandstorm during our stay. With shadows lengthening we wandered a little way down the valley. Tamarisk and artemesan bushes dotted the wide desert floor, and on either side massive sandstone ramparts of red rock rose straight out of the sand, their flanks scored with gullies which broke up the massive faces of sheer rock.

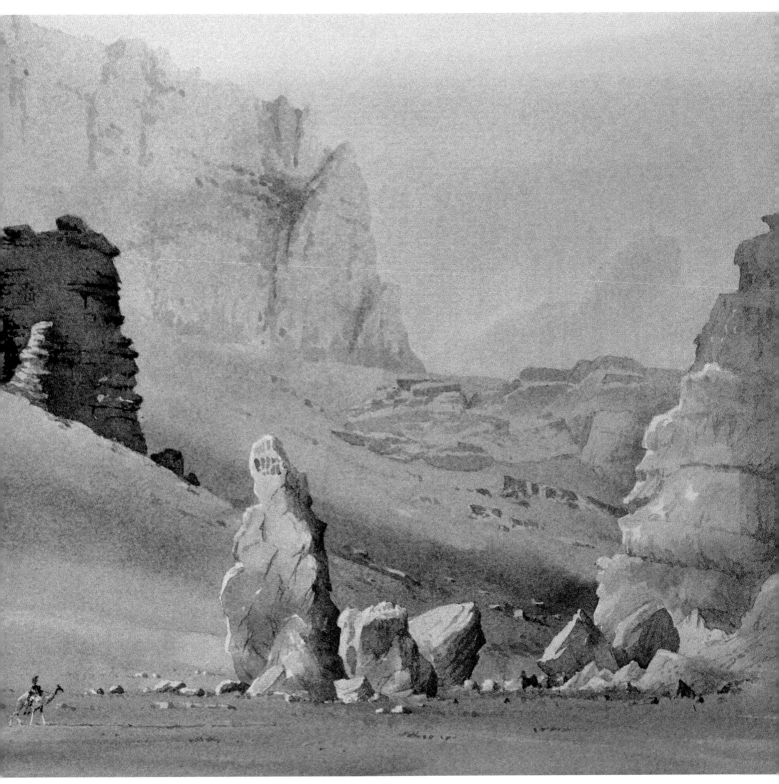

Jebel um Kharg

To get the most of the evening light flooding into Wadi Rum I scrambled high on rough crags, only to see this vast amphitheatre of sublime desert mountain scenery unfold before me, the massive scale of the place emphasized by a lone camel-rider.

As I gazed southwards to pick out the best composition in the fierce evening light, on the right Jebel Rum towered above us at 1,754m (5,754ft). Jebel Khazali positively glowed, demanding to be painted in full colour. An awesome silence pervaded the place, adding a sense of reverence to the moment. What a sight it must have been to witness the Arab army passing through this vast wadi, thousands of gaily-dressed Arabs marching to war. Lawrence wrote of an air attack on his great column, when they took to the shelter of the rocks 'nesting like ibises in every cranny of its face'.

Lawrence did occasionally find matters frustrating when working with the Arab army, such as their occasional habit of disappearing for a coffee break in the middle of a long battle.

BEDOUIN HOSPITALITY

Back at the Rest House, dinner was served to the accompaniment of Osama playing his guitar. Then Atala, a young Bedouin guide, called to take us to his house to meet his family. He had twenty-seven brothers and sisters, although several other siblings had died, and only a few were present. His father had three wives, each with her own house. We entered the rather threadbare room via a courtyard contained a scattering of cushions, Atala's box and a few pictures. He introduced his brothers and sisters. The Bedouin women, sharp-featured but strikingly pretty, had long eyelashes, flashing eyes and mischievous grins. Even without a veil, Hadna embodied a sense of Arab mystery. Slender as a Dhofari tent-pole in her long black dress, I would have liked to sketch her, but it was taboo: even the five-year-old males glowered in disapproval, so I instead sketched the younger girls. Her sister Geida was keen for me to do her portrait, which I finished quickly. The men were not happy about this so I declined to do a second drawing to give her, which is what I normally do when sitters show such interest. As subjects, the men were not particularly interesting, so I sketched some of the boys instead.

We chatted and drank Bedouin tea out of glasses before returning to the tent for the night. As arranged, the next day Atala took us off into the desert in his battered old truck to visit some of the prominent features. I had explained my sketching methods and the need to stop at times. Jenny and I sat in the open rear of the pick-up truck – not the most comfortable place, but it had

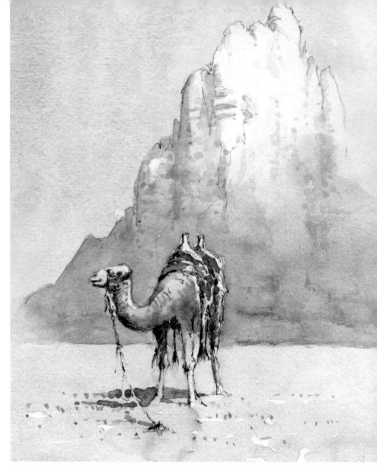

Camel at Wadi Rum
The background peak shows how many of the peaks of sheer rock displayed pale rounded tops that stood in complete contrast to the red sandstone lower down.

the tremendous advantage of allowing immediate 360-degree views without interruption. Our first stop was Lawrence's Spring. Through a siq on the north side of the impressive Jebel Khazali, we continued to explore a natural rock bridge at Um Fruth. A couple of Bedouins obligingly sat in the shade beneath the bridge, providing an indication of the scale of the great sandstone bridge. With the light showing up the crags and peaks to great advantage we painted in watercolour most of the time, for it would have been criminal to ignore such magnificent colours in both peaks and desert sand. In the shade of crags we worked away and ate lunch while Atala slept, until another Bedouin arrived to report a car breakdown. This appeared to be a common event, and unsurprising given the decrepit state of most of the vehicles and the severe wear and tear on them in this sandy environment. Atala disappeared in the truck for a while to sort out the chap's problem, so I decided to take a walk to explore rock scenery some way off.

When Atala returned, we set off again but soon ran into a sand dune which brought the truck to a halt. Several attempts to get the vehicle up the dune failed so we had to skirt some distance round the obstacle. It was easy to see why the trucks became so battered, as soon we encountered yet another obstinate dune. On the second attempt, Atala managed to get the truck to the top of the soft sand slope, then turned up a narrow defile. With so many rocky obstacles in the defile I wondered how the truck would fare, but in a rare display of caution Atala negotiated the rough bits without any wheels flying off, and soon we were ploughing through soft sand again and down another memorably bone-breaking slope. Heavy raindrops began falling as I sketched the distant Burdah rock bridge, but the resulting artwork didn't really suffer as I kept it fairly well sheltered under my *kaffiyeh*. Across a wide expanse of flat desert we drove in sheeting rain, both becoming saturated in the open truck, though when the rain stopped and subjects once more appeared, we forgot our lingering dampness.

Atala left us to set up home sweet home in a traditional draughty Bedouin heavy goat-wool tent in the lee of a huge crag, and didn't return with our dinner until long after dark. We spent the time painting the sunset, as the dying sun turned the crags to gold. The absolute silence of the evening desert while surrounded by magnificent red crags left a deep impression of a stillness impossible to find in Europe.

Not all the various bits of tent-fabric met, creating a bracing environment. Bedouin tents have separate sections for men and women. After learning from guidebooks that snakes in the cold desert night like nothing better than to cuddle up to you, one's imagination can run away, and with such delights common in Wadi Rum as Palestine vipers, Saharan horned vipers and other sand snakes, this did concern Jenny a little, but happily they stayed away. In fact we saw little wildlife at all.

During the night I crept out to view and sketch a full moon breaking through atmospheric cloud to light up the desert scenery but found no man-eating desert fox prowling around, the mythical creature of Atala's fertile imagination.

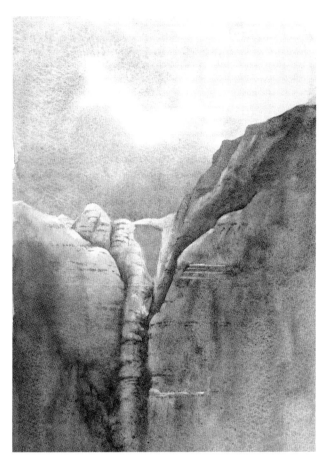

Rock Bridge, Wadi Rum

Several natural bridges and gaping holes in the crags added interest to the Rum peaks that soar up spectacularly from the desert floor.

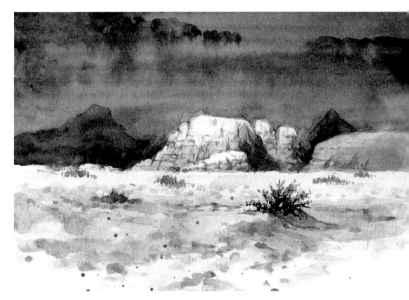

Storm over Wadi Rum

Threatening black skies at times struck a dramatic contrast to a light, sunbaked foreground.

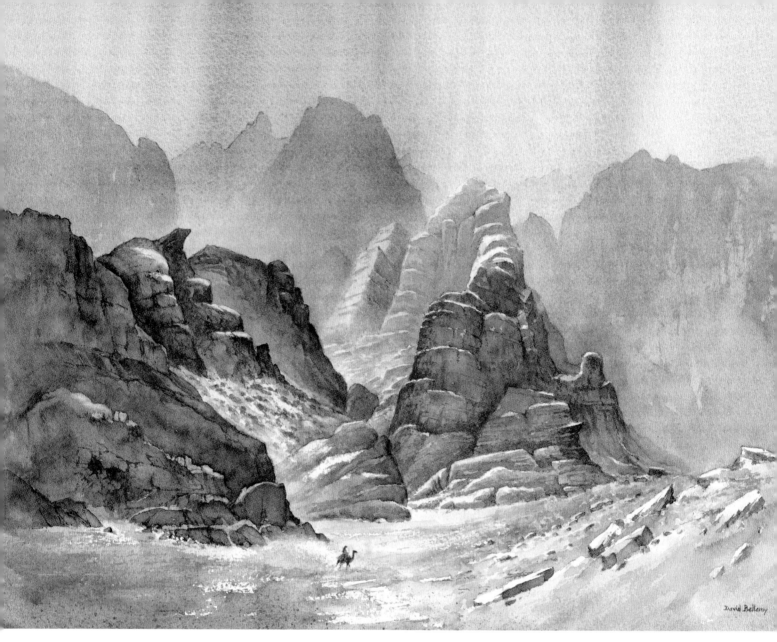

Towering Peaks, Wadi Rum

Scrambling up and over the crags of Wadi Rum brought an exciting new vista with almost every move; a combination of morning mist and strong sunshine adding to the sublime experience.

At times the visual sensation held me in such awe that I would forget the sudden falling away of a precipice, and only at the last moment stop myself from a dream-like plunge into oblivion.

By morning the truck's battery was flat. Atala had parked where it proved impossible for us to bump-start it so he had to hike off to search for help. We decided to walk to Lawrence's House, about halfway to Barrah Canyon, and told him to meet us there if and when he could manage it. My rough tourist map would probably suffice. Thankfully it remained cool in the early hours and we made good progress, occasionally slowed down by loose sand and the occasional drawing. After some time we turned north as the day became hotter and our pace slower. After a few more miles we climbed a gentle slope and arrived at Lawrence's House, a square black ruined building by a large rock. This is apparently where Lawrence stayed from time to time during his campaign against the Ottomans. Leaving a bright scarf in a prominent position, we retired to the rear to paint in a sheltered position as the sun was now at its fiercest.

A lone camel-rider passed in the distance, and quickly became an integral part of my sketch. He sang as he plodded slowly up the valley with the bulk of shapely Jebel Saifan in the background. The sand noticeably changed

colour across the valley in pleasing bands: pale yellow sand changed to pink or even deep red in places, with areas of light to dark greys caused by a mixture of sand and stone.

As I completed the sketch, Atala drove up in his truck. We piled in and after a short drive reached a Bedouin camp owned by Sheikh Mohammed al Pluoy, a cousin of Atala's father. Invited in for tea, we met the sheikh, his wife and two mischievous grandchildren. They were happy for me to work on portraits of the sheikh and the boys while we chatted and drank the sweet, refreshing Bedouin tea.

Bidding them 'masaalama', we sped off towards Wadi Barrah where Atala dropped us off so that we could hike along the canyon. At first the welcome breeze kept us cool, but as we moved further into the confines of the canyon, the high sides became a heat-trap. Although we kept in the shade as much as possible, there were long stretches where we were exposed to the intense heat. With rocks of many colours and shades, a veritable cornucopia of subjects assailed us. At one point the lightness of the distant summit rock appeared deceptively like snow against a slightly darker sky. Many small trees and stunted vegetation grew in the canyon. At the far end of Wadi Barrah the cliffs closed in to form a breach resembling an enormous gateway, and there in the shade we found Atala.

Following a lazy lunch Atala drove in the most frenzied fashion towards Wadi um Ishrin, the truck bouncing around alarmingly. This was a fine way of finding painting subjects quickly while wrecking the truck on a rock or two. How I wished to be on a camel, quietly absorbing the scenery that left us spellbound. Stark black crags stood out fiercely against hazy distant *jebels*. Many cliffs were capped with an incredibly handsome array of high notched columns, and red rocks sculpted and broken into weird shapes resembling birds, dragons, faces, monsters, or whatever the imagination could conjure up.

Atala's mad rush continued and once more he abandoned us at another Bedouin tent, though by then we were used to his little ways, and indeed truly welcomed the truck breakdowns as this afforded us quiet contemplation of the landscape. Towards evening, we were gladdened by the appearance of Atala's fourteen-year-old brother Matayo when he arrived with two camels, our transport in the morning.

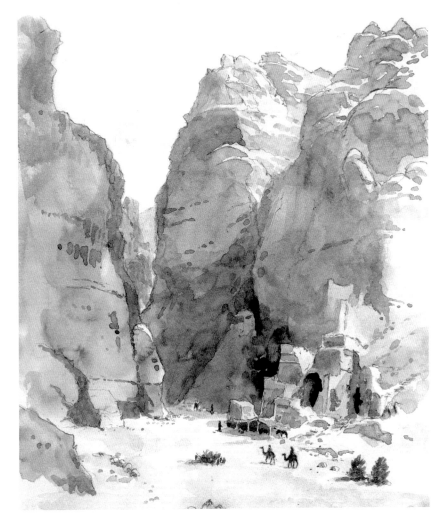

Outer Siq, Petra
A watercolour sketch done in a cartridge sketchbook around midday, with more Bedouin around than tourists.

Bedouin Encampment, Wadi Rum

Wadi Shelaali

I sat alone relishing the cool evening temperature as I sketched the magnificent rocky architecture with watercolour pencils. Well into the sketch, a herd of goats tumbled down the steep slope, and thankfully I still had enough room to fit them into my composition. Sudden intrusions into a scene can inject lively interest: something I've found fairly common in Middle East countries.

A strong mist hung over the mountains next day. In swarming layers of ragged shapes, the grey ridges warmed in colour temperature as they got closer. Patches of pale sunlight spilled dramatically across the desert floor to cut the distance away from our foreground in true Tolkeinesque fashion – I half-expected fantasy armies to appear. Atala and Matayo prepared a splendid breakfast of hot bread, olives, cheese, humous, extremely runny cherry jam, and tea. We then loaded our gear on the truck and Atala shot off with characteristic breakneck speed, while we happily mounted our camels and began a more sedate and contented amble to Wadi Rum Village.

Mounting the camel can be slightly alarming for the unwary, for as it rises on its hind legs, you pitch forward – hopefully not over the camel's head – and then immediately are jerked backwards as the front legs rise. Camels always appear to be ungainly creatures, and apparently are notoriously incompetent in sexual matters, often needing the assistance of their owners to direct the vital appendage into position. My camel stood gleaming white against the drab greys and sand-coloured desert, with long woollen tassles, dyed brilliant colours, hanging down to the beast's knees.

Crossing the desert on camels proved a delightful and peaceful contrast to Atala's manic driving. The landscape unfolded slowly before us in an atmospheric haze devoid of any signs of life. Above us, the *jebels* gleamed ghost-like through the haze, in places their pale domed tops shimmering while lower down their edges blurred into shadow.

A lone camel rider passed by. It occurred to me that men had been travelling this way since ancient times, and such thoughts conjured up a dreamlike feeling of riding in the camel-steps of Lawrence as he exhorted his legions forward.

On her long desert rides Jane Digby (see page 14) found she could read and write on her camel to pass the hours. The cameleers amused her by the way they sang affectionately for their camels. Although carrying out a full watercolour on the back of the camel would have been a challenge (but not impossible), I managed to sketch as we rode along without any need to dismount.

Thankfully our camels were well-behaved creatures, not given to rash Atala-like excesses of speed, and the long gentle swaying induced a soporific effect.

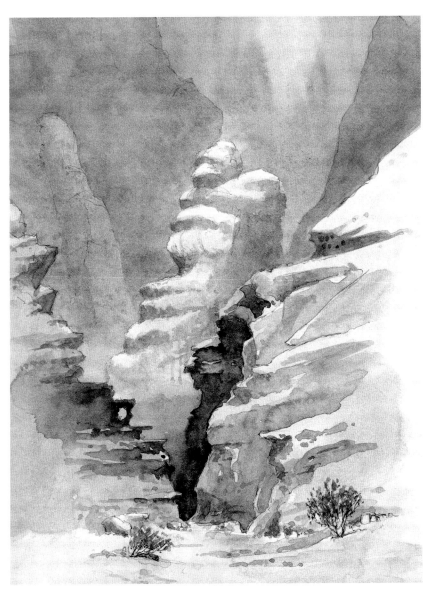

Kharazeh Canyon, Rum

As we approached Rum Village, with its white buildings standing stark against the sombre soft-edged background, some locals wandered by picking up litter strewn across the main desert route. I half expected someone to appear with a vacuum cleaner.

Before leaving Wadi Rum I managed some time alone to explore Kharazeh Canyon and found a promising path threading through rocks, climbing gradually. Traversing a boulder field to the right I climbed to where sunlight touched the rocks, and where I suspected a vertical gully lay hidden. Sure enough, a narrow gully ran up the face, with excellent holds and copious goat-droppings on the horizontal surfaces. Eagerly I climbed Goat Gully, and at the top found a flat area of rock beneath an impressive array of cliffs. To the right, great rounded cliffs of strident reds and ochres invited exploration in the direction of Rakabat Canyon. To the left, round some crags, lay the mighty cleft of Kharazeh Canyon. Which way to go? Every route held exciting prospects and I also needed to sketch these phenomenally picturesque scenes. I turned left, where I was reasonably sure of an outstanding subject. Easy scrambling and a traverse across solid rock led me to where I could view the grandeur of the entrance to the canyon. Using watercolour to capture the fiery colours I sat in quiet awe of these untamed heights, feeling rather smug that I'd escaped everyone for the first time in Jordan. No local had followed me or entreated me to act as my guide and at last I felt at peace in this incredible place, in my true element. I moved to another ledge to ponder in wonderment over views across to distant Rum Village, and the most deliciously-formed cliffs of violent reds and sepia tumbling to the desert floor.

OMAN

Call of the sunset canyons

Rugged mountains, wild coastlines, immense canyons plunging into unseen depths, dramatic forts, villages clinging to the edge of cliffs, raw desert... A wealth of outstanding scenery gives Oman a spellbinding aura for those who love the outdoors.

Until the mid-1970s, and despite the encroachment of the oil industry, the country was largely unknown. Most Omanis lived as they always had done, with a constant state of tribal rivalry. All that changed when Sultan Said was deposed by his son. The new Sandhurst-educated young Sultan Qaboos immediately brought a modernizing influence to bear on the country, but he also had the foresight to salvage as much as possible of the old Oman through the newly-formed Oman Historical Society.

Visiting in 2010, our final descent into Seeb Airport revealed jagged peaks that immediately reminded me of the barren rocks of Aden, further along the coast of south Arabia, and it stirred up a sense of wild anticipation. I deliberately avoided the large tourist hotels so that we could base ourselves in the attractive harbour town of Mutrah, where there was much to explore and sketch.

Oman has a rich seafaring heritage going back way beyond the early Portuguese explorers who built many of the striking forts that adorn the craggy eminences along the coast. Mutrah Fort, hanging high above the harbour in a commanding position caught my eye, a handsome stronghold that looked absolutely impregnable. It quickly became one of the first set down in my sketchbook.

THE OMANI COAST AND PORTUGUESE RULE

From around the 8th up to the 16th century, Arab mariners operated some of the longest sea routes of the time from these shores, controlling the maritime trade from the East African coast to the Far East. In the early 16th century, however, the Portuguese arrived on the scene, and began a brutal domination of the lands around the northern Indian Ocean. Muscat was ransacked and the Arab shipping destroyed by Afonso de Albuquerque (1453–1515) who continued his pillaging around the coast. The Portuguese built the forts of Jalali and Mirani at Muscat, but they were continually under threat – not only from Omani, but also from Persian, Turkish, Dutch and English forces.

It was not until the mid 17th century that the Portuguese were finally ejected. Their influence remained, however, in the construction methods of the dhows, with nails being introduced to replace the former sewn methods that used fibre to hold the planks of the hull together. (Some dhows, such as the *sambuq*, retain the sewn method of hull construction.) Transom sterns were another design based on the European vessels, although dhows such as the *boum* retained their double-ended form, coming to a point at both ends.

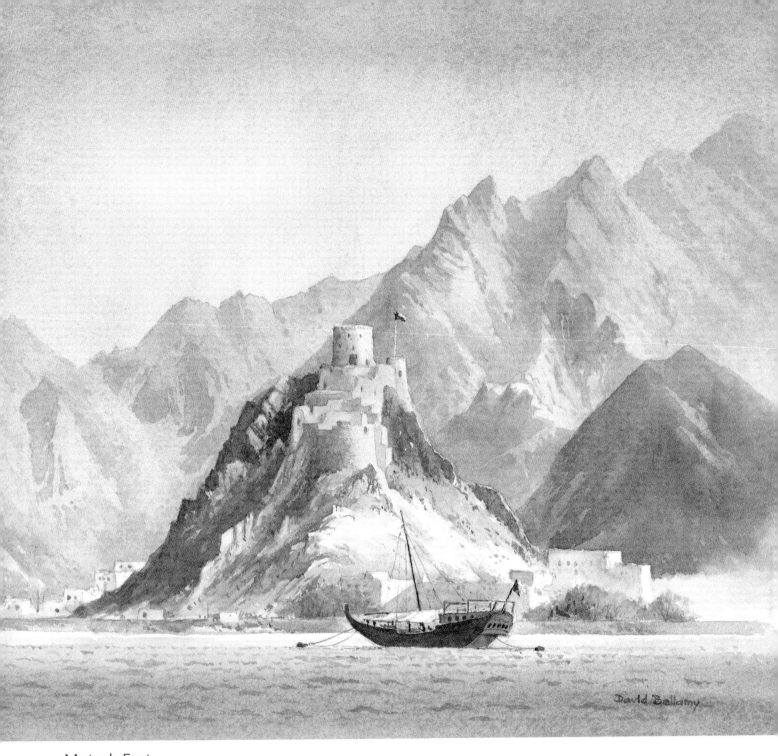

Mutrah Fort

Standing high above the broad sweep of the corniche is this romantically perched fort, built by the Portuguese during the 16th century.

Omani *ghanjahs* were once common around the Indian Ocean ports. Built at Sur on the south coast, these dhows featured attractive carvings, especially on the wide transom sterns with decorated wooden pillars between their windows. Unlike the European tradition of giving ships female names, the Arabs tend to vary theirs. The *ghanjah* vessels are regarded as female, but the *boums* as male – predictably perhaps, the *boums* are not only the largest of the dhow types, but boast a massive phallic-like bow projection.

These waters once teemed with traditional craft trading with many Arabian ports, as well as those further away in East Africa and India. Nowadays the few dhows that breeze into the harbour are genteel, elegant, highly-polished tourist vessels aimed at fishing, dolphin-watching, scenic excursions and other pursuits.

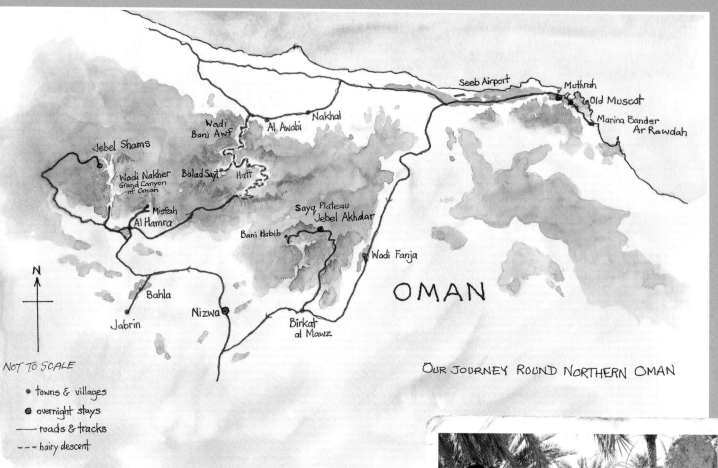

Map of Northern Oman

The map shows the following labelled locations:

Seeb Airport, Muthrah, Old Muscat, Marina Bander, Ar Rawdah, Wadi Bani Awf, Al Awabi, Nakhal, Jebel Shams, Wadi Nakher Grand Canyon of Oman, Balad Sayt, Hatt, Sayq Plateau, Jebel Akhdar, Misfah, Al Hamra, Bani Habib, Wadi Fanja, OMAN, Bahla, Nizwa, Jabrin, Birkat al Mawz

N

NOT TO SCALE

OUR JOURNEY ROUND NORTHERN OMAN

- towns & villages
- overnight stays
— roads & tracks
--- hairy descent

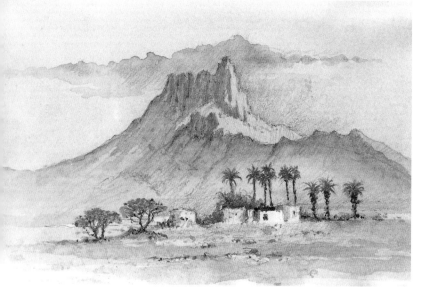

Sketching assistance from the local kids

Shapely peak on the plain

Numerous handsome peaks and crags rose above the central plain. This one caught my eye as the lowering evening sun lit up the western-facing slopes.

MUTRAH

Placing a dhow sailing beneath Mutrah Fort in my composition was almost obligatory, though I felt the urgent need to knock it about a bit to appear like the more rustic specimens I had been familiar with in Western Arabia and East Africa, where torn sails with gaping holes, threadbare ropes and ungainly bits hanging over the side were normal fare – and where you would often pray that the boat held together till you returned to shore. In Mutrah, everything afloat seemed modern, and badly in need of a little misinterpretation by the artist.

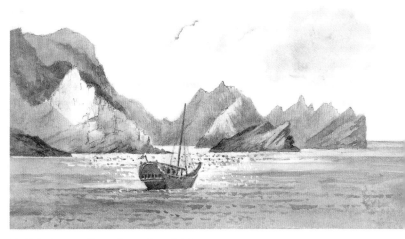

Wild Coastline South of Muscat

The vessel had the lines of a ghanjah, *with its galleon-like stern. It was probably an old traditional Omani boat converted for tourism. I saw no sign of an outside toilet-seat slung over the side, which no doubt would have left many European tourists somewhat non-plussed.*

The beautifully decorated main mosque, with its soaring minaret, lent an air of eastern mystique to the harbour, especially when evening backlighting cast a tranquil mood over the town. Many a hidden architectural gem suddenly became illuminated by a flash of reflected light as the sun made its rapid descent; images that almost always seemed to dance provocatively away before I could capture them on paper against the cirque of craggy background peaks. Jenny, meanwhile, had produced a brilliant watercolour of the mosque from across the harbour. The golden crescent adorning the cupola momentarily glimmered in the last rays of sunshine, then night descended.

After dark the *souk*s come into their own. I would hang around in shadowy spots to sketch the passing characters. Some would stop and chat, and unlike many other Middle Eastern countries, even the ladies would take an interest in what I was up to: why did I carry a lamp attached to my head? One offered her opinion on the hat I was trying on, while another young lass offered me some of her popcorn. Meanwhile Jenny had found a *burqa*-clad doll that ululated loudly when you gave her a squeeze.

Jenny sketching the canyon in evening light

Eventually extreme hunger curtailed my sketching, but even in the restaurant the sketchbook did not take long in getting back into use. Many of the cafés provided outdoor seating that enabled us to sketch away whilst drinking a coffee. At one café I drew a watchtower perched halfway up a steep rocky ridge, using a watersoluble pencil. Alas, I'd run out of water, so resorted to dipping my brush into the cappuccino to work into the watersoluble graphite tones – at which the Sudanese fellow chatting away beside me exploded with laughter.

Views across the harbour invited further compositions, but sadly few dhows swung at anchor as another celebrated Arabian icon is relegated to museum status.

The many exciting sights of Mutrah provided a wealth of outstanding images, but without doubt it was the natural scenery of the spectacular Omani mountains that set my inspirational pulse on fire, scenery that no traveller can ever forget. Hardly had we driven far out of town than wild, dramatic landscapes took over, holding me spell-bound. I sketched continuously as we drove along, a method I'd improved over many occasions when only fleeting glimpses of a scene caught the eye. When a particularly impressive subject appeared I called a halt, but had we stopped for every subject we'd never have got anywhere. Ali, the driver was a patient guide, full of information, who introduced us to many interesting locals in various places.

Jebel Akhdar

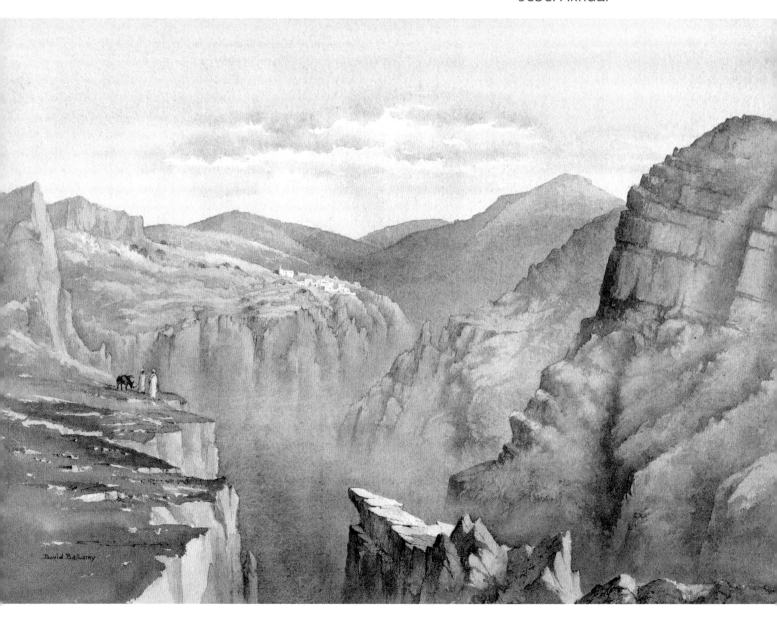

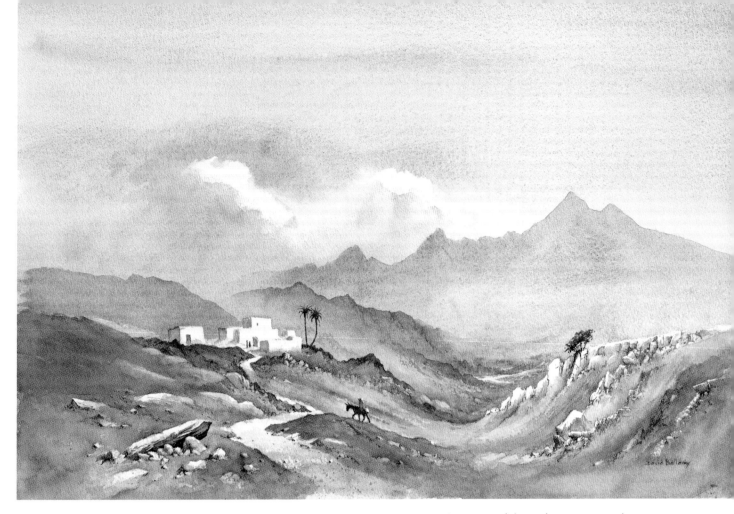

NIZWA

At Nizwa, the main town in the interior, over-spilling with pots of all shapes and sizes, we stopped for lunch. Nizwa was once the capital of Oman, where many of the ancient caravan routes converged. After lunch we explored the impressive fort where a reporter from Oman Radio accosted me for an interview.

In the afternoon we drove up the steep slopes of Jebel Akhdar, where we would stay the night. The sketching continued until the lengthening shadows of evening flung moody depths into the great canyon before us, intensifying the colours. Perched high on warm rocks we painted the violent sunset, while bursts of warm sunbeams streamed across the great canyon, before dying into the mass of purple twilight where mountain ridges melted into swarming clouds. The day evaporated into the mountain silence following a dramatic end to the day.

We began the hike next day at the village of Al Aqur, famous for its roses and dizzily perched on the rugged rim of a stupendous canyon. To one side, directly beneath the houses lay several monstrous rocks, so precarious that they seemed about to plunge into the unfathomable depths of the gorge at any moment. We left Ali and set off along the rim of the canyon.

Approaching the mountains
near Wadi Fanji

Bin Ateeq

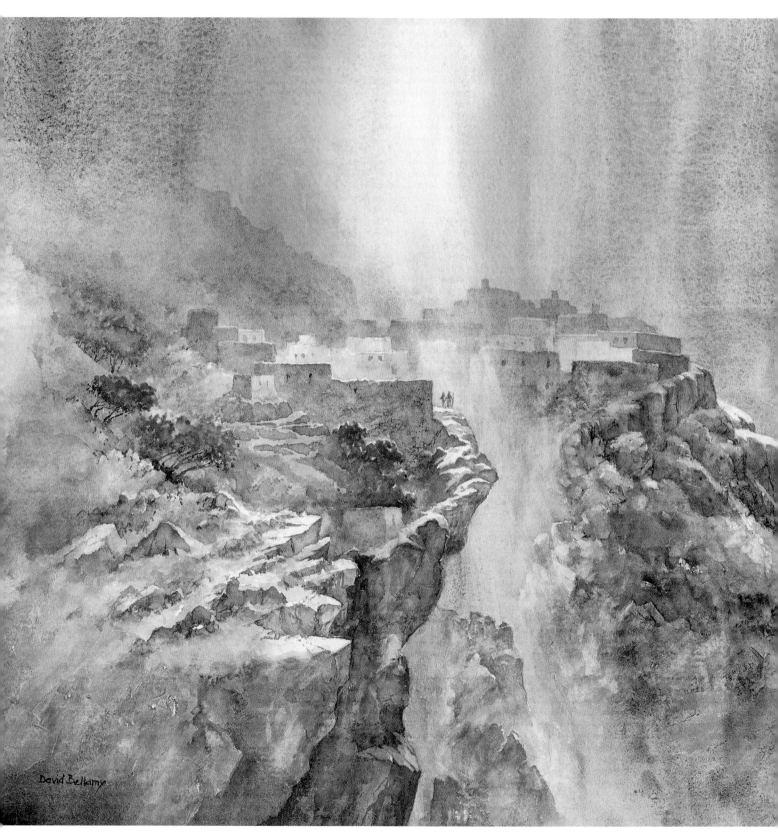

Al Aqur Village

This village stands in the most sublime situation on the very rim of the canyon, with many of the crags seemingly about to crash down into the void.

Each turn unfurled new scenic delights dissolving into distant haze, framed on either side by handsome crags that rose high above the surrounding plateau in places. No sketch could do this immensity of sublime nature true justice. We dropped several hundred feet before climbing again past narrow crop-laden terraces cascading down the less precipitous slopes which were punctuated by pomegranate, peach and apricot trees. Creating these terraces must have been a monumental task, having to carry soil across the vast plateau on donkeys, while toiling on such vertiginous gradients. We passed through a number of villages.

Characters around Bahla
My notes from this sketch read 'Most dishdashas are white, but many are fawn, light blue, grey or green'.

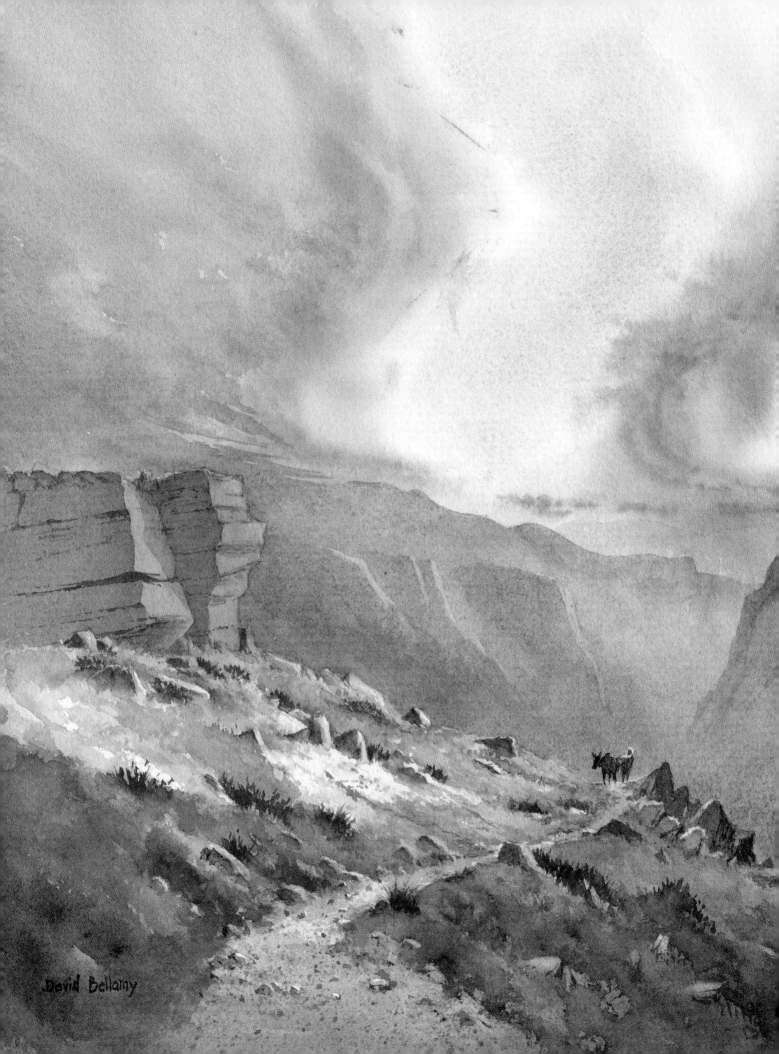

David Bellamy

A green spring appeared by the track, feeding a *falaj*, a narrow irrigation channel that meanders through the villages, in places dropping steeply. One of the villagers removed a rag and some stones from a notch in the side of the channel to allow water to flow into his field. Once this watering of his crops was complete he replaced the rag and stones. This brilliant low-tech system has worked for hundreds of years. Local crops include grapes, peaches, apples, walnuts, pomegranates, apricots, figs and lemons. The route continued to fall hundreds of feet into the canyon, but still views of the bottom remained elusive. As we began to get concerned that we were losing too much height and might have missed a change of route, it turned back upwards, quickly becoming uncomfortably steep.

These fascinating locations, where a painting subject absorbs your attention at almost every step, are the most delightful places to get lost in. You just carry on enjoying yourself until eventually you need to face the conundrum of finding the proper route again. We followed a dried-up *leet* upwards, often needing to use hands to keep a balance, and sometimes made even more awkward by having to carry a still-wet watercolour until it completely dried.

A pair of white vultures circled haughtily above, enormous all-white birds apart from black edges on their wings, drifting on thermals in search of something appetizing. In the next village, Ali awaited our arrival, which had been much delayed by all our sketching and stopping to engage with the locals.

Mule track on the Sayq Plateau

Warm evening light pours between the peaks on the canyon edge as the lower reaches melt into a Stygian gloom.

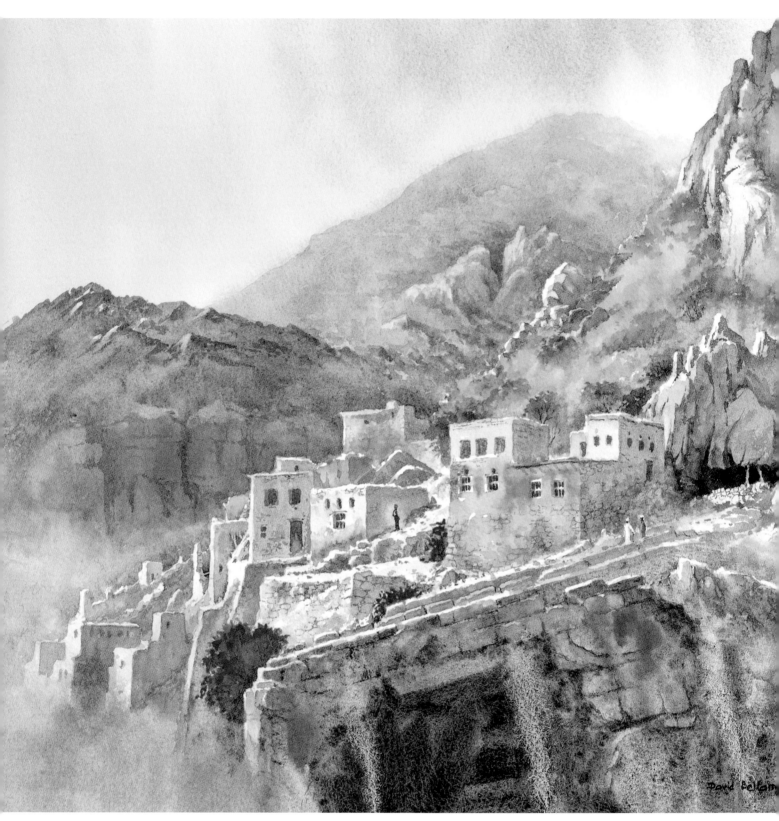

Bani Habib Village

This former rebel stronghold is now abandoned, perhaps sadly for the romantic, but happily for those who lived there, as it would be a pain to reach with bag-loads of shopping. The SAS attacked the rebels in the village and its caves during the battle for Jebel Akhdar in 1958.

BANI HABIB

The now-abandoned village of Bani Habib stands dramatically perched above a drop into the gorge below. Tentatively we explored the fascinating ruined buildings, for in places the structures looked anything but stable. Apart from the odd dust-laden wooden bed frames and detritus, these were bare. The villagers had all been moved to more modern housing out on the plateau, linked by a modern road. Previously, they faced rough steps descending steeply into the gorge, crossing the stream at the bottom, then climbing up a great many more steps on the far side before reaching any semblance of a decent road.

Happily, climbing to a position opposite the village provided us with a magnificent vantage point for sketching the buildings. Up on the plateau, extensive views of the vast canyon and plunging cliffs stretched into the distance. This is a sight not to be missed at sunset, when all the elements seem to coalesce into a mythical dream: we sat watching the lowering red orb start to edge into the mass of mauve atmosphere, the air balmy. No wind stirred as a distant *muezzin* began his slow, melancholy call to prayer across the vastness of the gorge, a beautiful sound breaking the silence. He was answered by another wavering call from a different village on the edge of the precipice, then yet another, echoing the haunting call across the darkening void. We sat sketching, mesmerized not just by the view but the sound of many *muezzins*, the poetic calls blending harmoniously in unison, adding to the mystique and romance of the Arabian night till they faded into the mountain silence. I touched the warm rock to see if this was real – yes, every sense induced a strong feeling of contentment. I knew I would remember these moments for the rest of my life.

The Jebel Akhdar War

Jebel Akhdar witnessed much fighting before Oman became a stable entity. In 1957 Talib bin Ali Alhinai, brother to the Imam of Oman (at that time only to the interior of the country), returned from Saudi Arabia with hundreds of well armed fighters. This encouraged Sheikh Suleiman bin Himyar of the Bani Riyam tribe to foster a general uprising against the sultan. The rebellion flagged when troops from the United Arab Emirates, backed by three companies of the Cameronians and some Ferret scout cars of the 13/18th Hussars, arrived with Royal Air Force support, at which point Talib retreated his forces into the mountain vastness of Jebel Akhdar. The sultan's army at this point was easily repulsed by the rebels, who were emboldened to carry out raids on areas beneath the mountain. This went on for two years.

It seemed that only a full-scale assault by a British brigade would be able to pacify the rebels. In late December 1958 it was decided to mount an operation by the British Special Air Service Regiment supported by RAF aircraft. The rebels comprised a mixture of several hundred well trained troops and well armed mountain tribesmen of fearsome reputation, the total numbering between 2,000 and 5,000. Against this SAS D Squadron mustered around sixty, a third of which comprised cooks, bottle-washers, clerks, drivers and other support staff. Half the SAS force climbed the north side of the Jebel with a local guide, and the other half climbed the south side. Both groups reached the Saiq plateau in good order. The rebel stronghold at Aquabat al Dhafar, a natural rock fortress standing on fifty-foot sheer cliffs, had never succumbed to attack before. The SAS men attacked it at night and after a short battle the defenders melted away.

Reinforcements were brought in to clear Jebel Akhdar of the rebels. The arrival of A Squadron doubled the size of the SAS contingent and to these were added soldiers of the Life Guards. The SAS climbed up to the village of Bani Habib which clung to rugged slopes a few hundred feet below the plateau lip. Regarded as one of the main rebel strongholds, with its series of caves, Bani Habib actually held few rebels, and after a brief firefight the place capitulated. By morning the SAS were up on the plateau. Here they were supported by RAF Venoms that shot up rebel positions. Valetta transport aircraft then dropped supplies of ammunition, water and food by parachute. On seeing masses of parachutes, the rebels mistook the dropping supplies for paratroop reinforcements and took to their heels. The campaign was over. Sheikh Suleiman went into exile in Saudi Arabia.

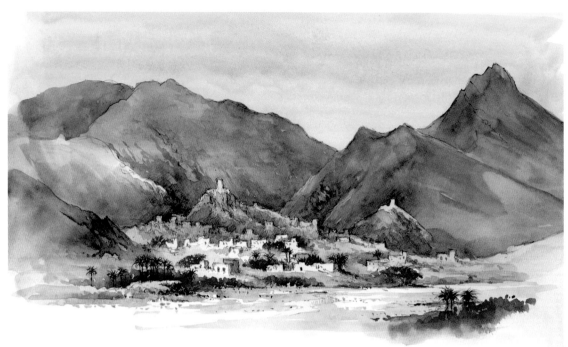

Wadi Fanji Village

Nizwa Spice Market

When we drove down off the plateau, Ali stopped to pick up a young man who was hiking down the road to give him a lift. Ali had left a copy of *OK East* magazine on the seat, and the lad picked it up and thumbed through every page, becoming increasingly goggle-eyed at the explicit photos of naked women. After meticulously studying the whole magazine he put it down, his hands shaking, and said in English,

"After seeing photos I must go to mosque to pray urgently!"

In the late 1940s Wilfred Thesiger made another of his epic journeys southwards down the western edges of Oman by camel, skirting the notorious Umm as Samim quicksands and ending up on the Indian Ocean coast, while surviving many encounters with hostile tribes. He tried to gain access to Jebel Akhdar, only to be denied every time he tried. Even though some tribes were friendly, travel for Europeans in Oman in those days was extremely risky. We felt privileged to be able to witness the remarkable scenes of this mountain utopia.

At Birkit Al Mauz a coffee shop beckoned. As it had a splendid view of the castle, I sketched as I sipped the coffee. After a while a National Biscuit Industries truck pulled up, completely blocking my view. The driver looked at me, saw what I was doing and as I raised my eyebrows meaningfully he grinned and kindly moved out of the way.

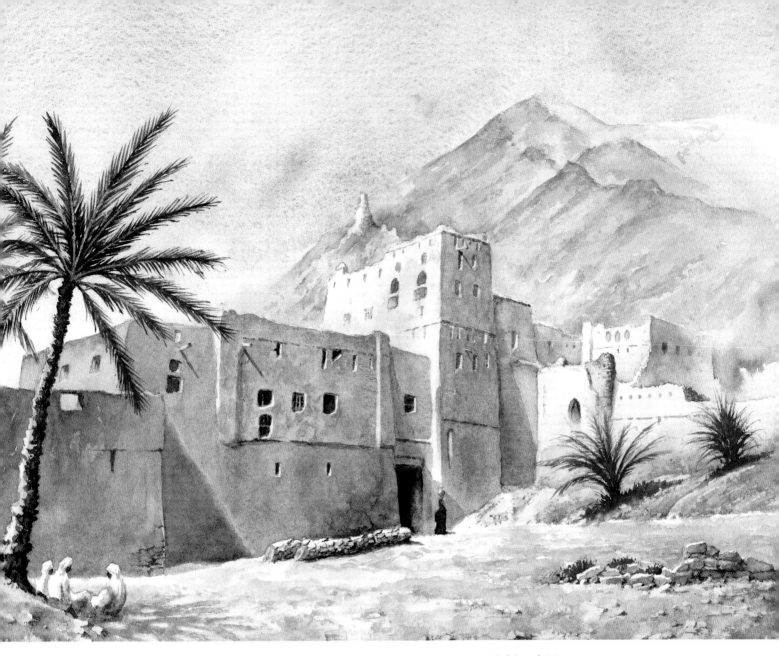

The old part of Birkit comprises crumbling, abandoned dwellings, much of it semi-ruined, yet fascinating to explore. Some of the houses rise several storeys high, and many scenes demanded deep concentration to capture all the intricate details. Only one dwelling seemed to be occupied, a tumble-down corrugated iron shelter on the very edge of disintegration amidst the ruins, incongruously adorned by a satellite dish, with an Arabic television soap clearly audible inside. Nearby lay the palmerie where colourful roller birds the size of magpies flitted high amidst the palm trees. Their brilliant turquoise plumage gleamed like jewels as they flashed by in the sunlight. We spent some time observing them, and though Jenny would have loved to sketch them, it proved impossible as they hid among the palm fronds.

Birkit al Mawz

This is the old part of town which evokes Biblical associations.

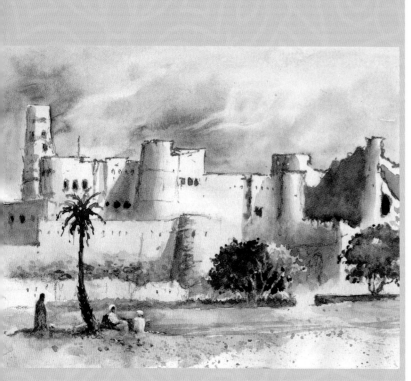

Bahla Castle

This is only a part of the magnificent castle which dominates the town. Some parts are pre-Islamic. This is what we were sketching when Ayah the Terrible turned up and shattered the peace.

Little Ayah

My portrait of Ayah was a reasonable likeness, especially considering that she ran around flaying her little brother most of the time, but she did take some time off from dishing out the thrashing to help me with the surrounding effects, with yellow obviously being her favourite colour.

Most of the Omani towns and villages boast a castle or some fortification. The one at Bahla is huge and every child's dream of a typical castle with many towers. We sat in the shade of palm trees in an open area sketching a particularly impressive part of the structure when three children wandered into view. The eldest, a girl of about seven or eight, pushed an empty buggy. She was accompanied by a younger girl and a much younger boy who smiled and waved to us. He came over and with the extreme seriousness of an authoritative grown-up, shook our hands. Ayah, the elder girl, lost her cool. She called him over, scowling daggers at us as she tried to force him into the push-chair. She whacked him hard with vicious blows, and twisted him over the buggy, continuing to thrash him mercilessly. At this point Jenny came to the rescue by asking the children if they would like a sweet. Ayah circled warily, like a vulture with one eye on its prey and the other on this new threat, but after her brother had stuffed down several sweets she lost her reserve and even smiled. This broke the ice and soon she was studying my sketch. As I continued to sketch her she wanted to join in the fun, so I let her loose with my watercolours to help me with my rendering, though insisting that she kept clear of my portrait as I was rather pleased with the cheeky image I'd painted of her. She did rather well in applying colour and surprised me when she cleaned the brush into water before mixing a new colour to paint a yellow flower. The younger girl then joined in, mashing one of my expensive sables into cadmium yellow, right up to the ferrule – a technique more pertinent to artificial bovine insemination than traditional watercolour methods.

At this point, a commotion nearby caught our attention. A policeman was trying in vain to stop motorists proceeding along the street as the King of Sweden and his entourage were due to pass through on the way to Jabrin. Cars were trying to get out of the castle car park where we sat, and from a minor road opposite, so the copper had his work cut out trying to keep an eye on all routes. Vehicles kept sneaking past behind him, while he whipped round, yelling and shaking his fist at the departing vehicles. Eventually the king's entourage drove past, some fifteen to twenty cars plus police escorts.

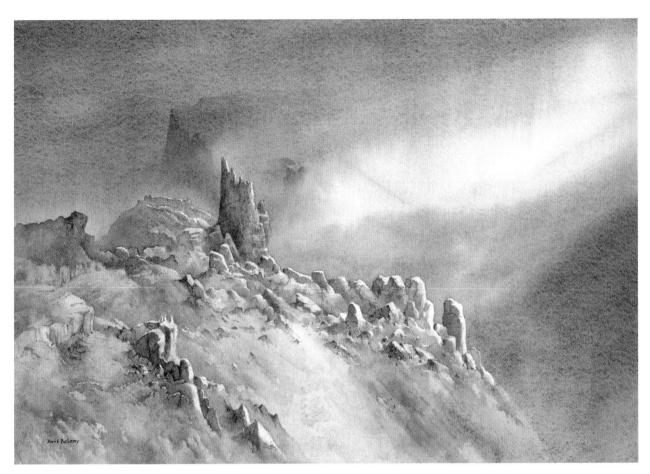

Al Rogan Fort, Misfah

Oman is littered with thousands of forts, castles and strongholds, some of which are only evident when you are close by, as this one above the mountain village of Misfah. The main crag rising above the edge of the gorge is topped with an old ruined fortress. I created a powerful atmosphere of early morning mist to highlight the fort, which otherwise is almost lost in the background mountain.

That evening we enjoyed a traditional Omani meal in the Bin Ateeq restaurant, sitting in a private room on cushions and carpets scattered around the floor with our plates of food also on the floor. Jenny found this most uncomfortable, but enjoyed her fish curry. I declined the boiled intestines with onion and spices, and pondered over the fried locusts. The desert locust was a dish much favoured by the eccentric 19th century traveller Wilfrid Blunt (1840–1922), though he insisted that the creatures were boiled, dipped in salt and the legs removed.
I eventually plumped for the *dijaj khasoosi*, a delicious meal of small chicken slices, ending up with dates, Omani coffee and a distinctly aching bottom.

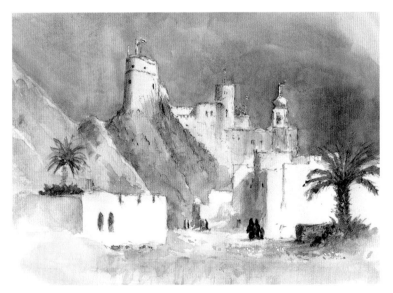

Al Mirani Fort from Lane 9518

The fort was built by the Portuguese in the late 16th century.

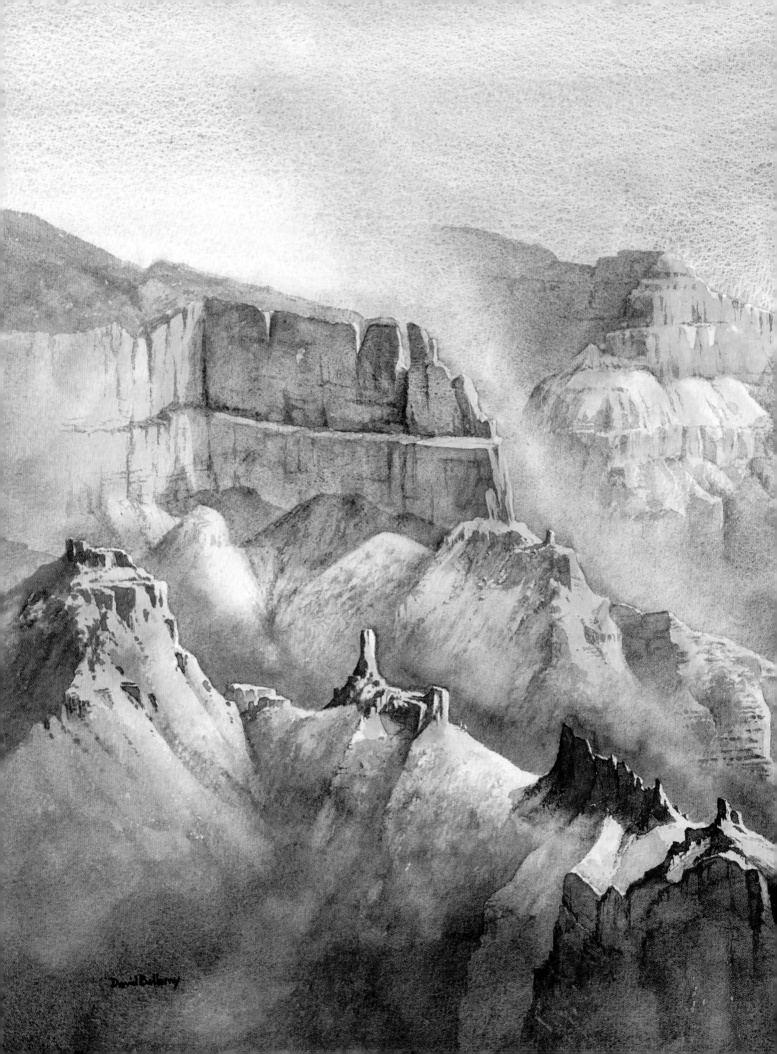

David Bellamy

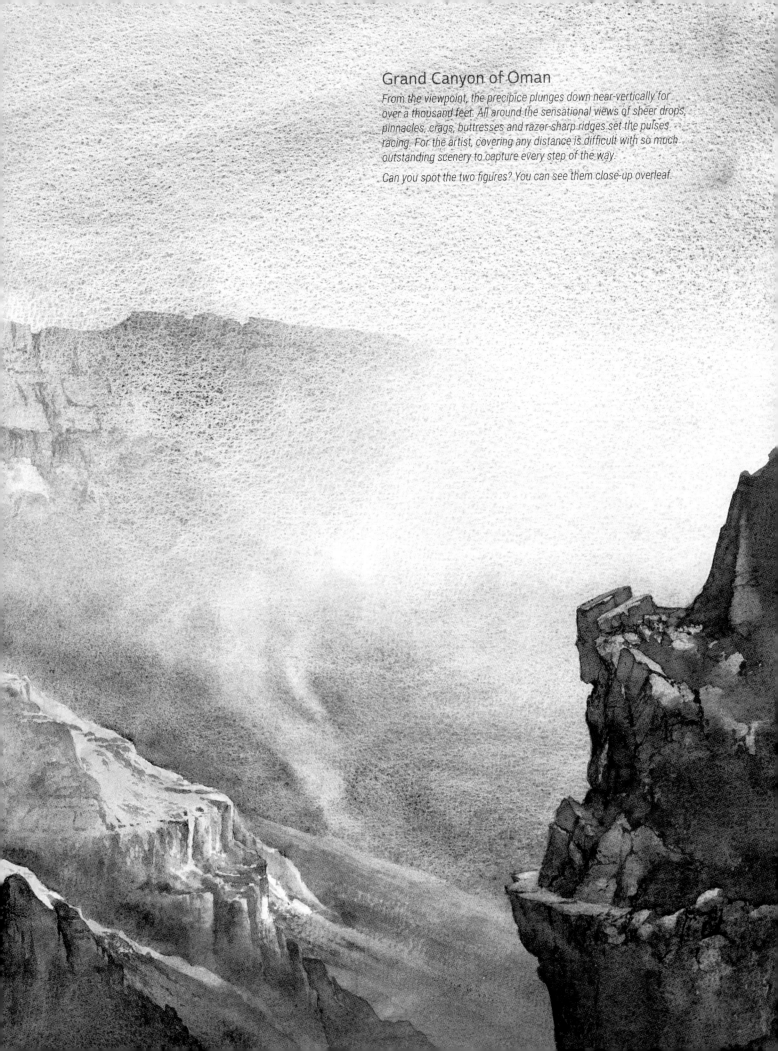

Grand Canyon of Oman

From the viewpoint, the precipice plunges down near-vertically for over a thousand feet. All around the sensational views of sheer drops, pinnacles, crags, buttresses and razor-sharp ridges set the pulses racing. For the artist, covering any distance is difficult with so much outstanding scenery to capture every step of the way.

Can you spot the two figures? You can see them close-up overleaf.

Figures on the ridge of the Grand Canyon of Oman (detail).

WADI AN NAKHAR

North-west of the town of Al Hamra lies Wadi an Nakhar, the Grand Canyon of Oman, one of the most spectacular landforms in the country. The wadi begins low down as a narrow breach in the mountain. Four-wheel drive vehicles can negotiate the bed of the wadi but it is far more interesting to hike. Sheer rock walls of ochres, oranges and reds rise on either side, in places allowing stunning views of the crags and buttresses higher up the cliffs, their features softened by the dizzying height while the wadi itself displays luxurious vegetation that offers some relief from the sheer wildness of the rock scenery. Deep pools of still water reflected these images. I spent hours sketching here, enraptured by the sublime scenes. The wadi climbs some 2,000m (6,500ft) into the vastness of the mountain until it opens out to its full grandeur, best viewed from high up on the rim of the plateau. Up on the plateau we found a wild, barren landscape of grey-green karst with a sprinkling of twisted junipers. Vertical cliffs plunged down, the immensity of the place taking our breath away.

On the far side Jebel Shams, the highest mountain in Oman, rises to some 3,048m (10,000ft). Its soaring ridges are festooned with jagged pinnacles and cliffs riven with enormous gullies, framing one of the most sublime mountain scenes in Arabia. Here and there juniper and wild olive trees soften the harshness of the rugged scenery, but not a shred of cultivation spoils the supreme savagery. This immense sublimity would truly hearten the brush of Salvator Rosa (1615–1673) the Italian painter renowned for the utter horridness of his rock-strewn scenery, often peopled by bandits and characters of the most savage countenance. All this had caught me unprepared, for I would need much more time to do this place justice with my pencil. As we hiked on each step brought new gasps of astonishment and wonder. A couple of goats attached themselves to us, presumably hoping my rucksack was full of goat-goodies. We spent several hours sketching in wonder, with mesmerizing subjects at every point of the compass, our watercolours struggling to render this enormous beauty. Such beauty can be elusive, but when it hits you with this intensity you find it hard to respond convincingly, so it is little wonder that so many modern artists prefer to seek out the ugliest, most revolting subjects imaginable.

Evenings up here are a time to relish. However tired you are the sheer inspiration of being in this monumentally spectacular place, in the electric atmosphere of mountain vastness and colour, keeps you entranced by nature in its most dramatic manifestation.

Painting watercolours at sunset, especially when punctuated by camera work, is prone to messy results, as you have to work fast, while the paint is slow to dry. An unwary brush-stroke can cause washes to run into one another where you may not want that to happen. To stay ahead of the game I try to draw in some of the most vital features of the scene before the actual sunset effect begins, otherwise the pencil has to be abandoned and I work directly with paint from the word go. Watercolour pencils greatly enhance the speed with which the washes can be controlled, simply by drawing into the wet washes, and this is especially effective where you need to correct a wayward wash. Obviously with a sunset scene it is vital to work in colour rather than just pencil. By this time I had lost count of the many brilliant sunsets I'd witnessed in these mountains.

Slowly the shapely peaks became redder, the plunging precipices a deeper purple as they gathered that magical atmosphere of mysterious darkness. Rocks flushed pink and rose-coloured as they caught the last glimmer of warm light in the dying glow. Stark crags took on a more menacing countenance as their detail blended into dark silhouettes against what was left of the light. Then all the light had gone, dark as the menacing gloom of Tartarus, leaving us to blindly grope our way back across the rock-strewn plateau to our base.

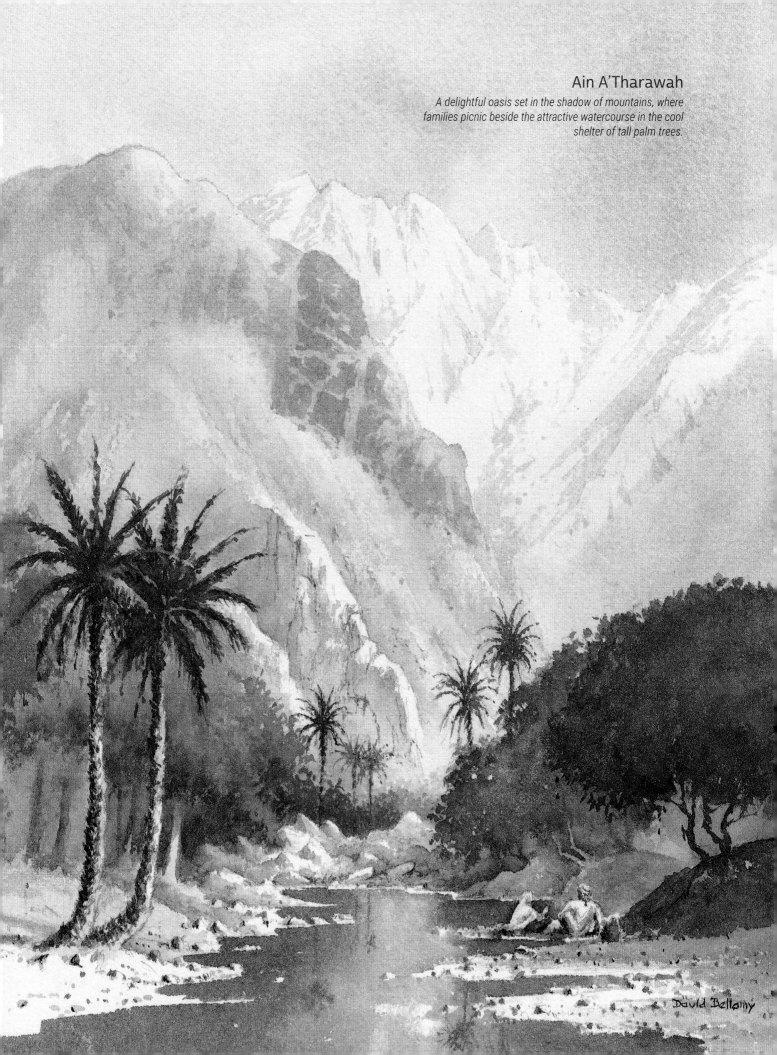

Ain A'Tharawah

A delightful oasis set in the shadow of mountains, where families picnic beside the attractive watercourse in the cool shelter of tall palm trees.

David Bellamy

One of the most exciting ways of descending this great mountain massif is on the east side, dropping down from the 2,000m (6,500ft) *col* at Sharaf al Alamayn to the village of Hatt, and eventually into the delightfully verdant Wadi Bani Awf. The unmetalled dirt track coiled steeply down the pinnacle-festooned mountainside, in places sloping alarmingly towards an edge in heart-stopping moments, as it dropped sheer for some two to three thousand feet into the valley below, and guaranteed to induce the jitters with thoughts of sliding off into oblivion. The prospect of meeting a vehicle coming the other way was too horrifying to contemplate on such a narrow track. In places the track had been severely eroded by rainwater or rockfall, making it even more unstable. Flared breaches and holes pierced some of the pinnacles and buttresses, lending them an air of exotic fantasy. After ages we reached a flat stretch which we thought might be the bottom, but this was but temporary relief, and we were soon plunging down further diabolical slopes, seemingly for hours.

Eventually we reached the village of Hatt, locked on all sides into the mountains, and shortly afterwards came upon a beautiful spot with palm trees and stream backed by colourful cliffs. Here we paused, relieved to be able to sketch with the only shelter from the scorching sun being a small but vicious thorn tree, before continuing along further heart-stopping ledges until we dropped into Wadi Bani Awf. Here the track followed the bed of the palm-festooned wadi, splashing through stagnant pools where we made many stops to sketch a mixture of palm trees, lush vegetation, and water-courses backed by red, orange and ochre cliffs, crags and pinnacles. When we came to the impressive Nakhal Fort that rises on a large crag the warm thermal springs of Ain A-Tharawah caught our attention. Water, rocks and date palms with a sprinkling of figures sitting beside the pools, including a number of washer-women in colourful robes, created a notable change from the raw mountain scenery. As ever, Ali could not be more helpful, for as we sketched he turned up with mugs of coffee.

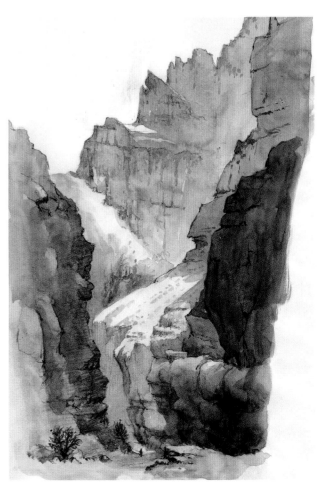

Wadi Nakhar Canyon
The tiny figure gives an idea of the immense scale of this place.

Scary track descending from Sharaf al Alamayn
This rough track was our dubious 900m (3,000ft) descent on the east flank of Jebel Akhdar, loose, sloping, heavily eroded, narrowed by rockfall, but absolutely fascinating.

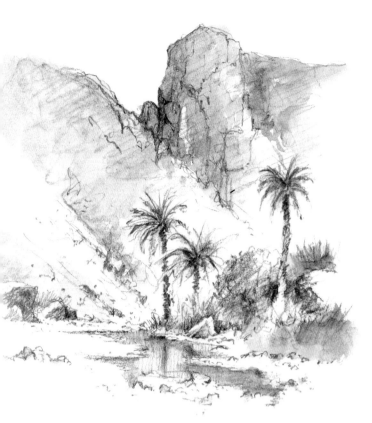

Hidden from the gaze of the Orientalist painters and in the main denying access to the early land explorers (and of no interest to the Crusaders), the delights of Oman's interior at the eastern edge of the Rub al Khali lay out of reach from Western observers for so long. There were no stirring accounts such as those of Lawrence of Arabia in the Levant, or the exploits of the Long Range Desert Group in the Western Desert, or the fictional adventures of P. C. Wren's *Beau Geste* in French North Africa to excite a visitor into action, but the sheer drama and outstanding savage beauty of the region makes it one of the most striking and exhilarating places on earth.

Wadi Bani Awf, Oman

We splashed through many watercourses and pools in this delightful valley, and in this sketch I used a watersoluble graphite pencil which creates lovely tonal effects.

Washer-women

These ladies were clearly enjoying themselves, indulging in gossip while they washed their garments in the running water.

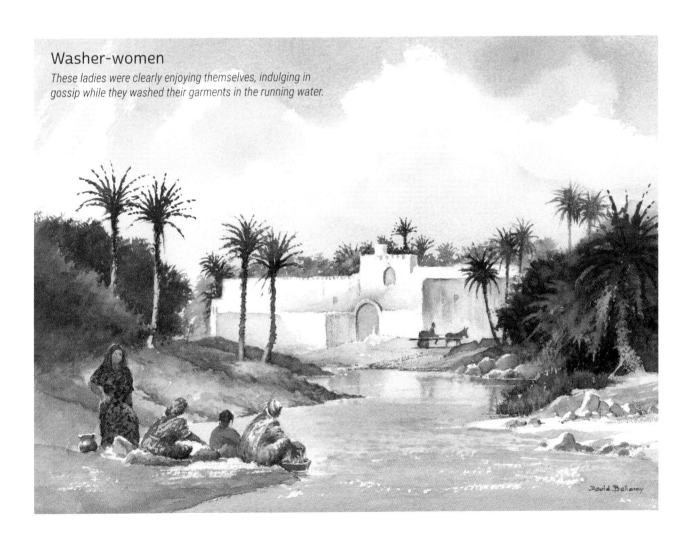

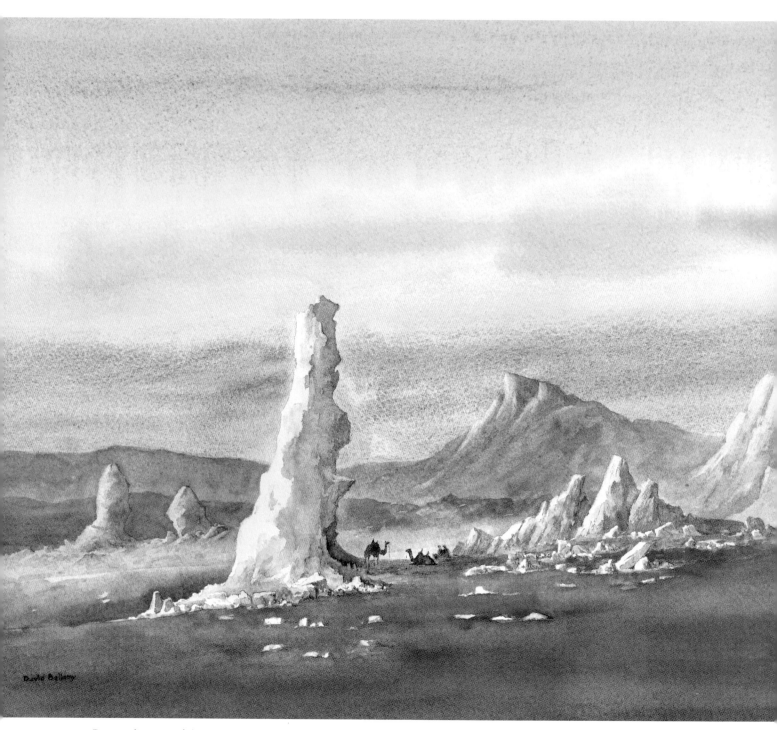

Rest time, White Desert
Travellers rest in the evening shade of one of the many pinnacles in the White Desert.

GILF KEBIR

Deep into the silent desert

In 2006 Jenny and I were invited by Nicole Douek, an Egyptologist at the British Museum, to join her and twelve others – plus eleven guides, drivers and cooks, one Egyptian army officer and a goat – on an expedition to the Gilf Kebir plateau in the south-west corner of Egypt, close to the Sudanese and Libyan borders. This involved over 1850 miles (3,000km) of driving, mostly across rough desert terrain, including the notorious Great Sand Sea south of Siwa Oasis. I had met Nicole briefly during one of my exhibitions at the Mathaf Gallery in London. We were delighted to accept her kind offer.

That October we set off from Cairo in a convoy of vehicles, with my old friend Mohammed Marzouk as the guide leader and Hamada his deputy. Sharing our SUV was Tessa, a teacher, and Saeed, our driver. We headed south-west through the Western Desert to Baharya Oasis where we paused for lunch. This was home to most of the lads who were driving, cooking, guiding and taking care of our needs. Saeed soon proved to be the clown of the party. His fooling around often got him into hot water, but he was a likeable fellow blessed with great dollops of Egyptian humour and hardly ever without a broad smile on his face. His driving was at best erratic and for some strange reason Jenny and I seemed to end up with him most of the time.

Sketching in Karkur Talh, Sudan

Saeed practising his driving
Even while everyone rested, Saeed was determined to perfect his driving skills to a higher level of annoyance.

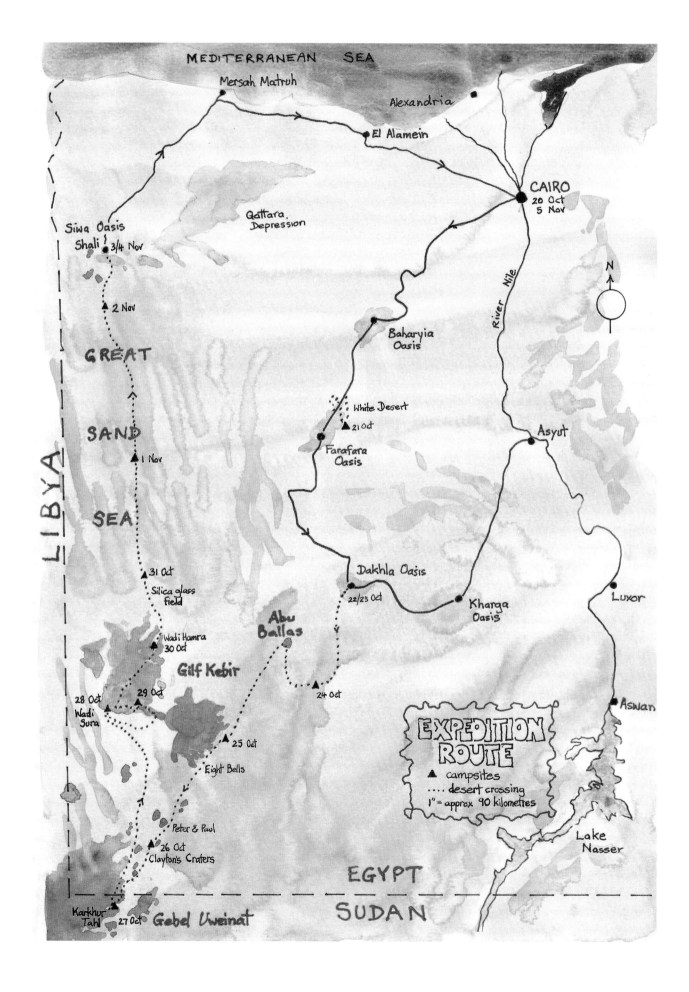

MEDITERRANEAN SEA

Mersah Matruh

Alexandria

El Alamein

CAIRO
20 Oct
5 Nov

Qattara
Depression

Siwa Oasis
Shali ● 3/4 Nov

▲ 2 Nov

GREAT

SAND

▲ 1 Nov

SEA

Baharyia
Oasis

White Desert
▲ 21 Oct

Farafara
Oasis

River Nile

Asyut

Luxor

▲ 31 Oct

Silica glass
field

Wadi Hamra
30 Oct ▲

Gilf Kebir

Abu
Ballas

Dakhla Oasis
22/23 Oct

Kharga
Oasis

LIBYA

28 Oct ▲ ▲ 29 Oct
Wadi
Sura

▲ 24 Oct

Aswan

▲ 25 Oct

Eight Bells

N

EXPEDITION
ROUTE
▲ campsites
.... desert crossing
1" = approx 90 kilometres

Peter & Paul
▲ 26 Oct
Clayton's Craters

Lake
Nasser

Karkhur
Tahl ▲ 27 Oct Gebel Uweinat

EGYPT

SUDAN

SKETCHING THE DESERT MONSTERS

Arriving late in the White Desert, I realized we would not have much time for sketching before dark. Although I'd explored the place before, the extraordinary wild rock scenery held an irresistible attraction. The sun hung low on the horizon, the white peaks and inselbergs wreathed in the potent atmosphere of approaching dusk, the more distant forms blurring into the violet haze of dim outlines of swarming ridges beyond. The dying sun strove to penetrate the evening haze, yellowing at the centre, with orange and crimson pushing into the purple lower reaches of the sky. The light level dropped rapidly when we came to a stop, and with symbolic drama a cloud seemed to rear up like some gigantic serpent above the sun as it began to disappear. The cloud curved up and over the sun in a great fiery crescent; gold-edged, and with trails of vapour shimmering along the blazing edge, like the gleaming scimitar of Saladin.

The group stopped and tumbled out with their cameras, while I sketched with the fury of a whirling dervish in the final moments of a frenzied trance. The whole atmosphere changed with alarming speed, the ground darkening, while great reptiles and monsters of every abominable shape rose out of the Stygian gloom like vindictive Egyptian creatures guarding a pharaoh's tomb. Seen out of the corner of my eye as I worked away, this became disconcerting to say the least, causing many a pencil stroke to trundle off-course. Working in semi-darkness against the clock can produce lively spontaneity in a sketch, or more likely in many cases, a ghastly mess. I drew in several of the black silhouettes of the monsters. The harder you looked at them the more astonishing their detailed outlines seemed to become. They seemed to move and grow in size as only a glow remained in the sky. This, of course was a trick of the light, for these rock sculptures in the fantastic shapes had been forged by wind-blown sand over the centuries into the most fantastic shapes. The glow lost its intensity and melted into complete darkness. We then drove on into the heart of the White Desert, threading our way through the ghostly white rocks with the aid of headlights, and after several minutes reached our campsite. This was just a flat part of the desert mainly free of rocks where three of our wagons had arrived earlier and already set up the kitchen tent. We erected our tents and settled down for an early night in this strange location, beneath a canopy of amazingly clear star constellations.

Ghostly pinnacles, White Desert
Seen at dusk, the pinnacles reflect the dim light to appear ghostly.

Ten minutes before sunrise I and several others perched on a flat rock, poised with sketchbook and cameras. On cue at six o'clock, the sun rose red and fiery between two rock sculptures. At these magical times you hope everything will work like clockwork. I began by laying on a wash of colour in the sketchbook, and while I waited for it to dry tried to take a photograph. The film had run out so much time was wasted sticking in a new film. The video camera then reported being full, so a new cassette was required – more wasted time. I worked into the still-damp sketch with an indigo watercolour pencil, to define rock detail, but I wasn't achieving the atmosphere I wanted. Nothing seemed to be working. The sketch looked dreadful, but I carried on, switching between sketchbooks to work on another composition at the same time.

The striking atmosphere amidst these natural monuments would not last long, so I worked in watercolour to capture the colourful mood, using sketchbooks of smooth paper – this tends to dry more quickly than textured watercolour paper.

Breakfast in camp

A rapid pen sketch illustrating the layout of the dining and lounge area between vehicles. I had little time to work before having breakfast, striking the tent and getting away.

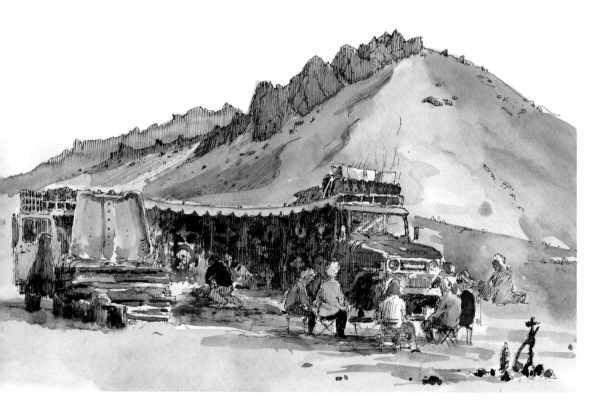

After breakfast we cleared up and continued our journey. How I would have loved more sketch-stops, but the group pressed on and I had to work as best I could from a bouncing, rocking vehicle as we traversed the rough desert terrain. As its name suggests, much of the White Desert rock is white. It is covered with features that resemble giant odd-shaped meringues, and which are extremely reflective, changing with the light in a striking way.

We passed camels resting on the sand beside a group of Germans, one of whom was clad in a bikini. This disconcerted Hamada, who was navigating in the lead SUV, so much that he failed to get up a sand slope. Our driver Saeed was jubilant as he roared past to take the lead – though the speed did not enhance my efforts to sketch in the slightest. Soon we reached the road and turned south. At Farafara Oasis a police checkpoint insisted on delaying us for some time before we were on the move again.

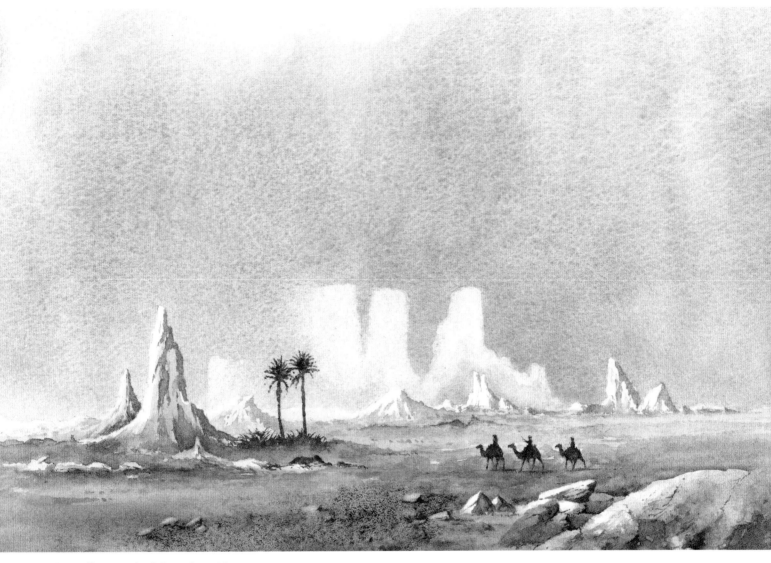

Inselbergs in Morning Haze

There are few palm trees in the White Desert, but happily I found a couple to break up the ghostly white landscape.

Part of the expedition
driving over the desert

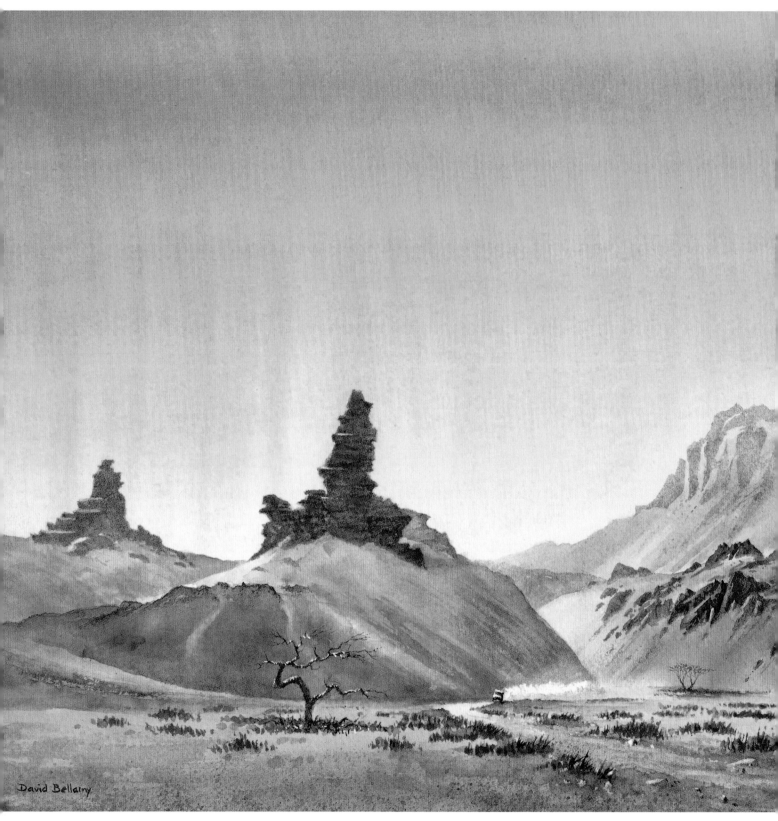

Karkur Talh, Northern Sudan

This enchanted valley of wind-sculpted crags and twisting acacia trees lies beneath the blue-grey massif of Jebel Uweinat.

David Bellamy

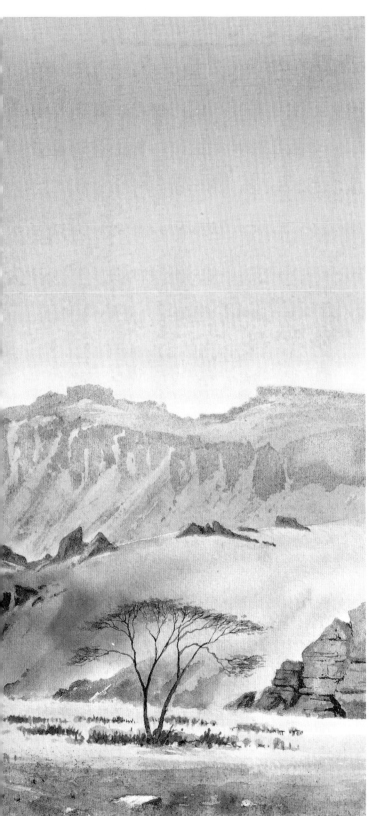

At one point we left the road to take a short-cut to avoid a great loop. This was pure sand and I dozed off for a while. As I awoke it startled me to see that Saeed was charging hell-for-leather into a lake, but suddenly it disappeared, replaced by the sandy plain ahead, over which was hovering a flying saucer. I began sketching it, but as we got closer it turned into a conical hill and I realized that what I had seen were simply mirages.

When we caught up with our brilliantly organized support wagons, they already had our lunches of pitta bread, houmous, tuna and tomatoes ready, and we relaxed for a while in the shelter of a wind-break which they had rigged up. As we continued our southward journey an endless mountain ridge cut across the eastern horizon, pretty much level all the way. Saeed continued to play games, terrifying the support vehicles and his passengers by being on the wrong side of the road as we approached a bend, while driving alongside another wagon with no intention of overtaking.

DELAYED AT DAKHLA OASIS

Beyond Qasr Dakhla Marzouk guided us into a hotel which would be our last touch of civilization for some time. This lay in a pleasant part of Dakhla Oasis surrounded by fields and palm groves with the desert starting about half a mile to the south. The hot-spring swimming-pool was particularly welcome. Next day we had a free morning while the vehicles were loaded with equipment and provisions. To get from Dakhla to Siwa Oasis via the Gilf Kebir, each vehicle needed twenty jerrycans of diesel which were stored on the roofs. One of the other members of the expedition, Lee, joined me on a walk, as she was interested in watching me sketch. Many locals wandered by, exchanging happy greetings, and it was a pleasant change from rough riding.

Before leaving Dakhla we picked up a soldier from the local army camp, who joined us to provide security and make sure we didn't do anything crazy like stray across borders. As we would be travelling up to the border with Sudan he would accompany us on the expedition, hopefully looking the other way when we nipped across.

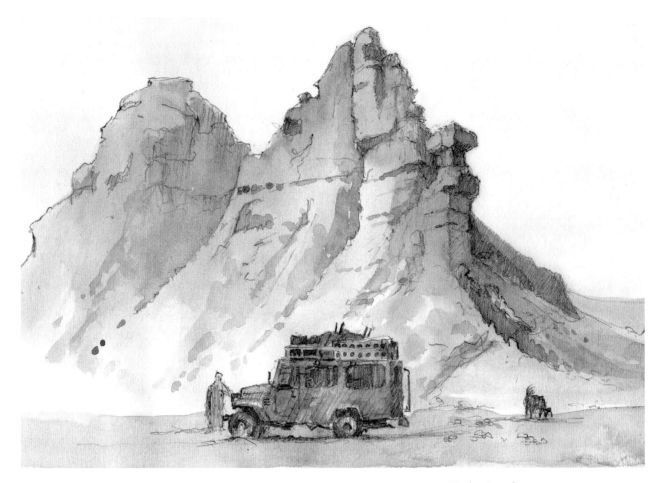

Twin Peak

This was a brief stop to slightly deflate the tyres, so I took the opportunity to sketch one of the kitchen wagons in front of some shapely crags, filling in the colour later in the tent. Dolly the goat was let out for a wander so I included her.

At the main Dakhla checkpoint all our papers were checked. As we waited a repair job was carried out on Saeed's wagon. The vehicle was jacked up and several drivers gave assistance. Apparently the leaf-spring at the rear had broken and Saeed repaired it with a couple of sticks tied up with string. To my (admittedly unpractised) eye this did not look promising, and I was glad we were travelling in Meheir's vehicle today. An hour passed. Jenny and I worked on our sketches, while Marzouk looked increasingly harrassed. Apparently one of the vehicle registration numbers didn't tie up.

Midday arrived before we were allowed to progress. We charged down the road at full speed for an hour or so and then pulled off beneath a shapely peak. Here the tyres were slightly deflated for the desert crossing, so I took the opportunity to sketch the peak – and Dolly the goat, who had been allowed to amble around.

From this point onwards, there were no more roads, villages or any form of civilization, just pure desert. It was with a tremendous sense of freedom that we roared off into the sandy wastes. The desert lay flat with occasional slopes, the surface in places pierced by upthrusting rocks, ribs and stones, some with vicious razor edges and incredible shapes, often wafer-thin.

That evening, Awayed the cook produced a fabulous dinner of roast chicken, rice, potatoes and salad – a veritable feast beneath the desert stars.

Next morning we turned north for Abu Ballas, a steep conical hill at the bottom of which lay a collection of smashed pots. Abu Ballas means 'The Father of Pots'. In the distant past tribes from Libya wanted to raid Dakhla Oasis, but the distance across the desert was too great to travel without sufficient water. The tribes solved this by setting up a store of large pots beneath the hill, which they could use to replenish water on the way to attack Dakhla. The hill provided an excellent landmark. When the citizens of Dakhla realized what was happening they sortied out and smashed all the pots, thus putting an end to the raids. When we visited, some of the pot remains still lay around, but most had been pilfered.

We then headed south-west directly towards El Gilf, stopping shortly amidst a collection of yardangs. These are crumbly mud-rock formations shaped like walruses and around the same size, and must look really weird at night. Nicole called them 'mud lions'. They were formed of silt from a former lake and carved by the winds, which undercut them to form the heads. Lee Young and Richard Winter joined us in drawing these strange beasts as we devoured a late lunch at the same time.

Awayed baking pitta bread on an oil drum lid

Yardangs
'Mud lions' sculpted by the wind. They reminded me of tuskless walruses.

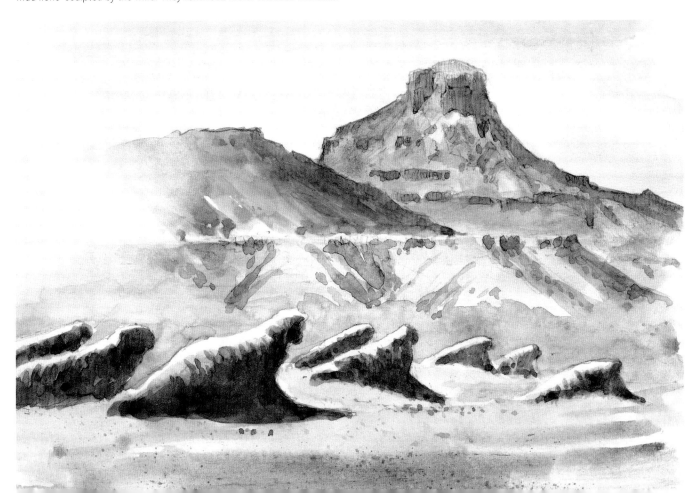

EIGHT BELLS

We motored on until evening, and drew up into the shadow of a handsome orange sand dune topped with shapely crags. This would be our campsite. As this happened to be the most spectacular dune we'd seen so far we tumbled out and plodded up the steep sides in the low evening light. Our sketching was brought to a rapid halt when the sun disappeared – so quickly that it caught us by surprise.

By setting up only the inner layer of the tent, we were able to admire the myriad stars in the night sky, with the moon a romantic crescent. Near the centre of all this ran the Milky Way, the whole providing a breathtaking sight.

We continued the journey, driving for several hours next day. At one point we had to skirt round a large area of soft sand. Unfortunately one of the drivers took it upon himself to carry straight on instead of turning west to achieve this manoeuvre, as the navigator Hamada had intended. We all followed the rogue driver. Several wagons became stuck trying to get up the first dune and

Eight Bells
Eight Bells is a former Second World War airstrip in the middle of nowhere, and is marked by a huge arrow-head made of old Shell Company aviation fuel cans.

it wasn't long before the sand ladders and spades were in action as we dug, pushed and heaved each wagon out of the mess in turn. The vehicles would crawl forward a few feet on the ladders, which would then be grabbed from behind, then raced forward to lay in front of the wheels for a few more feet. With time each wagon was extricated, but Hamada was furious at the mistake.

The group reversed down the slopes and back along the way we had come for a short distance before turning west to skirt round the dunes, after which we made good progress southwards. When we stopped for a break Assaf, the cook's assistant, entertained us by dancing to cassette music – initially with Awayed, then finally with the car radiator as a partner!

After a long session of further driving we came to a halt near some twin peaks. Nearby in the ground were stuck what appeared to be arrangements of tin cans formed into a massive arrow-head pointing into the prevailing wind direction, with another formation of cans spelling out '8 BELLS.' We had arrived at the old Second World War airstrip of Eight Bells: the tin cans revealing themselves to be four-gallon square aviation fuel cans. Here we had lunch around mid-aftenoon. The journey had taken longer than our guides had anticipated, so by evening we found ourselves driving in the dark: not such a great idea as there were minefields around and we might well miss any warning signs in the dark.

In the morning we awoke to find ourselves camping on sand as flat as a billiard table, surrounded at varying distances by a number of peaks. Our secondary objective on this expedition was the Jebel Uweinat region just across the border into Sudan, which has fascinating rock art, and this is where we headed today. Our first stop came not long after leaving camp, when we visited one of Clayton's Craters. These were discovered by P. A. Clayton (1896–1962) in 1931. Although there are no meteorite remains, remnants of springs do exist. It is likely these are responsible for the craters, having gradually undermined the ground and eventually causing it to collapse. We entered the vast natural amphitheatre via a breach in the wall of warm-coloured Nubian sandstone, and I managed to record a detailed drawing of this, with a couple of figures at the entrance to show the huge size of the place.

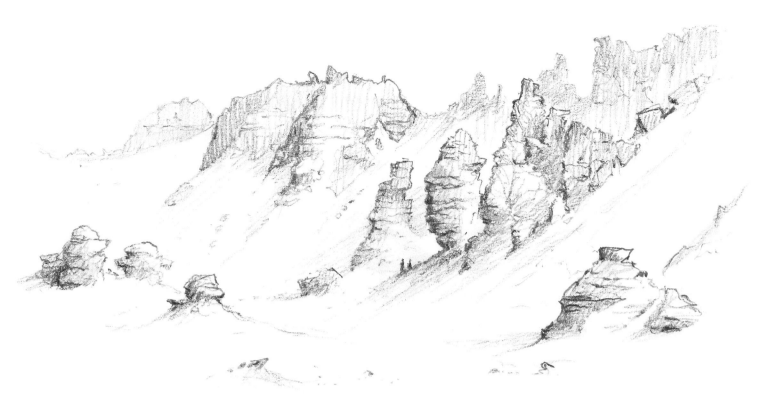

Karkhur Talh Valley

This pencil sketch is one of many I carried out in this unforgettable valley of natural rock sculptures, with brilliant orange sand cascading down the slopes onto the ochre-coloured sand on the valley floor.

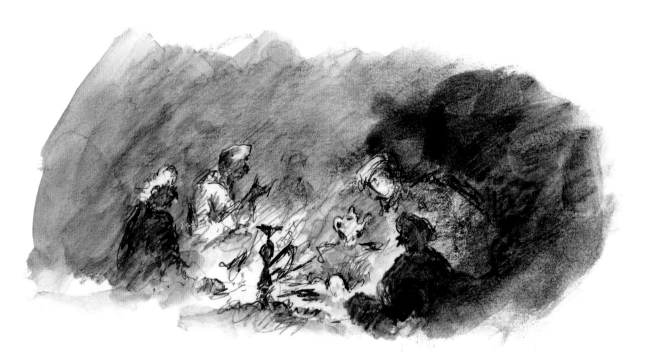

Desert guides by campfire

A rough watersoluble pencil sketch showing the indispensable sheesha and teapot.

KARKUR TALH – SUDAN

Around the middle of the day we crossed the Sudanese border, marked by a dilapidated signpost. We hoped to avoid any Sudanese border patrols in our fiendish endeavours to look at the rock art. We entered Kharkur Talh, a broad and incredibly beautiful wadi on the north-east side of Jebel Uweinat. Karkur Talh means 'the valley of acacia trees', and many of these had a softening influence on the arid landscape. Here the rocks and sand were much redder, with many crags sculpted into dramatic pinnacles by the winds of centuries. When set against the more distant blueness of the towering cliffs of the *jebel*, the brilliant orange and red of this enchanted valley exuded a sense of another world: no movement, utter silence. The sun beat down mercilessly on one of the driest spots in the Sahara, a landscape too dry and too far from water even for camels to survive.

Happily, we would spend some time here, the most wildly picturesque part of the expedition, and I felt grateful for Nicole and Marzouk in their excellent planning. We explored parts of the valley, members of the group heading off in various directions. Jenny and I made the painful mistake of deciding to sketch from the shade of an acacia tree: as I sat down on what appeared to be lovely soft sand, I leapt back up with a howl of pain. I'd just sat on a vicious acacia thorn buried in the sand. These were all over the place and easily penetrated our sit-mats.

We hiked along the valley and climbed a slope into a side corrie, gasping at the enervating heat. Thankfully the many crags provided shelter while we sketched, and here I felt in my element amidst the wildest extravagances of nature. The fierce light and constancy of atmosphere, a far cry from what I was familiar with in Europe, created a challenging situation in trying to vary the response, particularly in the watercolour sketches. No local figures inhabited this region. I'd seen no wildlife. The only form of life happened to be the expedition members which I'd already included many times.

Robert Talbot Kelly

One of the finest painters of desert scenery was Birkenhead-born Robert Talbot Kelly (1861–1934), adept at portraying the intense heat and wide open spaces, as well as everyday life in Egypt. He often painted charging camels, a horrendously difficult subject, and must have had great fun getting the Egyptians not merely to pose for him, but to charge around like lunatics on their steeds. No wonder many called him a *magnoon,* or madman – but happily most Egyptians seem to love such nonsense and are usually very obliging to the eccentricities of the artist.

Desert plant

To what would have been the undoubted dismay of Robert Talbot Kelly (see box opposite), we found no camels charging around, but the rock scenery of Karkhur Talh made up for the omission.

In the early part of the day stopping to paint and draw, followed by brief hikes or a scramble to the top of the next crag, was necessary – for too much effort at a time in this heat would have invited disaster. It was later in the day that we encountered some of the many sites of rock art: images of people, warriors, cattle, giraffes and other wildlife. Clearly at some time in the past this region had been more fertile and inhabited by much wildlife and many people. Some of the rock art is painted, some is scored into the rock. It dates back over 7,000 years; and provides evidence of a culture and a people long departed.

That evening the lads erected two shower tents against one of the vehicles, placing a large plastic reservoir of water on its roof. We had about a litre (1¾pts) of water each, our only shower between Dakhla and Siwa Oasis. It certainly made us feel good to wash off all the sand, dust and grime after so long without washing properly. After dinner the lads turned up the volume of the music and danced – the racket would have alerted any Sudanese patrols for miles.

Rock art

There are thousands of images of rock art in Jebel Uweinat, Gilf Kebir and Wadi Hamra, some engraved, some painted in red, white or yellow ochre. Most are pastoral scenes with cattle, goats, giraffe, gazelles, ostrich and people being prominent. Curiously, some of the human figures are endowed with antennae.

THE GILF KEBIR PLATEAU

As we waited for breakfast next morning I carried out a drawing of the genial Awayed as he baked pitta bread, his griddle a cut-off lid from an old oil drum over a log fire. He produced delicious fresh bread each morning. Fried eggs and pitta bread set us up for the morning's exploration. Jenny and Rosie headed across the valley, while Lee joined me on a hike up the valley, pausing to sketch here and there before it was time to move on to the Gilf Kebir plateau. There followed a little pantomime that can only be described as musical cars, with everybody trying to avoid travelling in Saeed's car. It was mid-morning by the time we headed north. For hour after hour we roared across a featureless desert. Well into the afternoon we stopped to lunch beside the rusted ruin of an old Second World War Bedford truck from which most of the fittings, wheels and engine had been scavenged. During the Second World War the Long Range Desert Group were active here. In the distance the great southern wall of the Gilf Kebir reared up out of the flat desert. We continued, and as we approached Wadi Sura at the foot of the great red cliffs riven with many gullies, the rock architecture became more spectacular. The light started to fade. I grabbed a tent and began erecting it when I spotted a patch of light falling on the crags above. Dropping the tent, I wandered over to where I could sketch the crags before the light disappeared. I managed to get most of the work finished when Jenny suddenly yelled for help out of the semi-darkness. Racing back, I found the wind trying to get the tent airborne like some half-inflated barrage balloon with Jenny hanging on grimly. Later, with our eyes red with sand irritation, we administered eye-drops to each other – though, perhaps being slightly disorientated, Jenny stuck them into my ear instead.

These were long days, as we arose early each morning. I already had my paints out as the sun came up, sketching the great cliffs and buttresses soaring above our campsite. After breakfast we wandered across to the Cave of the Swimmers to examine the rock art made famous by the film *The English Patient*. It could hardly be described as a cave, more of a hollow in the base of the cliff. The swimmers implied that there had once been a lake, which had long gone.

On this day Jenny and I drove with Hamada and Marged, a tall lad who said he did some watercolours at home. After following the impressive cliffs for a while we turned into a breach in the massive walls, and up the Aqaba Pass. Before beginning the climb all eight vehicles stopped to let down the tyres to help grip the soft sand. Saeed turned up late, having been looking for a lost car without realising that his was the lost car! This caused yet another furious argument amongst the lads. We then charged up the slopes, reaching the plateau without any problems.

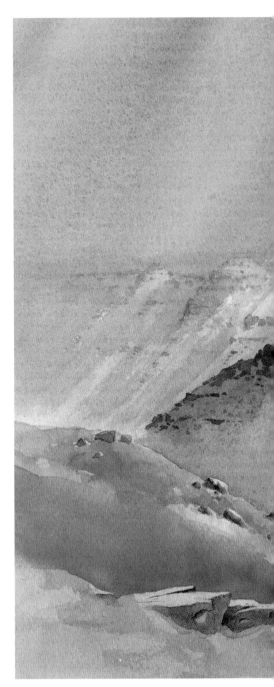

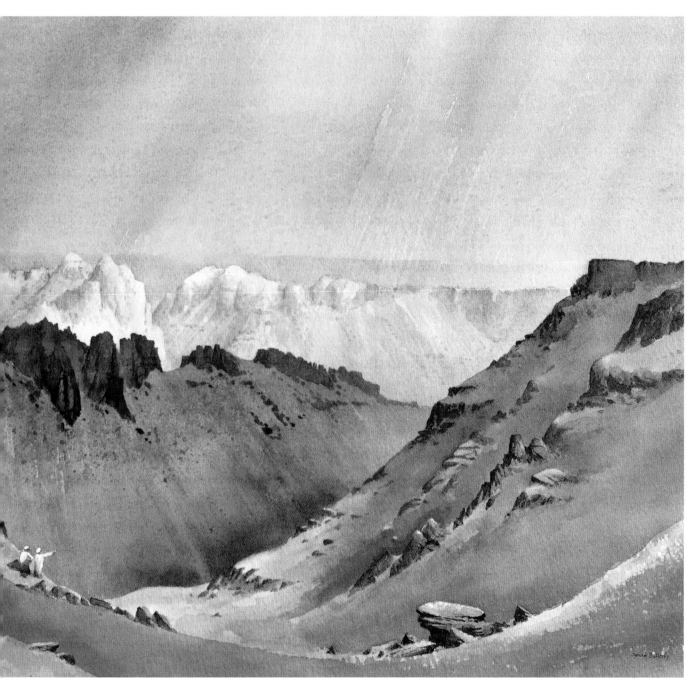

Descent into Wadi Hamra

This gully was the start of our descent off the Gilf plateau into Wadi Hamra to the north, the craggy eminences giving a clear impression of the complicated nature of the plateau.

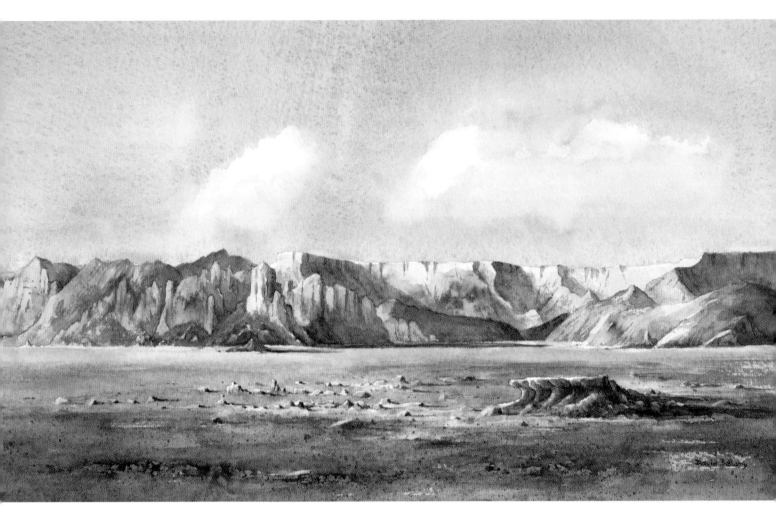

Gilf Kebir Plateau

The broken south-east ramparts of the Gilf plateau are caught in late afternoon light.

The great sandstone plateau of the Gilf Kebir rises 300m (1,000ft) above the surrounding desert, and some 1,000m (3,500ft) above sea level. It was first discovered only in 1926 by Prince Kamal el-Dine Hussein (1874–1932), and covers an area about the size of Switzerland. In the centre the sand appears reddish, becoming whiter further north, undulating with dunes. From the plateau itself rise a number of shapely peaks.

Climbing to vantage points here involved awkward ascents where the sand became so steep it poured away under the pressure of our desert boots. One of these points held much foreground interest in the form of a jagged hole in the rock, though I had to squirm into a ridiculously embarrassing position to sketch it. It would take a month or more to explore the plateau edge properly. At the Lama-Monod Pass it dropped sensationally in rugged precipices. Here, the tough sandstone capping that forms the edge contoured round in a vast semi-circle. I found it difficult to render accurately where the slopes met the shattered, rocky

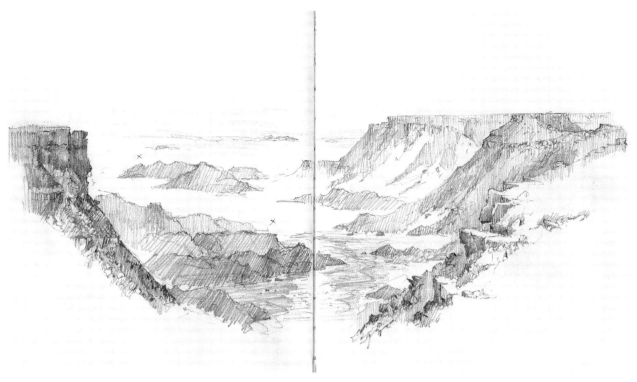

Lama-Monod Pass

Looking out across vast swathes of desert as far as the eye could see gave me a humbling feeling of how insignificant we are in this immensity. Here the desert floor is about a thousand feet below.

desert floor below. Some simply did not appear where they should have been on my drawing – but as the main objective was to capture the sensation and general character of the scene rather than absolute precision of topographical features, I considered it a success. Of all the scenes we encountered on this expedition, this landscape of titans spread out before us engendered in me the most humbling feelings of insignificance.

Such was the interest at this point that everyone spent some time studying the scene and taking photographs, enabling me to carry out a drawing of considerable detail. Even so, to speed things up I simply hinted at the varying tones once the basic shapes were outlined, and filled in the main areas of tone later in the tent. Rocky ground covered parts of the plateau surface, causing us to reflate tyres, then deflate them again when we reached sand dunes. At times we would roar along at speed, at others crawl at funereal pace. Navigating towards our northern descent route proved difficult and only after several false attempts did we eventually slowly descend

a steep sandy gully to find ourselves in the appropriately-named Wadi Hamra ('Red Valley') with its striking vermilion sides, where we found more rock art in the form of engravings of animals. It was here that our goat, poor Dolly, departed.

North of the Gilf Kebir lies the Great Sand Sea, the largest sand sea, or erg, in the world, and bigger than many countries. Dunes regularly rise to well over 90m (300ft) high, and up to 150m (500ft) in some cases, with some over ninety miles long. The dunes are mainly aligned in the direction of the prevailing south-south-east winds, so that travelling with the north-south grain is far easier than east-west. One dune has apparently been measured at 88 miles (140km) long. Most of the going is firm in between the dunes, but at the head of the dune valleys vehicles are forced to zig-zag to climb the softest and steepest dunes, providing many sporting moments. The steep descents on the northern side were invariably dodgy undertakings.

One morning as I sat sketching I suddenly realized that Saeed was reversing his Land Cruiser straight at me, but as I arose Hassan waved to indicate that all was OK. Seemingly well aware of the need for the artist to shade the painting from intense light, Saeed was reversing to a point a few inches behind me in order to provide this exemplary service.

We joined Hamada in his wagon to cross the Great Sand Sea, and as he was doing the navigating we were in the lead – a dubious honour, as we had to test the many extremely steep and unstable descents on the north sides of the dunes that blocked the valley-heads. As we progressed northwards the dunes became higher and more light-coloured. Some of the wagons became stuck in deep soft sand, causing delays as we dug, pushed and sketched them free. The glaring light became so harsh that edges blurred, ridges floated past and horizons disappeared. Were we going up or down? It was dangerous to continue in these conditions, so we stopped on the summit of a dune for a long lunch and siesta.

With little to sketch in this overwhelming lightscape I did a portrait for Meheir and made an interview recording with Marzouk. I took the opportunity of asking him why he employed Saeed when he seemed to be causing so much disruption.

"Because he is the best mechanic in Baharyia Oasis!" came his reply. Having witnessed Saeed repair the leaf springs of his wagon with a couple of sticks and some string I did rather wonder at whether Saeed had some *djinn* working on his behalf.

Two hours later we continued our traverse of the sand sea and, apart from a few minor hitches, made it to the northern end without any great problem. That night proved to be one of the coldest in the desert. Just before breakfast a vehicle drew up and three wild-looking individuals of unkempt appearance emerged. I had never seen Marzouk move so fast. Something was troubling him about these guys. They were Libyan hunters and had a falcon perched on the dashboard. I wasn't sure on which side of the border we were camped – we could be in Libya for all I knew. After much discussion the Libyans joined our breakfast and turned out to be friendly. I sketched their falcon and bird traps.

David Bellamy

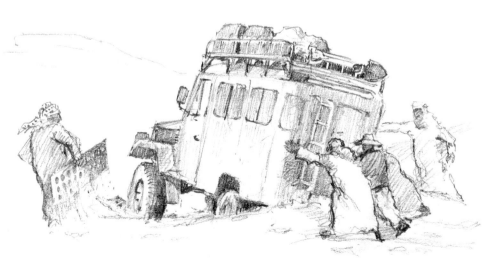

Stuck in the sand

Many times wagons became stuck in soft sand, especially in the Great Sand Sea. They could be extricated with the help of sand ladders and everyone joining in the great shove. On this occasion I did a rapid outline sketch in pencil, then joined the push, finishing off the details of the wagon later at leisure.

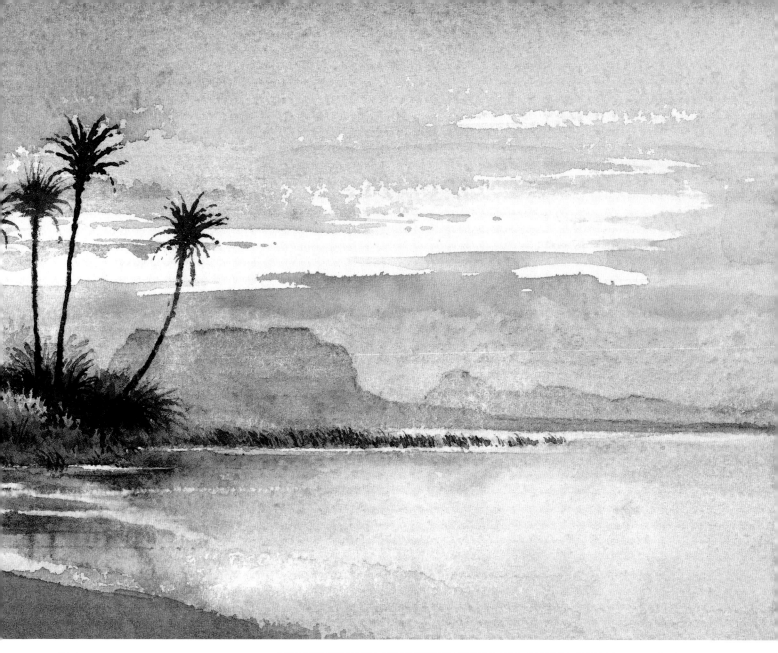

Fatnas

The palm trees and lake at Fatnas Island near Siwa provided a pleasant change from long days in the desert sands.

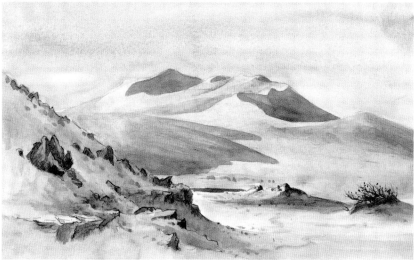

Dunes and Crags South of Siwa Oasis

Sketched from the site of our last camp.

Dancing on the Sand

Saeed, Hamada and Ashraf entertained us in camp with their dancing. In between Saeed and Hamada the spade is visible: this was frequently one of the dancing partners of these lads.

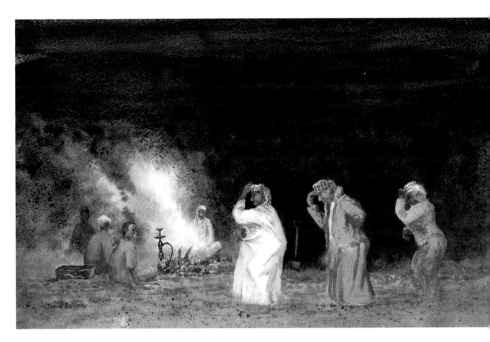

Shali Town, Siwa Oasis

This sketch of the main square includes the café where several of us would meet on the far left. I seem to have had one of my common slips of the pencil and, just above the donkey, included the hawk-headed god Horus walking hand-in-hand with his girlfriend.

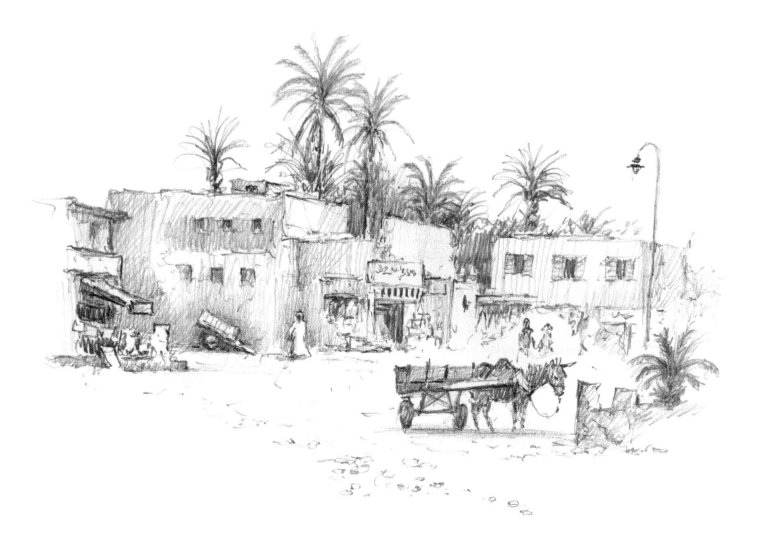

SIWA OASIS

On our last night of camping, beside some white crags, with the moon lighting up the whole area in a luminous, eerie glow, the lads entertained us with their unique style of dancing: sometimes with a partner, sometimes with a spade, often holding a hand to their forehead while wiggling their bottoms in the most ridiculous manner. Many of us joined in and I even sang for them, thankfully accompanied by Richard.

At Siwa Oasis the experience of running water, beds, tables and chairs brought us back to reality. After settling in we explored the delights of Shali, the main town of the oasis. The old town rose on a hill. It was almost in total ruin, its mud buildings having disintegrated in the early 20th century during a particularly heavy period of rain that had turned the place into a weird conglomeration of broken building shapes, pierced with holes, like melted cheese. Gaps of varying sizes, collapsed floors, beams and walls litter the place, threaded with alleyways and flights of worn, uneven steps. A tall minaret rises above the mosque, one of the few places still intact. Strong wooden doors punctuate the walls in places, and the whole place has a dull ochre colour. At night it is illuminated. Amidst the ruins we sketched accompanied by several youngsters, fascinated by our strange activities.

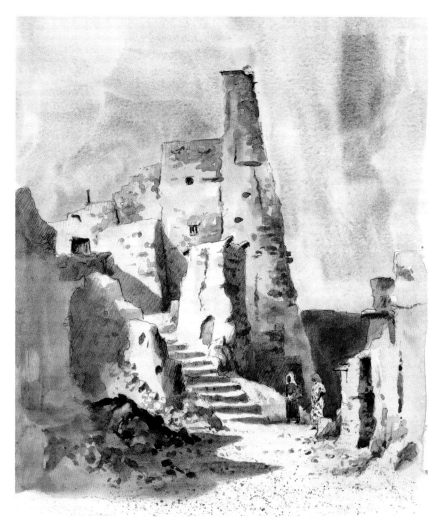

Part of the Old Town, Shali

All the buildings were crumbling and unstable with collapsed floors and holes everywhere.

Temple of the Oracle, Siwa Oasis

David Bellamy

Next day we all visited the Temple of the Oracle and the Temple of Amun, overlooking a delightful palm grove. Many legends abound regarding the Oracle and the founding of the temple, built during the Twenty-sixth Dynasty (664–525BC) and flourishing well into the Greek and Roman periods. Oracles were highly respected in the ancient world, said to be able to see into the future. The Sybils, priestesses who spoke the message from the Oracle, were thought to be blessed with prophetic powers, and able to communicate with the gods. The most famous client of the Oracle was Alexander the Great, whose most pressing concern was to find out if he really was the son of Zeus, the Greek god.

Following our visit to the temple, we joined our guides at Cleopatra's Spring for a picnic lunch in the palm groves. It felt good to spend a relaxing day in this fashion.

Our final day of the expedition involved an early start driving to the coast at Mersa Matruh. Despite my precautions, I found my 200mm camera lens had been wrecked by sand; happily on the last day. Dark clouds and strong winds hurled a heavy surf onto the Mediterranean shore. We had lost our desert climate. El Alamein flashed by and then we branched south-east for Cairo.

On the outskirts a minibus drew alongside us in the outer lane, driven by a chap with the most amazing four-inch moustache. It stood out on either side, turning upwards at right angles to form a pair of finely-pointed black needles. He grinned across at us and the moustache wings suddenly leapt upwards in unison, then began to dance up and down in an independent choreographic oscillation, combining expressive power and artistry in true Olympic style, before culminating in a synchronized moustachioed twirl on both sides. He kept this hilarious act up for some time, reducing Jenny, Lee, Hamada and myself to hysterical laughter before we lost him in the dense traffic. Checking into a posh four-star hotel clad in desert fatigues mantled with dust, and all the appearance of some unwashed tatterdemalion provided some entertaining moments, but it felt good. At the airport next day we bid farewell to Marzouk, Nicole and some of the others, filled in an enormous questionnaire from a lady from the Ministry of Public Mobilization, and sadly departed from this jaw-dropping country with a mixture of profound satisfaction tinged with sadness at leaving our Egyptian friends.

LEBANON

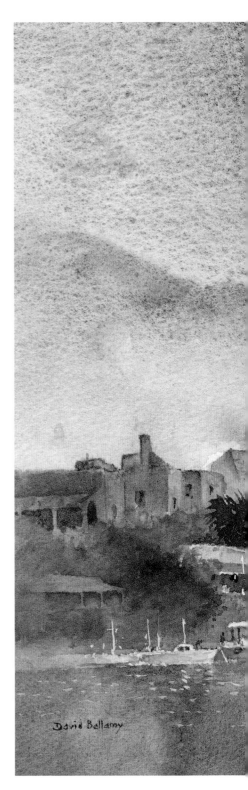

During the 1960s Beirut was regarded as the 'Paris of the East', beautiful and cosmopolitan. Formerly a squalid city, it was transformed by Mohammad Ali (1770–1849) during Egyptian occupation and by the mid-19th century it was flourishing with Arabs living side-by-side with Orthodox Christians, Maronite Christians, Jews, Greeks and others, while high above the city on Mount Lebanon lived a great many Maronites, Druze, Shia Muslims and Syrians.

In the latter half of the 20th century, however, the beautiful city crumbled beneath a series of disasters. Post-war, the demographic balance changed drastically as many Christians emigrated, while the higher Muslim birth rate and influx of some 120,000 Palestinian refugees created new pressures. The Lebanese Civil War began in 1975, lasting until 1990, and in 1982 Israel invaded the country. Some 2,000 mainly innocent and defenceless Palestinian refugees were massacred in Beirut refugee camps by the anti-Muslim Phalange. The brutal disregard for human life shocked the world. For anyone visiting the country it is impossible to avoid the recent history of suffering of the Lebanese people. The narrative of this appalling series of mass murders and assassinations is beyond the scope of this book, but I append a list of sources for further reading on these shocking and brutal issues at the rear.

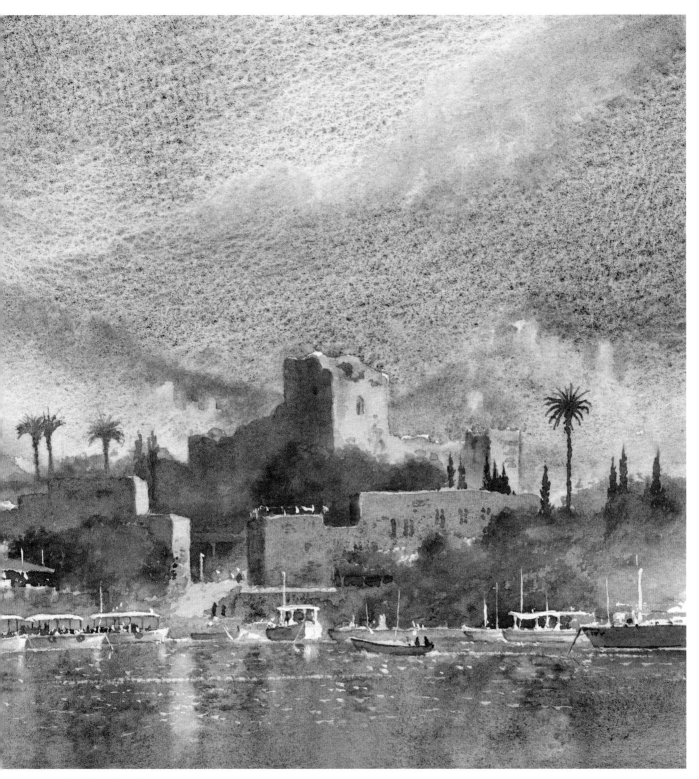

Byblos Harbour

The mist here was not invented, for much of the time the Lebanese mountains remained hidden. While I sketched I was joined by an eager group of school children who kept up a lively conversation throughout.

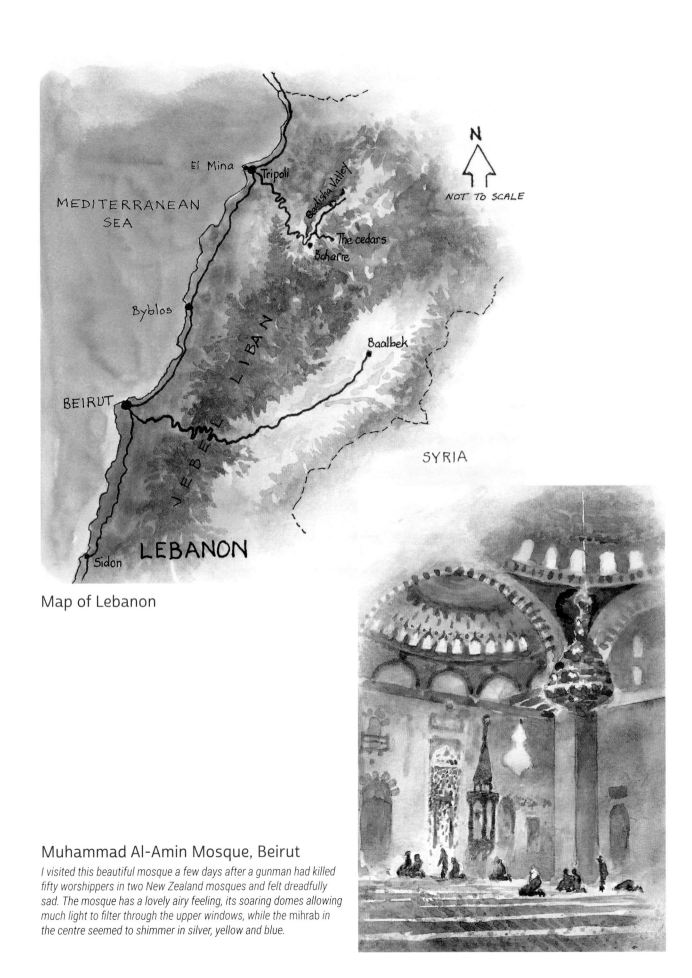

Map of Lebanon

Muhammad Al-Amin Mosque, Beirut

I visited this beautiful mosque a few days after a gunman had killed fifty worshippers in two New Zealand mosques and felt dreadfully sad. The mosque has a lovely airy feeling, its soaring domes allowing much light to filter through the upper windows, while the mihrab in the centre seemed to shimmer in silver, yellow and blue.

BEIRUT

Arriving in Beirut in 2019 I found the city seemed to be putting on a brave face. Here and there were signs of past fighting. My first need was information, so I set off to visit the headquarters of the Tourist Police. A taxi-driver pointed the building out: an austere concrete block into which I wandered via a side door. I climbed a wide set of steps and wandered along a vast corridor with uninhabited offices on either side. After wandering around for a while and peering into offices I eventually found a human being. An English-speaking woman invited me into her office and made some phone calls for further information, but said I would have to contact Hezbollah for certain items. Finally she asked me if I would like to put on an exhibition at the Beirut Police Headquarters. It was all rather eyebrow-raising. I returned outside with an armful of brochures and maps, and found Ali the Palestinian taxi-man to take me to the National Museum. There I spent a few happy hours amidst the splendid collections, including the gloomy basement, with its emphasis on funerary exhibits such as skeletons curled up inside large terracotta pots.

Despite its many problems, Beirut remains a vibrant, lively city. The many restaurants, swarming with customers bubbling away at their *narghiles*, provided both delicious food and equally delicious and characterful subjects to sketch in between courses. At one establishment I sat outside, about to devour my hairy ice-cream sweet when a car stopped in the middle of the street. Out jumped a young Arab woman dressed in tight black leather, a short black skirt with black tights and a bulge at her hip. She abandoned the car, oblivious to the chaos she caused, and strode purposefully straight towards me as I gulped on my ice-cream. Could this be an assassin? Instinctively I fingered my number ten sable brush, the only weapon I had on me, but at the last moment with a violent turn she veered off to the left to join a fellow two tables away. I made a note to upgrade my travelling painting kit.

The Levant has been the jumping-off place for many of the early explorations of Arabia. The fiercely independent Lady Hester Stanhope (see below) set up home at Mar Elias, a former monastery in the Lebanese mountains near Sidon in 1814, having left England four years earlier to seek a warmer climate for health reasons, taking with her a maid and a young doctor named Charles Meyron.

Lady Stanhope

Tall, fiery-eyed, and much too direct in speaking her mind, Lady Hester Stanhope (1776–1839) could be awkward in polite company and a positive disaster in affairs of the heart. She learned Turkish and Arabic in Alexandria, became shipwrecked off Rhodes, and when rescued, having lost her clothes, turned to wearing the dress of a Turkish gentleman. However pointless her travels, Lady Hester, being a person of distinction, made sure she and her party were always received royally. She delighted in meddling with Eastern politics. In Damascus she refused to wear the veil or change out of men's clothes, despite warnings about fanatics. The people of Damascus were amazed, but became so enthused by this extraordinary woman that she was hailed as a queen.

In 1813 she travelled to Palmyra dressed as a Bedouin with a caravan of 22 camels to carry all her gear, plus 25 horsemen and a Bedouin escort, and survived what was a potentially dangerous journey through a desert infested with Bedouin bandits (indeed, even Bedouin escorts could themselves turn their hand to a little banditry). In Palmyra she was celebrated. She decided to stay in the Middle East for good, and make her home in Lebanon. Discovering an ancient parchment, she mounted an expedition with a massive retinue, to search for the buried treasure of Ascalon, but her only find was a statue which she broke up, fearing that she might be accused of stealing antiquities. The cost of the expedition began her financial impoverishment. After Dr Meyron returned to Britain, Hester's eccentricities increased. She became a recluse, and with a violent temper constantly slapped and hit her many servants, labourers and slaves, who took every opportunity to steal from her, as she could not afford to pay wages. Finally she walled herself up in the monastery until she died in June 1839, alone and close to madness.

Lady Anne Blunt

In 1878, another adventurous lady of distinction, Lady Anne Blunt (1837–1917) came to the Middle East in search of the Arabian horse. She brought her husband Wilfrid, a rake, blatant womanizer, anti-imperialist, poet, atheist and political outcast.

Lady Anne, granddaughter of the poet Lord Byron, was an accomplished watercolourist, taught by John Ruskin. She carried out many sketches on her travels. She and her husband had already been on an earlier expedition to Mesopotamia so were familiar with Bedouin life. After time spent in Damascus organizing the expedition they set off across the desert, aiming to visit Hail in the centre of the Arabian peninsula before turning north for Baghdad. *En route* they were attacked by a Ruwalla raiding party. Lady Anne was knocked to the ground while Wilfrid was hit over the head. The fighting only stopped when Lady Anne cried out, claiming to be under the attackers' protection. In her Bedouin cloak they were astonished to find she was a woman, and soon they were all sitting around eating dates, drinking, laughing, joking, telling tales and smoking a pipe with their attackers. Needless to say, the redoubtable Anne lost no time in creating a sketch of the incident in her tent.

They continued their way into the endless sands of the Nafud Desert with locals hostile to their presence. Charles Doughty had travelled to Hail only two years earlier, and his appalling attitude to the locals would hardly have smoothed the Blunts' passage. They took on a local guide, 'a curious little old man, as dry and black and withered as the dead stumps of the yerta bushes', and he filled them in on what to expect at Hail. The Amir, Ibn Rashid had risen to power in a bloodstained coup, in which he murdered many of his own family and his reception might not be to their liking. Anne, however, was confident that as they were 'persons of distinction' there would be no problems. The barbaric and ruthless Ibn Rashid turned out to be intelligent and well informed and dazzled his guests with his finery. He showed them around, including his famous horses, the highlight of Lady Anne's visit.

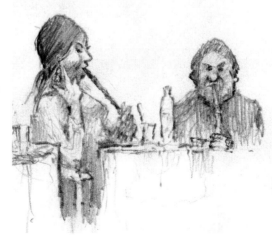

Ladies having a puff

These ladies were enjoying a puff on narghiles at the Al Manara Café on the seafront at Ras Beirut.

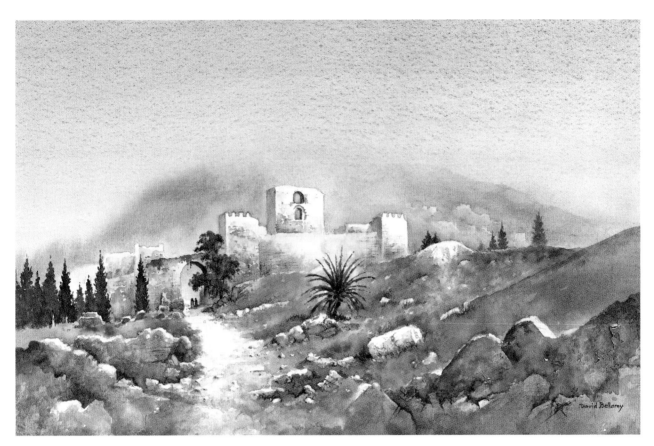

BYBLOS

I left Beirut in a luxurious air-conditioned coach bound for Tripoli in the north. Eager to see its ancient buildings, castle and *souk*, I found information on the place hard to come by. First, however, I would explore Byblos, mainly to sketch the magnificently situated castle that guarded the harbour. The coach pulled off the main highway and stopped in a dodgy position with traffic hurtling past, to disgorge a few passengers.

Finding the castle was easy as it dominated the town, but I wandered down to the harbour first to get a view of the castle with the harbour in the foreground. As I sat sketching, a school group of Lebanese teenagers gathered around, took photographs and asked many polite questions. When they left all went quiet until hauntingly beautiful Arabic music drifted across the harbour, sung by a truly soulful lady. Where it was coming from I had no clue, but it added a dream-like ambience to that sunny morning.

The eye, drawn to the shattered Roman columns lying scattered in confused order amidst the castle grounds, found exquisite vignettes of castle architecture framed by these delightfully broken pieces of history. I hesitate somewhat at using the term 'delightfully,' but these ruins are much improved aesthetically on those that remain pristine, polished and complete, or fussily manicured to irritating exactitude. Let us pray that when Palmyra is restored after its savaging by ISIS that they leave a certain 'worn and weathered' look to the place and not making it look as though it was built yesterday.

Byblos Castle

Built by Egypt's Fatimid Dynasty in the 12th century, the castle was taken over by the Crusaders, but in 1187 Saladin recaptured Byblos. The city retained its commercial links with European countries during the Mamluk rule.

Student audience at
Byblos Harbour

Byblos is deservedly popular with Europeans and is well served by modern cafés and restaurants. If I expected to find this in Tripoli I was in for a shock. I returned to the highway having been reassured by a police officer that I would be able to catch a Tripoli-bound bus 'within a minute' of standing there. I assumed she was exaggerating, as back home in Wales one would most likely have to wait at least half a day. As I descended the slip-road to the point where I'd been dropped off, I caught sight of a rickety old bus bounding along the highway at speed, then suddenly careering across the carriageway straight towards me, and screaming to a halt. There was no one else around, so the driver must have spotted me approaching, and by the time I arrived the door was open. Nobody got off. The police lady hadn't been exaggerating.

I managed to jam myself into a seat on the crowded bus, not far behind the driver so that I could keep an eye on progress, though this did me little good. My offer of a fare was waved away, and only after some time did I realize that you paid this as you were leaving the vehicle. After some time we turned off the main highway, although Tripoli was signposted straight ahead. The bus crawled through crowded streets for ages. I kept a look-out for a grander sort of location that might indicate the centre of the city, but it never came. When asked if we were near the city centre a fellow passenger said, "almost." I took this to mean that we would soon be there, but on reflection I think he meant, "We're close to the centre, but going away from it!"

I waited a while, but we still drove through dusty streets that clearly fell short of a modern city centre. The bus sped up on a faster road and I spotted a large sign in both Arabic and English stating, 'You are approaching the Syrian border'. This was definitely no-go territory as far as the British Foreign Office was concerned, but hard as I looked, I couldn't see any terrorist-type folk lurking in the bushes.

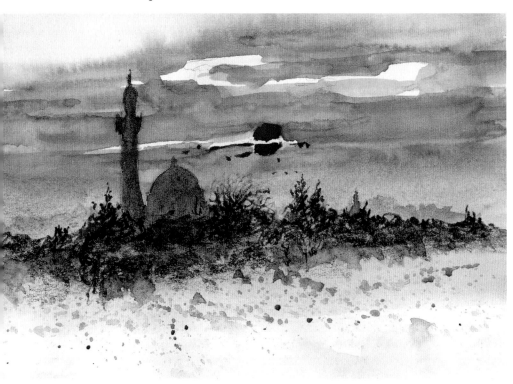

Sunset Near Syrian Border

At this point I had strayed off course close to war-torn Syria, but couldn't resist this stunning view.

TRIPOLI

After a completely incomprehensible conversation with the driver, who might have been going to Istanbul or Damascus for all I knew, I alighted at the next stop. These moments reminded me so much of my days travelling in my twenties, when everything was so unpredictable and exciting, with few guides and maps to help me. You had to sniff out everything for yourself, not knowing where you'd end up that night, or in what circumstances. By hiring a car you shut yourself off from interesting encounters with local people. As I waited to cross the road to find transport back to Tripoli, I felt a gentle tap on my shoulder. A young Lebanese lady speaking perfect English was standing next to me.

"You have a problem?" she asked. She had followed me off the bus. Before I finished explaining she said "Follow me!" I wondered if I was dreaming. She had appeared with the suddenness of a *djinn*, but there had been no puff of smoke and I hadn't rubbed any golden lamp. Would she grant me three wishes? I followed her and she stopped in the middle of what must have been the busiest road between Istanbul and Tripoli. I tried to remain with complete equanimity as cars hurtled past on either side, honking, shouting, and almost clipping my rucksack, but the situation appealed to my sense of the absurd and I felt happy to let this lovely woman – Sara, who taught English in the local village – sort things out for me. We parked ourselves by the flow of a roundabout, hardly the sanest or most obvious place to stop traffic, but the formidable Sara had a definite plan.

After a few minutes she spotted a mini-bus and stepped forward imperiously to bring it to a sudden halt. I winced. The mini-bus screeched to a halt and she addressed the two swarthy-looking blokes in the front in Arabic. To a background of hooting and yelling she ordered them to take me to El Mina which was near the port area of Tripoli where I had booked an apartment. They protested that the vehicle was full, but she insisted that I should sit in the front with them, so I squeezed in and thanked Sara for her kindness, amazed at her audacity. Off we went, Tripoli bound.

Mohammed, the guy sitting next to me, could speak a little English, but we conversed largely using his smart-phone to translate. He was an electrical engineer from Tripoli. The driver struggled a bit to find the apartment, but he insisted on dropping me off right outside the building, for which I was eternally grateful. I pondered

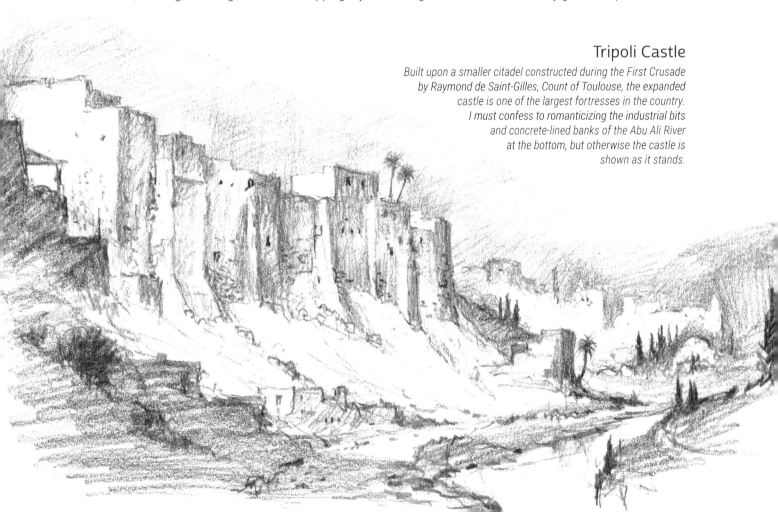

Tripoli Castle

Built upon a smaller citadel constructed during the First Crusade by Raymond de Saint-Gilles, Count of Toulouse, the expanded castle is one of the largest fortresses in the country. I must confess to romanticizing the industrial bits and concrete-lined banks of the Abu Ali River at the bottom, but otherwise the castle is shown as it stands.

on how, had I stayed on that luxurious coach, I would have arrived at Tripoli in comfort and been taken to the apartment by taxi, all without any hassle. Sometimes though, as in this case, the hassle was a far more enriching experience.

In the morning the taxi driver had some difficulty understanding my request to be dropped off at Abdel Hamid Karani Square. He must have picked up on the 'square' bit, as he then described a circle with his index finger. I nodded vigorously, aware that the 'square' was actually a circle, in fact a huge roundabout, but I wasn't the culprit who named it. With the exercise in geometry over, the driver was happy and soon dropped me off bang on target for a ludicrously small charge. Indeed, I found the taxi drivers in Tripoli always helpful, kind and probably the most honest I have ever met. Nearly all of them seemed to drive around in Mercedes that had seen better days – most with a dozen previous owners.

Alas, the tourist office in the circular square was closed, so I set off in what I thought was the direction of the Crusader castle using a primitive map that left out most important city landmarks, street names and the usual signage for finding one's way around.

After some hiking I asked the way: it was back the way I'd come for about a kilometre, after which I had to do something to the right, the left, or maybe straight on. Hot and bothered in the sunshine, I came upon the old *souk* and finally got my true bearings by the time-honoured expedient of following my nose. This covered labyrinth (the *souk*, not my nose) afforded many new subjects to sketch, and I worked away, glad to be out of the scorching sun. I saw no other Europeans.

Passing the fish vendors' stalls I came to the baskets, balls and burqas section where a lovely old time-worn archway caught my attention. Many interesting, sketchable characters filed past, often

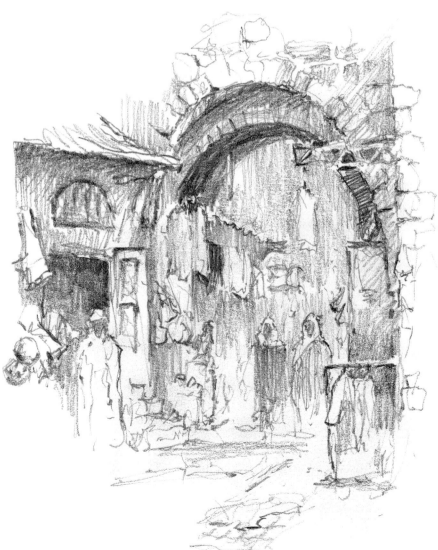

Tripoli *souk*

A pencil sketch done amongst the clamour of the marketplace. The people were good-humoured, though perhaps lacking the gloriously uninhibited eccentricities of the citizens of Cairo.

demanding frenetic pencil-work. Here, the pencil proved its advantages over photography: rather than stuffing a camera into someone's face, with a pencil I could render that lady's magnificent Roman nose as she ambled by, then add the walnut-like cheeks of the dervish as he whirled past trance-like, and so on. Although this is not generally my normal way of working, I built up characters one after another as this never-ending line of intriguing humanity shuffled along. Everyone was so friendly in this place that the London Foreign Office advised one to keep well away from.

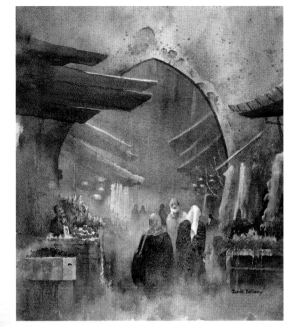

Tripoli *souk*

The souk was thronged with friendly locals. I did several sketches and saw not a single European.

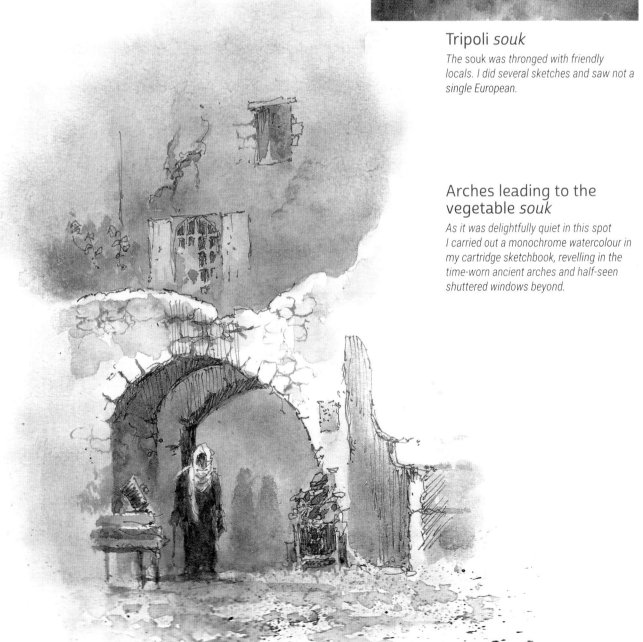

Arches leading to the vegetable *souk*

As it was delightfully quiet in this spot I carried out a monochrome watercolour in my cartridge sketchbook, revelling in the time-worn ancient arches and half-seen shuttered windows beyond.

I emerged from the *souk* into a street below the castle where some Lebanese soldiers lounged around their armoured personnel carriers. One of them called to me to point out the castle entrance which I had just missed, as it wasn't exactly clear. The enormous old Crusader castle embodied massive curtain walls that dropped down to the river. Built by Raymond de Saint-Gilles (1041–1105) during the First Crusade at the start of the 12th century, it was burnt down in 1297 then partially rebuilt by the Mamluks. Formerly Turkish and Circassian slaves schooled in combat, the Mamluks eventually overpowered their masters and succeeded the dynasty founded by Saladin in Egypt and the Levant. Many of the chambers were pitch-black and riddled with holes and crevices without any railings or warning signs, but it was an impressive stronghold.

Along a path running above a main road jammed with traffic I found a fine position to sketch the great building. After a picnic lunch in a small park I wandered through another part of the *souk* and came to the Grand Mosque, although the façade looked something less than grand. The intricate Mamluk architecture on an imposing portal presented an interesting challenge to draw, especially the two tiers of *muqarnas*, the stalactitic vaulting so typical of Islamic architecture, and a nightmare to sketch effectively. With the Lebanese economy in a parlous state, it seemed as though the lovely old buildings in this fascinating city were gradually falling into decay.

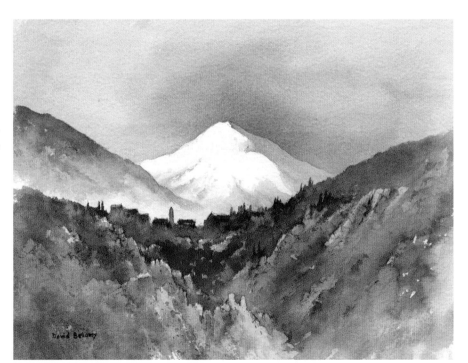

Mountain Village

Climbing high into the mountains, the mist dispersed revealing great swathes of snow-clad peaks, mainly massive whalebacks.

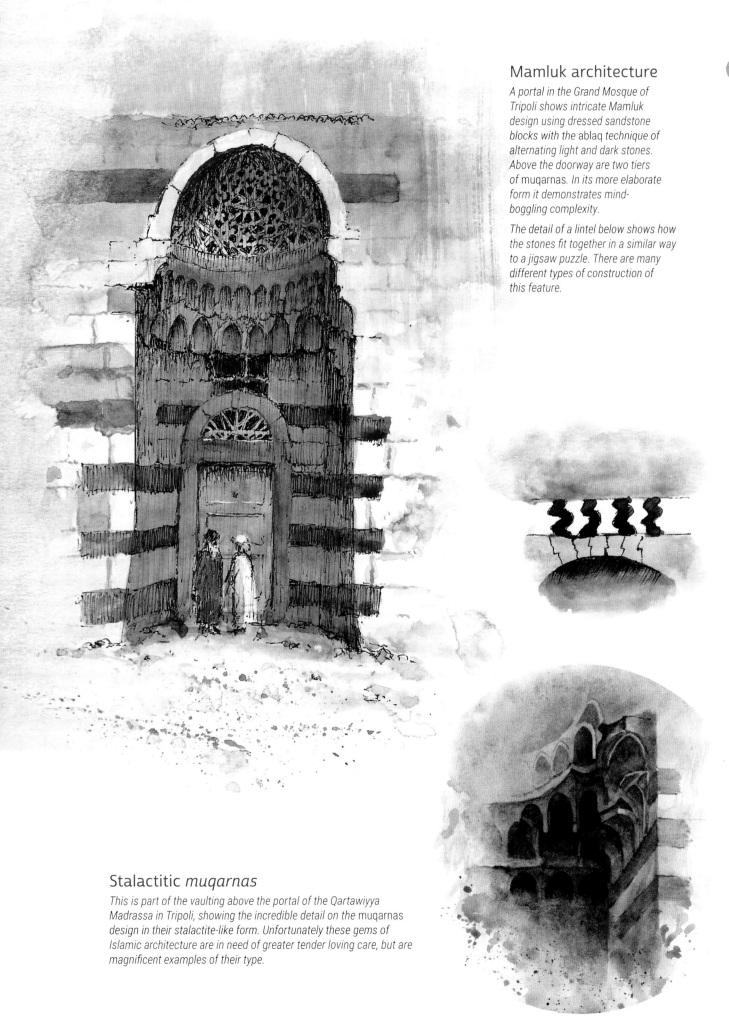

Mamluk architecture

A portal in the Grand Mosque of Tripoli shows intricate Mamluk design using dressed sandstone blocks with the ablaq technique of alternating light and dark stones. Above the doorway are two tiers of muqarnas. In its more elaborate form it demonstrates mind-boggling complexity.

The detail of a lintel below shows how the stones fit together in a similar way to a jigsaw puzzle. There are many different types of construction of this feature.

Stalactitic *muqarnas*

This is part of the vaulting above the portal of the Qartawiyya Madrassa in Tripoli, showing the incredible detail on the muqarnas design in their stalactite-like form. Unfortunately these gems of Islamic architecture are in need of greater tender loving care, but are magnificent examples of their type.

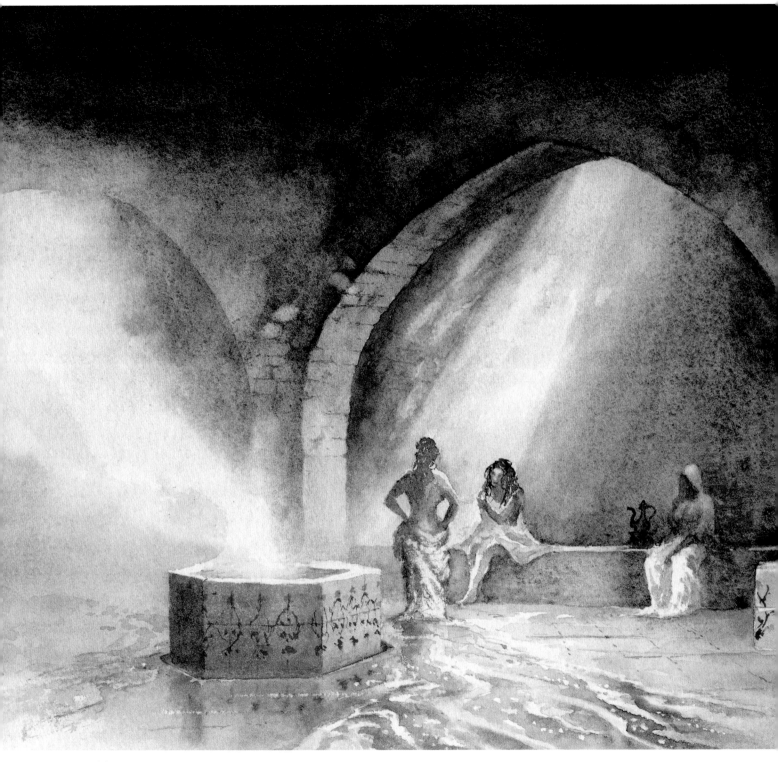

Hammam

As far as their users were concerned, these public baths were more than just places to wash, for they were popular for providing a day out where they could meet and chat. Hammams made popular painting subjects for the Orientalists, although they tended to depict the more elaborate, grandiose ones, where ladies were tended by their maids. The artist Jean-Léon Gérôme even sketched in one while totally naked, though that was a male hammam.

How does a chap get to sketch a ladies' hammam? I found it easy enough, as some will alternate male and female sessions during the day, so I took my sketchbook in during the men's period, when no women were present.

This painting has been put together from a variety of references, with the tiles, brassware and arabesque wall-covering gleaned from other sketches, and the figures from life drawings. There are still a few hammams working.

David Bellamy

Painting the hammam

No fewer than six *madrassas* (religious schools) stood near the Grand Mosque, and three *hammams*. *Hammams*, or public baths, usually feature domes or vaults pierced with small skylights which let in light during the day and allow steam to escape. Many are highly decorated, though smaller ones can be fairly plain inside. Even ladies of wealth who might own their own *hammam* within their home would visit the public ones from time to time to meet up and gossip, providing variety in their lives.

Many of the Orientalists, especially continental painters, depicted women taking their baths, attracting much criticism by modern writers. The work tended to be highly detailed without much atmosphere, and that in a place which generates vast quantities of steam. These are places to wash, clean, to be scrubbed and massaged, yet there is no sign of any water, apart from the occasional inclusion of a bath or pool in the background: not a drop has been spilled while these ladies are being dried by their maids, even though in many paintings the tall pattens worn on the feet to ensure the wearer did not get her feet swamped in dirty water are clearly depicted. Frenchman Jean-Auguste-Dominique Ingres (1780–1867) painted numerous *hammam* scenes, his ladies entirely naked and as stark white as a Victorian ladies' tea party in Kensington (though a group of the latter would quite likely have their clothes on). Like many Orientalists, Ingres never went anywhere near the Muslim world and obtained much of his information on harems from a number of published sources, including the translated 'Turkish Embassy Letters' of Lady Mary Wortley Montagu (1689–1762), wife of the British ambassador to Istanbul in 1717. Lady Montagu visited *hammams* on many occasions and was invited to the harems of upper class Turks, mentally noting details with such accuracy, describing the ladies, their adornments, apartments and goings-on. She even claimed that Turkish women had more freedom than their British sisters. Ingres' painting of *The Turkish Bath* includes a mass of naked women, with not a single Muslim woman in sight, some in suggestive positions, bodies heaped high like a walrus colony, although the baths were probably free of lewd snorting, farting and other rude walrus-like noises.

Undoubtedly the harem and *hammam* paintings were executed with incredible artistic talent. The intricate detail of Islamic tiles, *masharabyia* panels, decorations, gowns and other Oriental paraphernalia were rendered masterfully – yet in such overwhelming detail that it often tends to detract from the overall impression, particularly to modern viewers. However, the inclusion of these Oriental artefacts implied an air of authenticity to the paintings.

INTO THE MOUNTAINS

Leaving Tripoli, I took a bus up into the mountains, quickly gaining height while passing through many villages with a backdrop of vast snow-clad whaleback mountains that sloped down gently, with few crags. Bcharre, my destination, lay at the head of the Qadisha Valley and the bus swept round in a great curve as it approached the town. I caught a glimpse of the dramatic view down the gorge and determined to hike back there immediately after booking into the hotel to catch a sunset view. At 1,450m (4750ft) in altitude, Bcharre is distinctly cooler than coastal Lebanon. I changed into warmer clothes and set off in search of the view.

On the far side of the valley rose a huge, dramatic red crag – an obligatory subject – although I was more interested in exploring the gorge section of the Qadisha Valley than the mountains. Gone were the mosques and minarets of lower Lebanon, and here churches and orange-roofed houses crowded the skyline. This was Christian territory. I wandered back along the road to the point where I found the dramatic vista down the gorge. Wild, dark, seething clouds towered above the gorge, with fiery glimpses of light breaking through the colossal skyscape in places, a church cupola gleaming bright beneath the gathering mass of rolling clouds, the whole resembling one of the apocalyptic compositions of John Martin (1789–1854); scattering the buildings of whole towns and villages as the earth shuddered on his canvas. I worked fast in charcoal and watercolour, trying to render the sense of the savage atmosphere in this sublime scene where tiny houses perched on the very lip of cliffs that dropped hundreds of feet into the gorge.

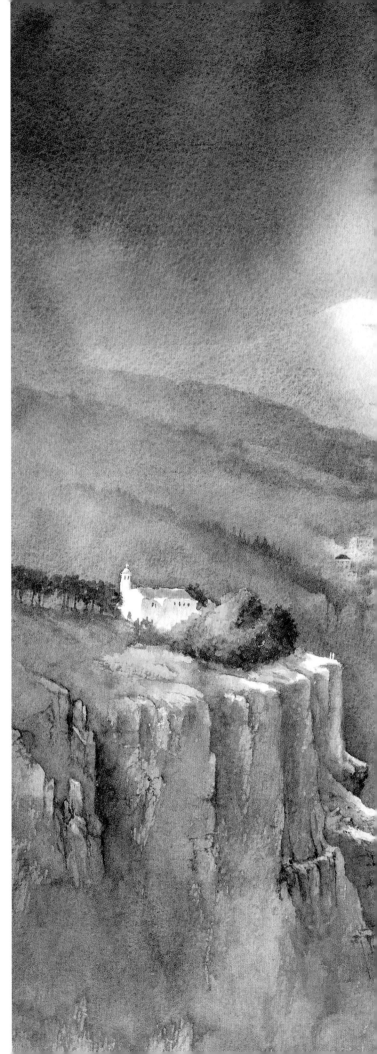

Looking Over the Qadisha Valley

At Bcharre the Qadisha Valley forms a spectacular gorge dropping a thousand feet to the bottom. Gone are the mosques and the minarets, and in their place are the Maronite Christian churches. Stormclouds rolled across the sky with light cascading out of gaps to flood parts of the scene with golden highlights amidst the shadowy cliffs. Happily, the deluge held off until I had retired for the day.

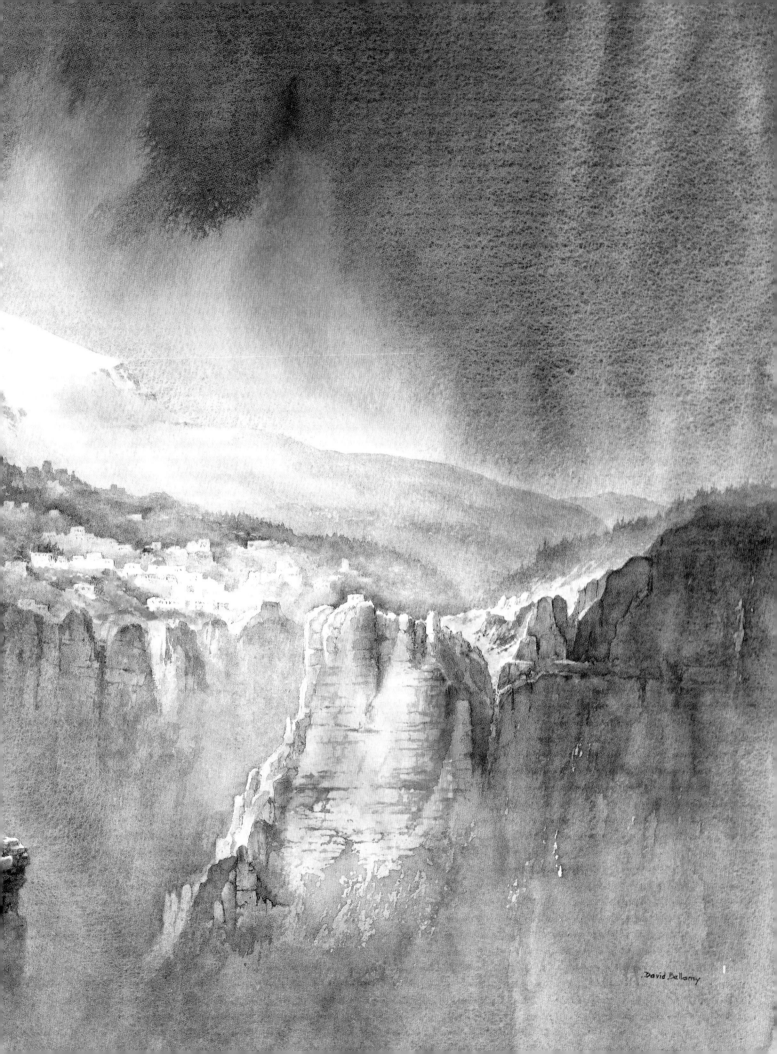

David Bellamy

The Qadisha Valley name is derived from the ancient semitic word 'Qadosh', meaning 'holy' – not because of the many caves, but due to the many monasteries and hermitages dug out of the limestone cliffs. Christianity spread into these mountains during the 5th century: the mountain folk, tired of being harassed by wild animals, are said to have asked St Simeon for help. He installed crosses at the entrances to their villages and asked the villagers to convert to Christianity. The wild beasts disappeared and the new religion spread all over the mountains. Till the beginning of the 12th century the valley, with its river and terraces of fertile soil for planting olives, mulberries, fig trees, apples, vegetables and vineyards, seemed like heaven. It lay on the trade route from Tripoli to Baalbek. Muslim hermits were welcomed by the Christians, and various religious communities lived harmoniously. However, the arrival of the Crusaders in the valley at the end of the 11th century increased division and fanaticism. In 1137 a Muslim army heading from Baalbek to Tripoli to fight the Crusaders was given help by the Christians of the valley. The Muslim army defeated the French Crusaders, but the French later exacted revenge on the mountain Christians by killing those who had helped the Muslims, including the women and children.

On my first full day in Bcharre I took a path out of town, almost immediately descending into the gorge. The bottom lay some 400m (1,300ft) below. On the far side a multi-staged waterfall crashed down between limestone crags. I stopped to sketch it as three young men came along, politely asking me if I was OK and did I need help? I thanked them and explained I was perfectly fine. They gambolled off down the rough path like new-born lambs.

I stopped to sketch the impressive falls, admiring the handsome shapes of the rock profiles balustrading the white falling water as it plunged into dark pools before continuing its drop to the unseen bottom. Packing my sketching gear away, I descended an extremely steep

Crags above Bcharre

path, circling crags and pausing frequently to take in the dramatic views down the gorge, framed by rock structures soaring several hundred feet from unseen depths. At one point I missed my footing, made a grab at a bush and yelled in pain. I'd grabbed the branch of a vicious thorn bush and my right hand was flowing red with blood.

It took some time to reach the bottom where a disappointingly dull concrete bridge crossed the river. This led to a minor tarmac road with stupendous cliff scenery rising on either side. In places monasteries seemed to hang impossibly in the grey confusion of ochre-splashed precipices. Jammed in a great gash halfway up the opposite cliff I could see a strange structure with a small door which had steps leading up to it. After drawing it from a distance I hiked over to the far side and climbed up crumbling earth banks and through rampant undergrowth to reach the steps. Near the top the wooden steps remained reasonably firm, although they didn't seem to have been used much, perhaps only by the occasional inquisitive visitor or recluse. I squeezed through the doorway and to my surprise the wall turned out to be a wooden façade supported by scaffolding, a most peculiar and unromantic culmination of my climb to this hermitage, for that is what it turned out to be.

Returning to the bottom of the steps I came across a pleasant track winding through the trees near the foot of the cliffs. It rose steadily upwards until it was some way above the valley floor as it approached the monastery of Mar Lishaa along a ledge. The monastery was built into the cliff and wide steps led up to the entrance. Here I encountered a number of Lebanese visitors who arrived at the same time. I went inside, but found no monks. Against the outer wall a series of cells contained a number of artefacts and basic furniture, the inner wall being the raw rock. At the far end stood a small chapel. I found no windows looking out onto the valley and felt that to stay any length of time in this place would induce claustrophobia, even though I was well used to caving.

Mustapha's Head

This handsome rocky projection which hangs out over a side gorge to the Qadisha Valley is known locally by the name of Mustapha's Head. Whether Mustapha was a sheep, llama or deformed character is unclear.

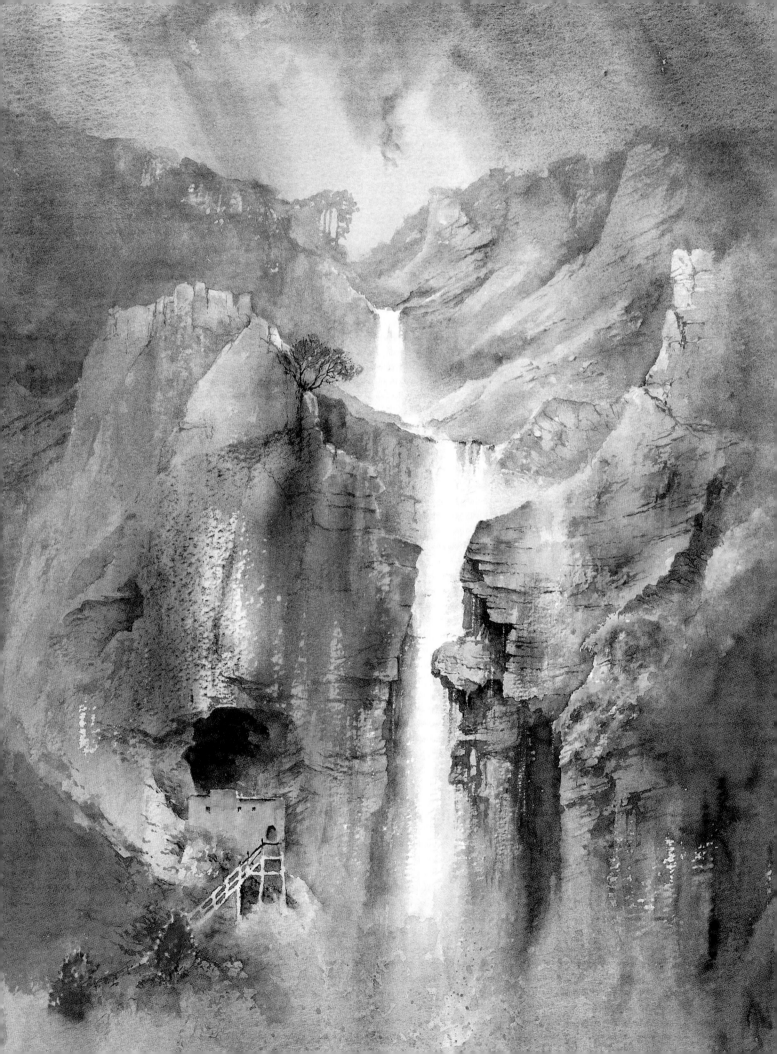

The national emblem of Lebanon is the cedar tree and fine examples of these grew on the slopes high above Bcharre. Up there at an altitude of 2,000m (6550ft), I found the place distinctly colder – and under 2m (6ft) of snow. As I had no skis or snow-shoes, making progress through such deep snow was purgatory, but I determined to manage some sketches of the magnificent trees standing stark amidst the snow slopes.

In 1858 the poet and artist Edward Lear faced similar difficulties, the cold making it difficult for him to hold the pencil properly. He made great sacrifices in his travels, hindered as he was by poor health, epilepsy and extreme short-sightedness. Amazingly, his sketching methods involved the use of a monocular glass or telescope, through which he would study the subject before replacing his glasses to draw the scene. His visual memory, even with this constant practice, must have been phenomenal. On occasion where I need fine detail in the distance I resort to binoculars and find it immensely difficult to remember more than a few strokes of the pencil. Lear worked in pencil, making copious notes on the colours, tones and anything that took his fancy, including delightful bits of nonsense in his idiosyncratic style all over the sketch. He would normally apply colour washes later. With his love of nature and his constant seeking of the truth of the subject at a time when so many of his contemporaries worked from the sketches of others, I feel a great bond with him. Curiously, unlike most other artists, he forsook the great ancient sites such as Baalbek to concentrate on the more natural subjects. He had little time for Jerusalem which he reckoned was '...the foulest and odiousest place on earth.' Like Chateaubriand, Flaubert and others he was appalled with the city, commenting on 'horrid dreams of squalor and filth, clamour and uneasiness, hatred and malice and all uncharitableness.'

The cedars of Lebanon

High above Bcharre these magnificent cedars stood in two metres of snow. Some are said to be over 2,000 years old and it is fitting that they should be the national emblem of the country.

The Hermitage

Down in the Qadisha Valley the scenery is equally impressive, though this hermitage appears more interesting from a distance than when I climbed up to examine the place. Behind the façade is simply the gaping mouth of a shallow cave.

From the heights by the cedar trees wide panoramas of mountain scenery rolled away, a distant patch of light falling here and there on occasional crags that pierced the huge whalebacks, while ridges melted into the distant mists. Such magical subjects flared up in sudden bursts, only to dissolve just as quickly. These wild heights became a great inspiration for the poet Khalil Gibran (1883–1931), whose home was once in Bcharre.

At times imaginative reconstruction is invaluable when that one vital ingredient is missing: light. As I study a promising subject in poor lighting I try to envisage how exciting lighting might enhance the scene, rather than ignore it simply because of a lack of light. This method has yielded some of my best paintings.

The Exedrae, Baalbek

Indifferent weather sometimes helps the artist, for if just a part of the scene is catching the light, it creates delightful highlights in places. Here, I took advantage of this effect in the composition to lose some of the repetitive detail in shadow.

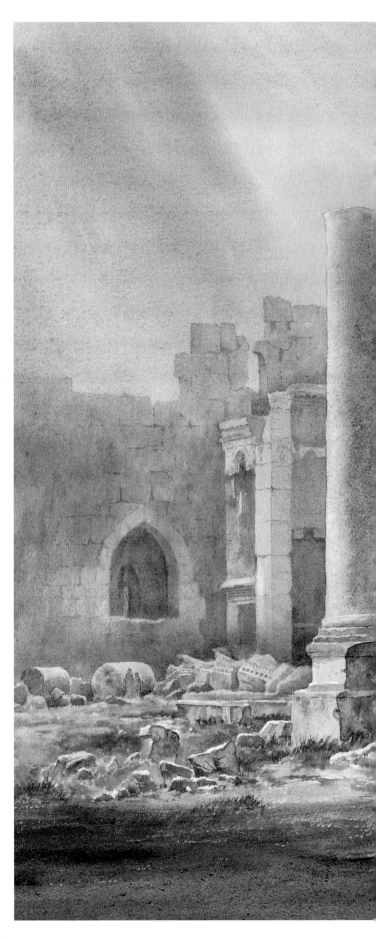

Khalil Gibran

Below the shapely crags where I stood sketching stands a museum in the poet's honour. As well as being a poet Gibran was an accomplished painter. The museum was once a monastery cut into the cliff, and contains a fine collection of his work. Curiously, much of his work depicts naked women set in a background of wild mountain landscapes, with one extraordinary example entitled *Yearning for Heights* depicting a man dragging a prostrate woman up a cascade. I wonder if he employed a model for such an excruciating pose?

Gibran is the best-selling poet of all time after William Shakespeare and China's Lao-tzu. His best-known book, *The Prophet,* was published in 1923 and has never been out of print.

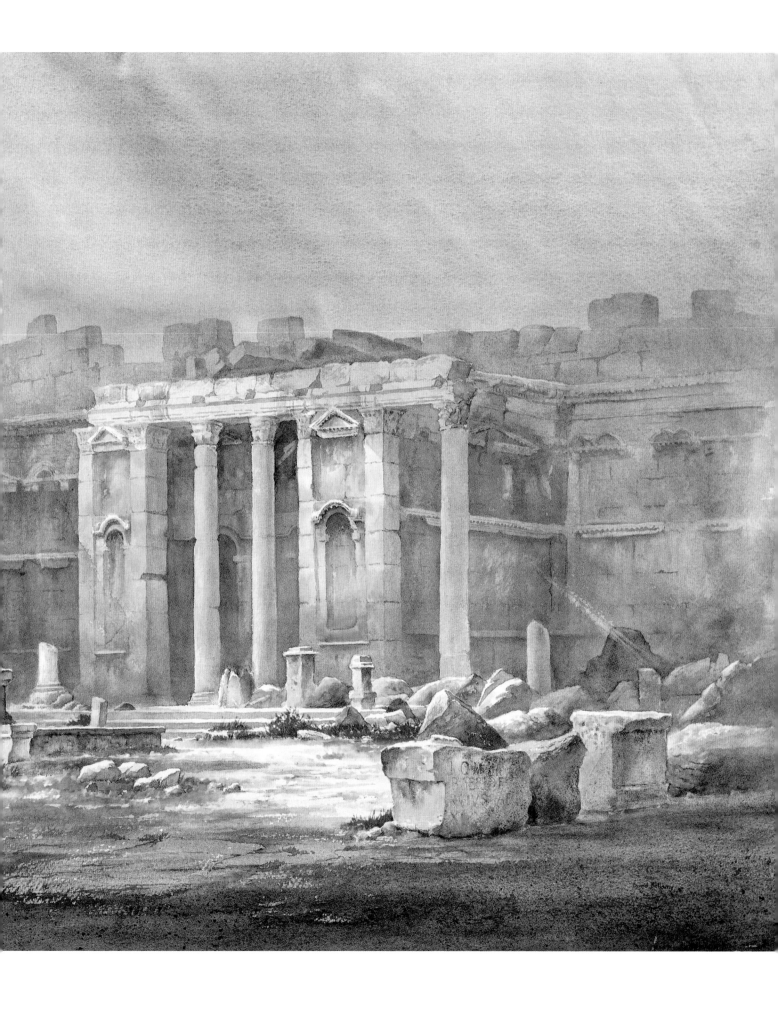

BAALBEK

One of the highlights of Lebanon is the magnificent Roman ruins at Baalbek. These lie in the heartland of Hezbollah country, and a two-hour drive from the capital. Hezbollah, designated as a terrorist organisation by the US and many other Western countries, was formed in 1982 following the Israeli bombardment of Beirut which galvanized the impoverished Shi'ite population. In the late 1980s it carried out kidnappings of Westerners which included UK envoy Terry Waite, but the organization provides a comprehensive welfare programme which includes schools, hospitals, clinics and low-cost housing among other projects, in addition to defending Lebanon against aggressors.

Limited for time I took a taxi, and as we cleared the traffic chaos of Beirut it began to rain. Higher up it really closed in and began lashing down. Once through the mountains the rain eased off as we descended to the plains beyond. Huge photographs of politicians, Hezbollah leaders and Ayatollahs adorned the highway, many of them of martyrs or men assassinated by non-terrorists (i.e. state operatives, whereby the nomenclature of Western powers defines such states as non-terrorists). All around lay snow-clad mountains, those to the east forming the border with Syria.

Beside the Hexagonal Court, Baalbek

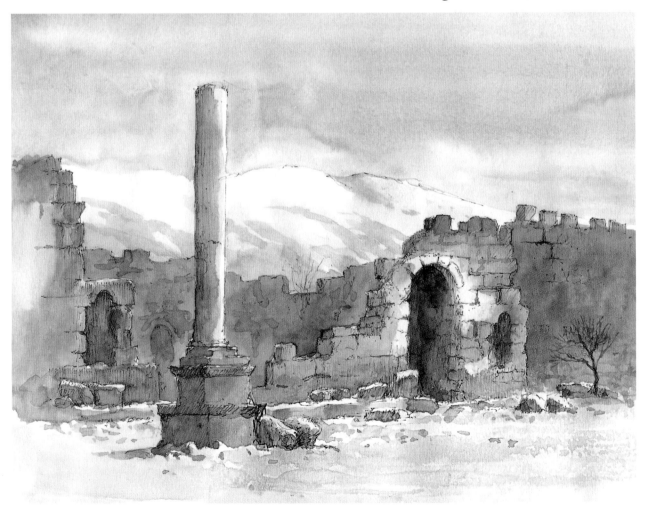

On reaching the Roman ruins I stepped out of the taxi and was immediately accosted by a chap selling Hezbollah momentos. "What size Hezbollah t-shirt you like, sir?" he asked. I enquired what colours he had. "Only yellow," he said, to which I replied, "Much as I would like to impress British security at Heathrow airport with a Hezbollah t-shirt, sadly yellow is definitely not my colour!"

"Would you like some ancient coins, sir?" It went on and on until I managed to sidle away and head into the Roman site. Baalbek is one of the best preserved Roman sites in the Middle East. In Hellenistic times it was known as Heliopolis, or City of the Sun. The whole place was littered with stone artefacts: fallen columns, capitals, entablatures, great blocks decorated with lions heads, many with inscriptions, and just plain bits of stone amidst the awesome buildings, outstanding gems of history lying around as though casually tossed away by some mythical giant. I worked up several sketches in the Great Court, marvelling at the size of the site and the huge girth of the broken columns lying nearby.

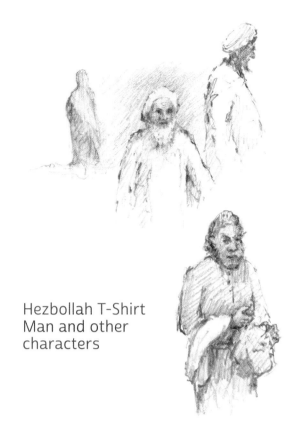

Hezbollah T-Shirt Man and other characters

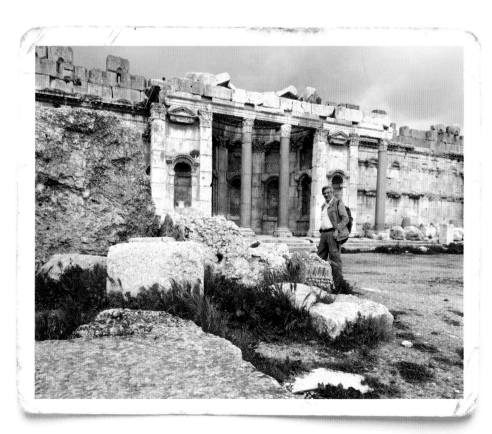

Baalbek Roman Ruins

Much fascinating Roman architectural detritus lies around the Baalbek site in the form of columns, capitals and other impedimenta, giving the artist many opportunities for interesting foregrounds to paintings.

Characters at Baalbek

The 22m (72ft) columns of the Temple of Jupiter, the tallest in the Roman world, were clad in scaffolding and could not effectively be sketched, so I moved on to the enormous Temple of Bacchus. Detailed friezes and Corinthian capitals gazed down in such intricate beauty that my pencil seemed to be struck dumb. Much of the time it can be sheer luck if the artist finds inspirational lighting falling on a particularly good subject, but on this day most of the time I had to conjure up my own lighting effects.

Few visitors appeared, but the only one who approached me was a Malaysian lady who chatted politely for a while. Occasionally the sun came out, but the atmosphere remained overcast, poor lighting for such outstanding subjects, though occasionally throwing a patch of golden light over the scene as sunlight pierced through a breach in the gloomy sky.

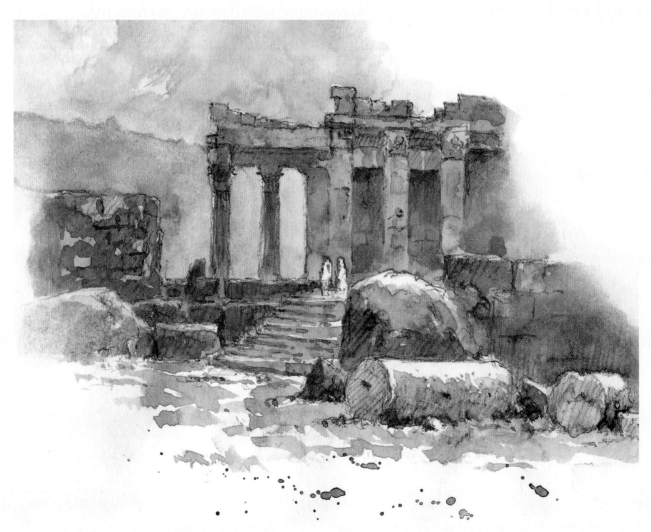

Temple of Bacchus, Baalbek

The temple stands on a base well below the steps, thus losing some of its impressive size from this viewpoint. The fallen columns in the foreground are around 2m (7ft) in diameter and would have taken an immense effort to lift into place.

Gustav Bauernfeind

The German Orientalist Gustav Bauernfeind (1848–1904) visited Baalbek in 1882 and painted the impressive Bacchus Temple with a huge leaning column displaced by an earthquake, yet still in exactly the same position during my visit. Bauernfeind was unfortunately plagued by sickness. He became fascinated by Lebanon and Palestine, but encountered great hostility in Jaffa to his sketching, the locals making his life a 'living hell'. Despite his weak constitution, chest pains and having to overcome local hostility that badly affected his concentration, he produced the most outstanding paintings of street and figure scenes. One monumental oil painting of Turkish soldiers press-ganging Palestinian men in Jaffa harbour is crammed with so many incidents of abject pathos where the men are being torn from their families, that it makes one wonder how on earth Bauernfeind could create such an impressive composition when in extremely poor health.

The Veil

Near the site stood the beautiful Ommayad Mosque with a highly decorated exterior topped by a golden dome. The resulting watercolour sketch seemed almost unearthly, with the golden glow as a centrepiece. Beside the mosque stood a large restaurant. My taxi driver suggested this as a good place to eat, but on entering we were confronted by a throng of about a hundred Iraqis, mainly black *abaya*-clad ladies. Apparently they had come to worship in the Shiite mosque. Some of them invited me to join their table, but the waiters offered me a table of my own upstairs. They brought far too much food, fresh and delicious, all served with broad smiles. How I wished I could have lingered for some time in this fascinating town that bubbled with lively humanity, a world away from the debauched cities of Western materialism.

PAINTING
IN HOT PLACES

The prospect of painting and sketching in desert lands in endless sunshine is appealing, although the reality can be somewhat different. Intense heat dries watercolour washes quickly, which can force errors; bright sunlight on your watercolour paper can create a blinding glare with consequent strain on the eyes, as well as making it difficult to assess tonal values accurately. In this chapter we will look at how I tackle some of my subjects, and include some tips for those who wish to paint these fascinating places.

For lengthy work you need to seek shade, which is not always available. The first time I added glycerine to the painting water to slow the rate of drying, I applied far too much and the watercolour painting didn't dry for two weeks. Additionally, when you sit down to sketch or paint you become something of an interesting object for the local kids. While this can provide some fascinating insights into local life, it can often become extremely distracting when you need to concentrate wholly on the subject you are painting. Yet despite all these distractions and discomforts I nevertheless find sketching and painting in the eastern lands rewarding in so many ways.

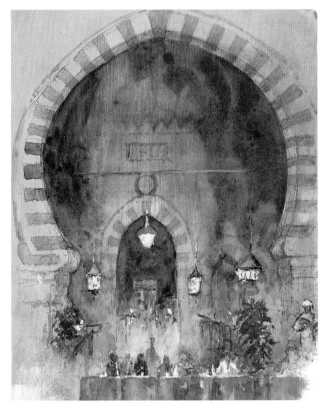

Dining room at the Old Cataract Hotel

I always keep a sketchbook handy when travelling by train, bus, camel, donkey, or when dining as in this case, otherwise valuable images can easily be missed. Here I used an A5 cartridge book and a pencil, working quickly to establish the main features. The ceiling in this enormous and spellbinding place goes up much higher than shown. It seemed to stretch up to the clouds. I coloured in the sketch later in my room, using the colour notes I'd written.

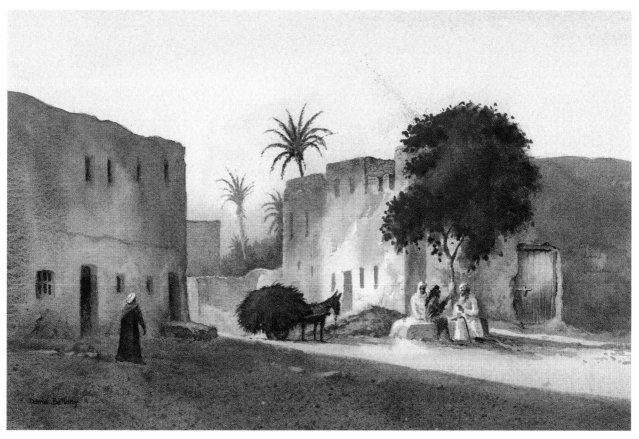

Al Qasr, Bawiti
I enjoy creating a narrative which in this case shows the donkey patiently waiting for his master to finish his natter with the locals.

Sketching and painting kit for hot places

- Box of watercolour half-pan paints – I add an extra red and yellow to my normal set;
- Reserve of a few important colours, such as French ultramarine, in tubes;
- Sketchbooks of varying sizes, mainly cartridge paper;
- Homemade folder of watercolour paper with a variety of surface textures;
- A variety of brushes, pens and pencils;
- Water pot, eraser, and a set-square for complicated architecture.
- A wide-brimmed hat is essential, sunglasses without coloured tints, and an umbrella or parasol is useful for keeping the sun off your work when you can't find any shade.

I keep all these items in a rucksack, as well as an additional A6 format – that is, 105 × 148mm (4 × 6in) – sketchbook and pencil stubs in my pockets.

Initially I used glycerine to retard the drying process, but these days when applying large washes of colour I flood the surface with clean water first and then lay on the colour, to produce a more even wash.

PAINTING PEOPLE

Art can cross language barriers without effort and before you know it you are enjoying interaction with the locals. I've found the people across the Arabian Peninsula always kind and helpful, and often ebullient and entertaining. I've never been asked for money to sketch someone here, as I have, for example, in the Himalayas, where an old woman insisted on payment to sketch her beautiful walnut-crinkled face. When I made the mistake of showing her the result, she was so offended that she demanded compensation. On meeting a nomad group in the desert on one occasion I began to draw one of their camels. A number of little boys watched in great fascination and were quick to point out the rude parts of the bull camel, urging me to emphasize these features.

Arab Relaxing

 I have included more figures in these paintings than in any previous body of work, mainly because of the colour and life they introduce. It seems to me that in the West these days I don't see so many characterful individuals as I used to, but wonderfully distinctive folk pop up regularly in the Middle East. Also, while in more developed countries people might simply press a button or use a mechanical means to achieve a task, the Arabs generally carry these out with physical exertion, such as loading donkeys, riding camels, women carrying pitchers of water or perhaps car spare parts on their heads (yes, it could be anything!), and so on. Even smoking a *narghile* has far more picturesque content than having a drag on a half-smoked fag.

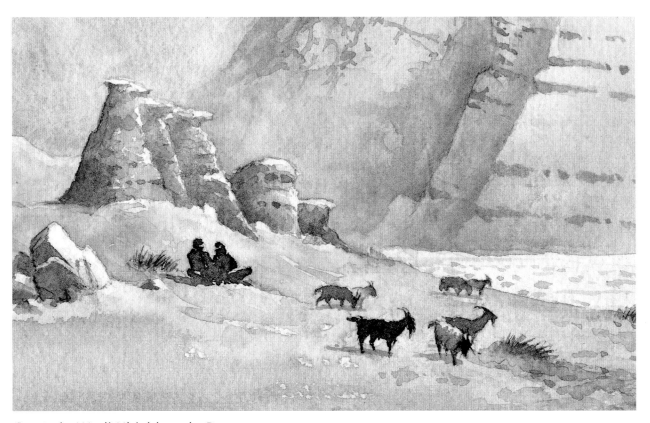

Goats in Wadi Khishkaseh, Rum

Bringing some form of life into a landscape is often essential so I take every opportunity to record figures, animals and birds so that even if they are not present in a scene I am painting, I can introduce them to enhance the composition.

In most countries now people adopt western dress, but here the men so often present much more interesting painting opportunities with their flowing robes and the colourful *kaffiyehs* of the Levant.

Most of my sojourns to the Arab countries have taken place without there being many tourists around, apart from at the ancient Egyptian sites and the Cairo *souks* during the day, and this has undoubtedly made it easier to sketch and observe the locals.

Sometimes men will ask for a portrait of themselves, and if they are interesting subjects I do two versions: one I keep, the other I give to the model, which he will usually fold up into quarters and stuff up his *djellabah*!

Saeed, Ashraf and Dolly the goat

These are typical quick pencil sketches of people in action, drafted mainly in outline with the shading filled in after the moment has passed. I look more for movement and gestures rather than detail such as faces, and sometimes it's the humour shown briefly that I wish to capture. In this scene from the Gilf Kebir expedition Saeed was making a point to Ashraf, while Dolly just fitted onto the page because she happened to be the next thing I saw.

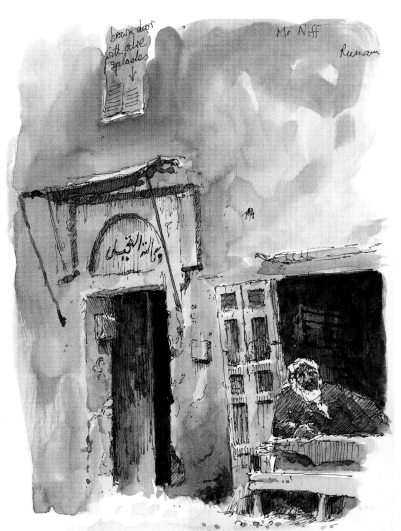

Mr Niff

This pen sketch, done while standing in the street, was accompanied by the usual Egyptian banter from the adjoining store-holders and the odd passer-by. They related how Mr Niff the draper acquired his nickname because of the extraordinary way in which he blew his nose, and that his real name was Abu Ruhman. Mr Niff seemed quite happy for me to draw him, but declined to offer a nose-blowing demonstration.

As with many sketches that need colour, I carried out this one using a fine pen, and added notes on the main colours directly on the sketch as can be seen here. Later in the day I then apply the colours, aided by the notes and any photographs I have taken – and not least, my memory of the scene.

Orientalism, cultural bias and art of women in Arabia

Orientalist artists generally painted their figures with great care and feeling, although astonishingly David Roberts detested the Arabs at the ancient sites he wished to paint, yet they were an important ingredient in most of his work. His sense of religious superiority was revealed by his comments on "...the barbarianism of the Muslim creed to a state as savage as wild animals". By contrast French artist Paul Lenoir, who accompanied Gerome to Cairo, commented that he could not help comparing seeing Arabs prostrate themselves without affectation before the mirhab to his own church, where he considered the service to be "just like the opening night of a show." In all countries where I have watched Muslims pray, I cannot but admire the sheer sense of honesty and reverence in their supplications that is sometimes lacking elsewhere.

While there is usually no problem in drawing portraits of men and children, the situation in sketching the Muslim woman is much more tricky and this varies not just from country to country, but often within the various regions of a country. Much of the time only the eyes can be seen anyway, and sometimes when you visit a family the women do not appear at all.

Having honed many speedy drawing techniques on wildlife, I tend to work rapidly, trying to capture the main gestural movements of the figure in as few strokes as possible, and this is generally less obvious than taking a photograph. Also I've found it useful to develop ways of helping my visual memory to retain details of subjects when I am unable to sketch for some reason. A number of old pencil stubs in my pockets also enable a fast reaction when suddenly confronted with a fascinating figure. The graceful movements of an Arab woman carrying a load on her head, however, are generally much easier as you can effectively render this from a distance, and the person is then anonymous. It pays to be on the look-out for such opportunities in order to be able to respond quickly.

In contrast to this hard, physical life of the *fellaheen* women, the decadent, languorous life of the harem ladies, as depicted by the Orientalists, must have been monumentally boring; yet the methods used by these artists to paint scenes they never saw remains an intriguing conundrum. Painting such scenes was a lucrative business, especially in continental Europe, even for those who never visited the East. None of the male Orientalists could visit a harem so they relied on any published accounts, snippets gleaned by female friends and partners, and of course their imagination. Edward William Lane's *Account of the Manners and Customs of the Modern Egyptian* published in 1836 became an invaluable source for artists on all manner of Egyptian customs. The harem settings would be based on Eastern interiors with all the accompanying paraphernalia: divans, cushions, carved wooden screens, the inevitable *narghile*, and all the opulent furnishings expected of the upper classes of Eastern society. The ladies, almost always marble-white, could be painted from European models, although those artists working in the East never found it easy to obtain women to pose. Most of the Orientalists built up vast collections of Arab artefacts which could be used as props in their compositions, and this was a vital resource for those who never travelled to the East. While one could hardly accuse John Frederick Lewis of overt eroticism in his harem scenes – many after all had the innocence of a Victorian nursery, the paintings of Gérôme, Ingres, Delacroix, Chassériau and countless others drew the ire from the modern academics who lambasted not just the sexual exploitation, but the rampant cultural imperialism they alleged to be rife amongst the artists. Many of these artists would undoubtedly be scraping an existence from their art, with thoughts of cultural imperialism well beyond their compass.

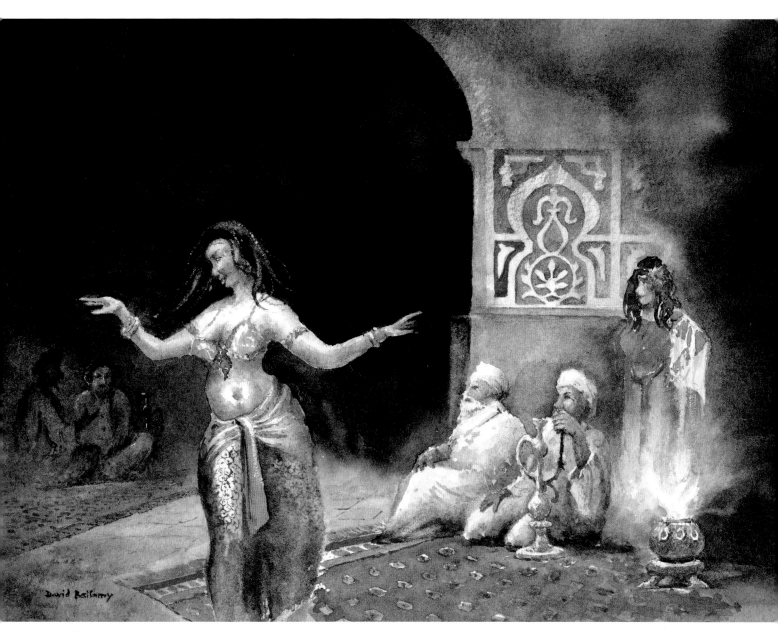

Bellydancer

Putting together a scene like this is fascinating, and needs several different sources for the setting, the audience and the dancer. Having sketched many bellydancers performing in various locations, it was still a challenge, and on one of my early escapades I found myself lying on the floor with the bellydancer bouncing away on top of me before an audience of my students which included Jenny my wife, and a dear friend who happened to be a vicar in Cumbria. Fatima, the dancer, then changed tack and rose up to dance away as she loomed above me, slowly descending until her tassles began to tickle my nose. Formerly I'd assumed bellydancing to be a non-contact sport, but at this point I did a quick flip to one side and escaped. Sadly I wasn't in a position to manage a sketch of these rather unusual moments.

The dancer has been drawn from more than one bellydancer, because the one with the most exciting gestures had on the most unappealing clothing that revealed bits I didn't wish to show, and hid other bits I really needed: the belly, for instance, is surely a vital ingredient, yet so many seem to hide it away. The audiences at these tourist events tend to be tourists, of course and rarely of great interest visually, so I've picked locals up off the street as it were, and included them, keeping the two on the left really subdued. The arabesque on the wall and the hookah and incense burner have been introduced from other sketches, and in a departure from my normal practice, for all the metalware and jewellery I've introduced Daniel Smith iridescent gold and bronze colours into the watercolour.

THE ARABESQUE

At night-time, Islamic Cairo becomes a visual treasure of Eastern promise, the darkness hiding much unwanted detail as well as providing a powerful sense of mystery. The arabesque designs common in these interiors provided a further challenge to the artists – as do those found on stonework around the grand portals of important buildings, the intricate wood-carving on panels and *mashraibya* window coverings; and designs on metalware, often inlaid and further complicated with gleaming reflections of light.

Designs of the arabesque took the form of geometrical or floral shapes, sometimes combined with Arabic calligraphic lettering; all types taken to a high pitch of expertise that included work on ceramic tiles.

The Orientalists rose well to this challenge, especially Lewis, Gérôme, Rudolf Ernst and Ludwig Deutsch, although sometimes this could be over-laboured. I found working on these aspects surprisingly enjoyable, but I determined to restrict the urge to fill half the composition with them by introducing smoke, shadows, figures and other features deliberately positioned to reduce these areas, or sometimes just leaving out parts of the intricate sections. This applies whether working on interiors or the exteriors, as can be seen in Qasr Beshtaq on page 63.

Of all the Islamic arts, calligraphy holds the highest esteem because of its association with the Koran. The original Korans created by scribes were beautiful books, as indeed are many you can obtain in the Arab world today. Arabic scripts decorate many mosques, madrassas and other important buildings, carved out of the stonework, and many of the Orientalists took great trouble to render these faithfully in their paintings.

One of the less familiar types of subject I encountered for this book has been the Nabatean architecture of Petra, which is certainly not my usual area of working.

Detail: Nabatean architectural design

This detail from the Urn Tomb painting shows stepped demi-merlons on the left upper part of the building, the right-hand ones badly eroded and not clearly visible. These are typical of many of these Nabatean façades.

Sketching all this detail did not present any great problems unless I worked too close to the subject, and in these instances a camera to back up the drawings proved a useful piece of kit. In the finished paintings, however, accuracy is important, otherwise the effect would look bizarre. One has to work either very loosely or reasonably accurately. I chose the latter, using a set square working from a base line to draw construction lines in lightly to ensure the verticals did not start to lean erratically. Working over these with watercolour soon lost the construction lines and, by using shadow, eroded areas, smoke, figures, trees and other objects to hide

Sheeshas and Shadows

In this painting I have lost excessive detail on the tiles and brown wooden lattice-work, as well as rendering the two background figures without any detail.

or break up certain repetitive features, the final effect loses that over-elaborate appearance. The overwhelming amount of detail, in particular of the decorations, needed great care, as these imparted a sense of gravitas to bring out the Roman, Hellenistic or Nabatean characteristics. The stepped demi-merlons, for example, are a common form of Nabatean decoration on the upper parts of the structures, usually with one on either side. Because of the lighting and the fact that they are well above your eye level, you can normally only see one side of these unless you are aware that the other is present and then it might become discernible. The camera is not as discerning as the human eye so simply relying on a photograph would most likely lead to parts of the architectural gems being lost on these façades.

Photographic reference for architecture

The photograph on page 155 is a good example of how photographs, while useful, can sometimes be deceptive. Note how the verticals splay out towards the tops of the features, the only true vertical being the left-hand side of the entrance. This lens distortion is caused by being so close to the subject. Secondly, the amount of detail in the internal part beyond the columns is too pronounced and likely to cause confusion with closer objects. To create a sense of depth to the structure this background information needs to be subdued. Thirdly, a large block of rough-faced stone on the left hides much of the detail of the main building, and because of the flat lighting this could be mistaken for part of the building. This is a fine example of how important it is for the artist to carry out sketches on the spot in order to record a correct interpretation of a subject of this type.

LIGHT AND DISTANCE

Strong sunlight, of course does not ensure that everything in the scene is clearly visible. Most of the time you can see well into the distance in the desert and desert mountain regions, and this can be a problem where you wish to create atmosphere or reduce overwhelming detail in a scene, or to emphasize a feature by subduing adjacent elements. There have been times when a rain squall has blotted out desert peaks and clouds covered summits, but these situations are extremely rare, except in places like Lebanon. My usual answer is to introduce haze to soften off strong features of crags, cliffs and mountainsides, losing large areas of detail at times. You will see many examples of this throughout the book. In some cases the haze was actually present as shown, but in others I have deliberately introduced it to throw emphasis on to other parts of the scene. Sketching outside in front of the subject has always been my favourite way of working, using a variety of media, then producing the final painting in the studio from the sketches and photographs.

In the Middle East one of the joys of painting is the constant and reliable light. To capture the brightness of the light on paper involves painting fairly strong contrasts of tonal values. Painting in the middle of the day presents difficulties with the sun directly overhead, but at different times when the subject is back-lit, often with a halo effect, one can achieve a more dramatic result. Much of the subject's detail becomes lost in dark shadow tones, almost like a silhouette while adding a sense of mystery, and this strong contrast with the sunlit areas produces a powerful suggestion of strong light. Léon Belly (1827–1877), the French Orientalist, often employed this technique in his desert scenes. He took a methodical approach, and for his monumental *Pilgrims Going to Mecca* he is reputed to have done hundreds of preliminary studies in preparation for that particular painting.

Qasr al Din, Dakhla Oasis

One technique I relish imposing on a composition is to restrict my palette to a few harmonious colours as I have done in this scene in the Western Desert. This imparts a pleasing sense of unity on the subject, although in this case there was little colour variation.

Here I have mainly applied burnt umber, plus some light red (mainly in the foreground), and a few touches of French ultramarine for the darkest tones. For the sky and one or two other places I used yellow ochre. In all this I have tried to keep the few colours within the warmer spectrum of the colour wheel to achieve a feeling of unity.

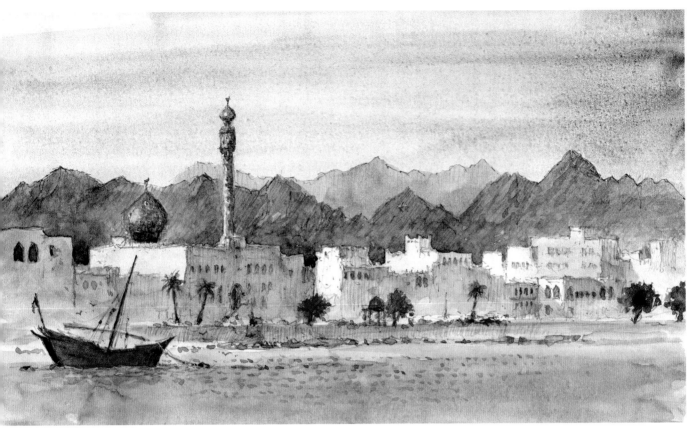

Mutrah Harbour

Tonal values are normally more important to me than colour and in this sketch, carried out only in pencil on the spot, I needed to record the most important tonal relationships in the scene. For this I hatched with mainly vertical pencil lines as can be seen on the shadow sides of the white buildings. By drawing pencil lines in this way the subsequent watercolour when applied back in the hotel, would take to the paper better than if I had scrawled the pencil tone over the paper and created a resistant sheen. The reason I was unable to paint on the spot was because darkness fell quickly.

Amir el Goush Street, Cairo

In a scene like this, simply relying on a photograph to paint from is not enough: I use the sketch to interpret what I see, and to isolate features to give me a better understanding when I'm back in the studio. For example, the pots on the bottom left are made clearer by removing any background detail, and likewise the distant figures. Additionally I add further information above and to the side of the sketch. This is often the safest option, as when a barrow boy is heading towards you the scale is constantly changing and almost always it's difficult to fit that sort of feature into crowds already rendered.

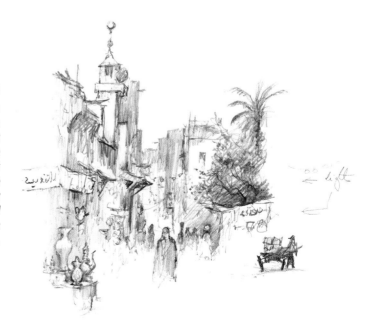

ENGAGING WITH THE LOCALS

With such a vast array of new subjects in the Middle East, the Western artist is confronted with many unfamiliar and exciting challenges, and when one is working outdoors there are so many distractions, both welcome and otherwise, that there is rarely a dull moment. I find that engaging with the locals in a positive way always reaps rewards, and usually brings a sparkle of joy into your day. Even when things go wrong, at the end of the day one can often look back and see the humorous side of events. Those Orientalists like William Holman Hunt, who felt the need to take a whip to people who got in his way, would not only have lost the opportunity for that engaging rapport with local people, but also denied himself that goodwill feeling so important in setting one's artistic mood for the day. Whether one is recording the decadent languishers of a glittering harem, or some smelly street-seller's sand-smothered and battered old trinket-stall, the scope for artistic rewards in this fascinating region is a never-ending tale of unpredictable excitement.

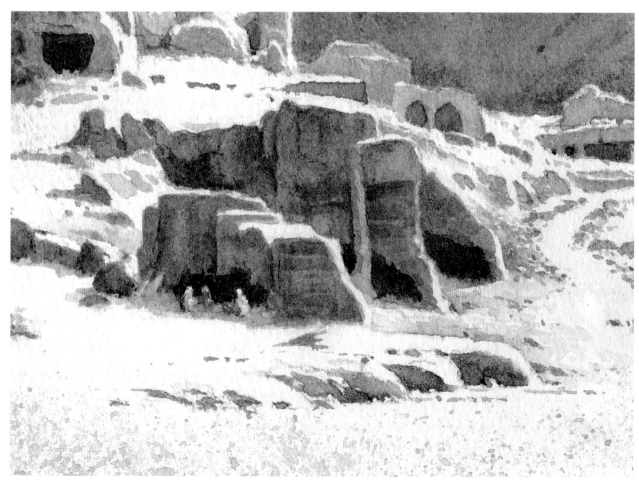

Light effect

This is a detail taken from Heat of the Day, Wadi Musa *(you can see the full painting on pages 72–73). Here it is the feeling of intense heat of the day that I wished to convey. While the cast shadows are vital to suggest the bright light, it is the strong contrast of tones and lack of detail in the sunlit areas that provide the sense of heat.*

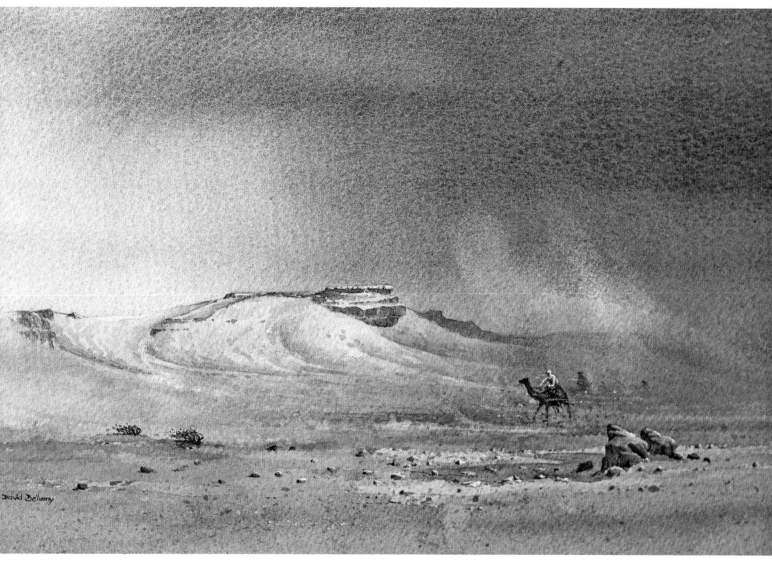

Racing the Sandstorm

The desert scenery shown here is typical of that south-west of Fayoum Oasis, which the riders strive to reach before being overwhelmed by the storm. Energetic brushstrokes and scratches across part of the camel and rider suggest the onset of the storm. Capturing a sandstorm in a sketch is best done from a closed vehicle as flying sand on a watercolour can quickly reduce the artist to a state of dementia.

AFTERWORD

Research for this book has been exciting, stimulating and rewarding. Sadly it also took me into some very dark corners of man's depravity; corners that I would have considered unbelievable in my younger days, but which now, in the 21st century, have come upon us so gradually that we are inured to the collapse of morality within western democracies, and accept what in earlier times we would have rejected out of hand.

Constant propaganda justifying Western actions in the Middle East emanates not just from governments, but also other dubious organizations, the media, films and even novels. Much of this propaganda is subliminal, reaching its utmost depravity during the Iraq war. There is no justification for suicide bombing of civilians, but it is sadly the only way many people feel they can fight back against tanks, fighter-bombers, heavy artillery and missiles. It's not simply because they hate the Western way of life: for most suicide bombers life is not worth living if their home has been blown to smithereens, their family murdered wholesale in what is described as 'collateral damage'. They have no work, little food, poisoned water, have been forcibly dispossessed of their land, and left utterly without hope.

Assassination, death squads and torture are becoming more prevalent by all sides, but the vast majority is by Western countries, with increasing use of drones that introduce a sinister dehumanizing effect. Real lives are being extinguished, and without judicial process. Innocent bystanders are often eliminated or maimed: those killed are not necessarily the so-called terrorists allegedly targeted.

The word 'terrorist' is itself an emotive one. Are we fighting terrorists or those trying to free their country? Western media and 'experts' usually describe Arab militants as terrorists and actions by white militants as 'isolated incidents', though these are far from isolated. Shocking and awful bombing of Middle Eastern cities is the pinnacle of terror, but even the vibrating surge of heavy military helicopters flying over homes brings constant terror and humiliation. How can people who just want to get on with their lives in peace live with this constant fear of being blown apart by trigger-happy aliens who regard the Arab as something less than human? How can children grow up in a world where they are never free from guns, bombs, drones, helicopters, and assaults by tanks and not feel anger and hatred?

The British, European and American taxpayer has every right to demand accountability for the billions spent on pointless wars, and the deaths and maiming of thousands of our brave servicemen and women, when the only 'victors' are the armaments manufacturers whose ordnances vaporize wedding groups and incinerate children. As I write this, a British mother in desperate agony at losing her son in Afghanistan asks on the radio, 'Why – what did it all achieve?'

Since the Second World War, America, despite its military might, has lost every war, and as it retreats from Afghanistan, Americans have every right to ask why the decision makers continually make these costly, humiliating and morally obnoxious errors. We inflict sanctions on the poorest of countries and watch while their youngsters die in thousands of malnutrition as the supposedly civilized West blasts them back into the Dark Ages. We pretend we are wholesome democracies, but modern governments constantly renege on their political manifestos, while at the same time bringing our dubious democracy to the Middle East at the end of the tank barrel. Indeed, It is hardly democracy when a Prime Minister is able to ignore the mass of the British electorate and invade Iraq in 2003, following US President Bush's wild exhortations to visit war on the Iraqi people, when to be anti-war is not to be 'anti-American'.

The Sultan of Lahej said as we abandoned Aden, "You British always betray your friends." We need to look at how we are seen through the eyes of the world.

Patrick Cockburn, writing in the *i* newspaper in September 2020, reported on a study published by Brown University in the US which states that 'at least 37 million people have fled their homes in the eight most violent wars the US has launched or participated in since 2001.' Refugees flee to Europe where they may be incarcerated in squalid camps for long periods. Our actions fuel this terrorist environment and feed the more fanatical elements who want to destroy us, while the legislation attempting to control this further erodes the freedoms of European people. Everybody loses.

Western countries are in the driving seat and can change all this, stop the sheer greed, the vast profiteering from mass weapon sales, the dismembering of the rule of law and their racism, and rebuild our sense of morality and respect for others, and allow Westerners to once again enjoy the cultures of these amazing countries. Twenty-first century Britain is a different country to the one I was born into, yet so many Britons seem unaware of how their lives are being so manipulated and degraded. In my experience, the Bedouin may still live a hard life, but he feels much freer and happier.

Fiery Sky Over A Minaret

Acknowledgements

Putting this book together from the mountain of sketches and journals that have accumulated over the years has been exciting, though something of a struggle in deciding what to leave out. Many people have smoothed my way through these amazing places: Mohammed Marzouk, whose knowledge of the desert is unerring, and his amazing team; Nicole Douek the Egyptologist who organized such an outstanding expedition to the Gilf Kebir; Abo el Khair Eissawi, the Egyptian guide who coined the phrase, "Always I believe David have Golden Fingers;" Kamal, Abdellai, Mohammed and Naghib, the crew of the Kenyan dhow *Queen*; Najah, the Palestinian taxi-driver who took me to Baalbek and patiently waited while I explored and sketched; Atala al-Pluoy, with whom we bounced around Wadi Rum, punctuated by some delightful breakdowns; the Bedouin cameleers at Petra; Jenny Keal for checking my manuscript as well as accompanying me on many of the trips, and the lovely folk at Search Press who turn my wayward writing into a great presentation: Katie French the Editorial Director, Edward Ralph my patient editor with whom it is a delight to work, and Juan Hayward who creates the fabulous book design. I would also like to express my appreciation of the late Brian MacDermot of the former Mathaf Gallery in London, who encouraged me in my Middle Eastern work.

I cannot emphasize enough how, in every country, the people have always been so kind and helpful; nearly always with a smile and a sense of humour that brings a sparkle to every day. My sincere thanks to you all, and others unmentioned, for helping to make this happen. Finally, a very special thanks to Zouzou the camel at Petra, who entertained us so well.

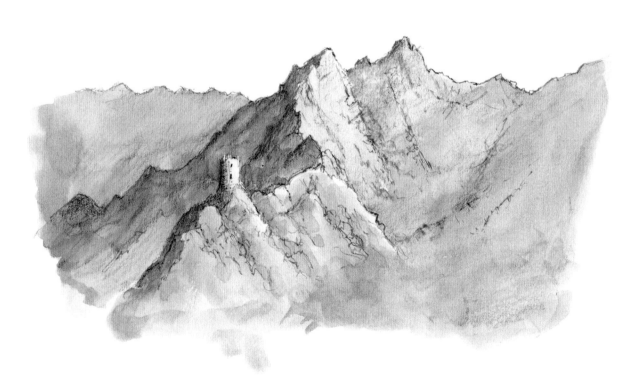

Omani watchtower

Glossary

The spelling of Arabic words and places can vary considerably, but in this book I've tried to retain the most common usage. I have listed a selection of more commonly used Arabic and Swahili words here.

ARABIC

Abaya A thin black cloak, covering the wearer from the top of the head to the ankles.

Ablaq Islamic design incorporating alternate light and dark colours in stonework.

Abu Father.

Baqsheesh A present or gratuity.

Bashi-bazouk An irregular unpaid soldier permitted to plunder.

Burqa A face mask that covers the whole face except the eyes.

Djellabiyya Loose-fitting robe that covers from neck to ankle.

Falaj Irrigation channels.

Fellaheen Land worker, farmer.

Futah A cotton wrap common in southern Yemen. It is worn round the waist to below the knees.

Hajj An annual Islamic pilgrimage to Mecca.

Jambiyya A curved dagger worn by Yemeni men.

Jebel/Gebel Mountain.

Joggled voussoirs Interlocking stones of an arch or lintel with alternating colours.

Kaffiyeh Red and white, or black and white, headdress worn by Palestinians and Jordanians.

Madrassa A school.

Maghreb North-west African Arab countries.

Mashrabiya Wooden screens of decorated latticework.

Mihrab A niche in a mosque on the side facing Mecca.

Muezzin The one who calls the Muslim faithful to prayer five times a day.

Narghile/sheesha/hookah Waterpipe.

Nasrani Christian.

Shiites Adherents of the house of Ali, disciple and son-in-law of the prophet Muhammad.

Souk Market place,

Sunnis Orthodox Muslims who are followers of Muhammad.

Wadi A valley.

SWAHILI

Boriti Mangrove poles.

Mzungu European.

Panga A long-bladed knife the size of a machete.

Nile at Aswan

Select bibliography

Aithie, Charles & Patricia, *Yemen: Jewel of Arabia* (London, Stacey International, 2001)

Burton, Richard, F, *Personal Narrative of a Pilgrimage to Al-Madinah and Meccah* (London, Constable & Co., 1893)

Cockburn, Patrick, *The Occupation* (London, Verso, 2006)

Davies, Kristian, *The Orientalists: Western artists in Arabia, the Sahara, Persia & India* (New York, Laynfaroh, 2005)

Donahaye, Jasmine, *Losing Israel* (Bridgend, Poetry Wales Press, 2015)

Doughty, C M, *Travels in Arabia Deserta* (Cambridge, Cambridge University Press, 1888)

Fisk, Robert, *The Great War for Civilisation: The Conquest of the Middle East* (London, Harper Perenial, 2005)

Gardner, Frank, *Blood & Sand: Love, Death and Survival in an Age of Global Terror* (London, BBC, 2007)

Geniesse, Jane Fletcher, *Freya Stark: Passionate Nomad* (New York, Pimlico, 1999)

Gibran, Khalil, *The Prophet* (New York, Alfred A Knopf, 1923)

Guiterman, Helen & Llewellyn, Briony, *David Roberts* (London, Phaidon Press, 1986)

Hill, Ginny, *Yemen Endures* (London, C Hurst & Co., 2017)

Hindley, Geoffrey, *Saladin, Hero of Islam* (Barnsley, Pen & Sword Books, 1976)

Howell, Georgina, *Daughter of the Desert: the remarkable life of Gertrude Bell* (London, Pan, 2006)

Kabbani, Rana, *Europe's Myths of Orient* (London, Pandora, 1986)

Lane, Edward W, *An Account of the Manners and Customs of the Modern Egyptians* (London 1836)

Lawrence, T E, *Seven Pillars of Wisdom* (London, Penguin, 1926)

Lovell, Mary S, *A Scandalous Life: the biography of Jane Digby* (London, Fourth Estate, 1995)

Ministry of National Heritage & Culture – Sultanate of Oman, *Oman, a Seafaring Nation* (Muscat, 2005)

Murphy, Dervla, *A Month by the Sea: Encounters in Gaza* (London, Eland, 2013)

Noakes, Vivien, *The Painter Edward Lear* (Newton Abbot, David & Charles, 1991)

Noakes, Vivien, *Edward Lear 1812–1888* (London, Royal Academy of Arts, 1985)

Omaar, Rageh, *Revolution Day: the Human Story of the Battle for Iraq* (London, Viking, 2004)

Parry, James, *Orientalist Lives: Western Artists in the Middle East 1830–1920* (Cairo, American University in Cairo Press, 2018)

Payne, Robert, *The Crusades* (London, Wordsworth Editions, 1986)

Said, Edward W, *Orientalism* (New York, Penguin, 1985)

Shlaim, Avi, *The Iron Wall* (London, Penguin Books, 2014)

Taylor, Di & Howard, Tony, *Jordan* (Milnthorpe, Cicerone Press, 1999)

Thesiger, Wilfred, *Arabian Sands* (London, Longmans, 1959)

Trench, Richard, *Arabian Travellers: The European Discovery of Arabia* (London, Macmillan, 1986)

Tromans, Nicholas, *The Lure of the East: British Orientalist Painting* (London, Tate Publishing, 2008)

Van der Bijl, Nick, *British Military Operations in Aden & Radfan* (Barnsley, Pen & Sword Books, 2014)

Villiers, Alan, *Sons of Sinbad* (London, National Maritime Museum, 2006)

Vivian, Cassandra, *The Western Desert of Egypt* (Cairo, American University of Cairo Press, 2000)

Walker, Jonathan, *Aden Insurgency* (Staplehurst, Spellmount Ltd, 2005)

Winstone, H V F, *Lady Anne Blunt* (London, Barzan Publishing, 2003)

Index

First published 2022

Search Press Limited
Wellwood, North Farm Road,
Tunbridge Wells, Kent TN2 3DR

Text copyright © David Bellamy, 2022

Photographs are the author's own except for those by Mark Davison at Search Press Studios (pages 53, 65, 74–75, 102–103, 150 and 152–153) and Heather Louise at Heather Louise Photography Studios (pages 91, 92–93, 96, 147 and 149)
Design copyright © Search Press Ltd. 2022

ISBN 978-1-78221-729-9
ebook ISBN 978-1-78126-661-8

The Publishers and author can accept no responsibility for any consequences arising from the information, advice or instructions given in this publication.

Suppliers
If you have any difficulty obtaining any of the materials and equipment mentioned in this book, visit the Search Press website for details of suppliers: www.searchpress.com

You are invited to visit the author's website at:
www.davidbellamy.co.uk

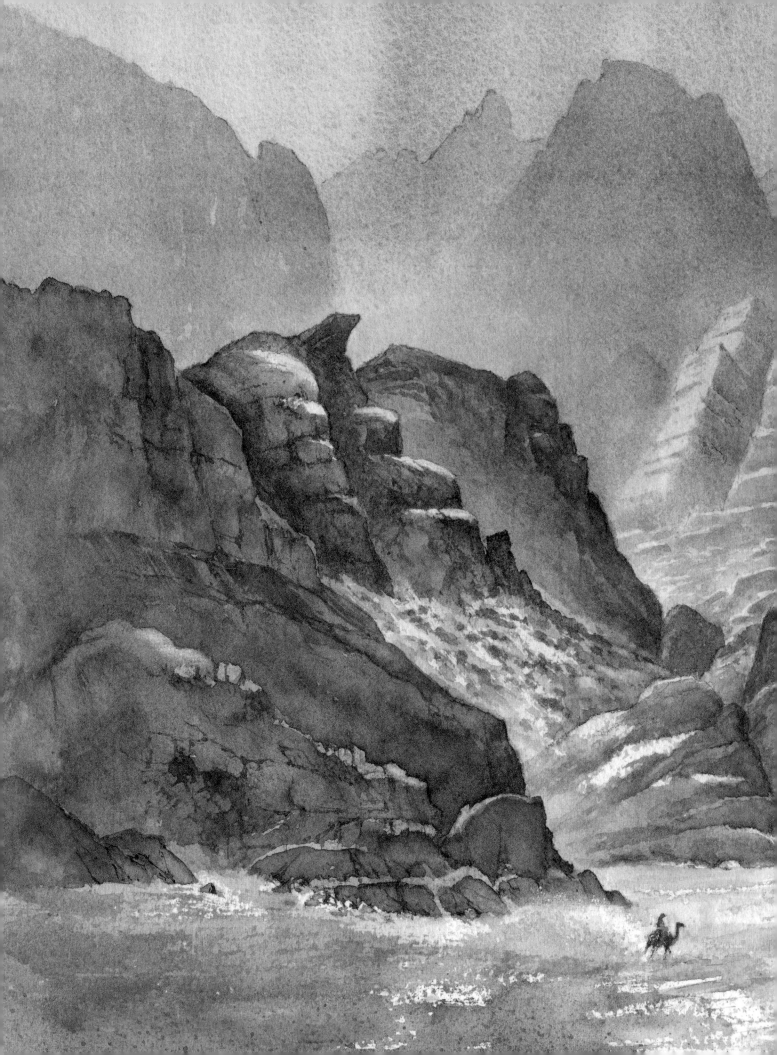